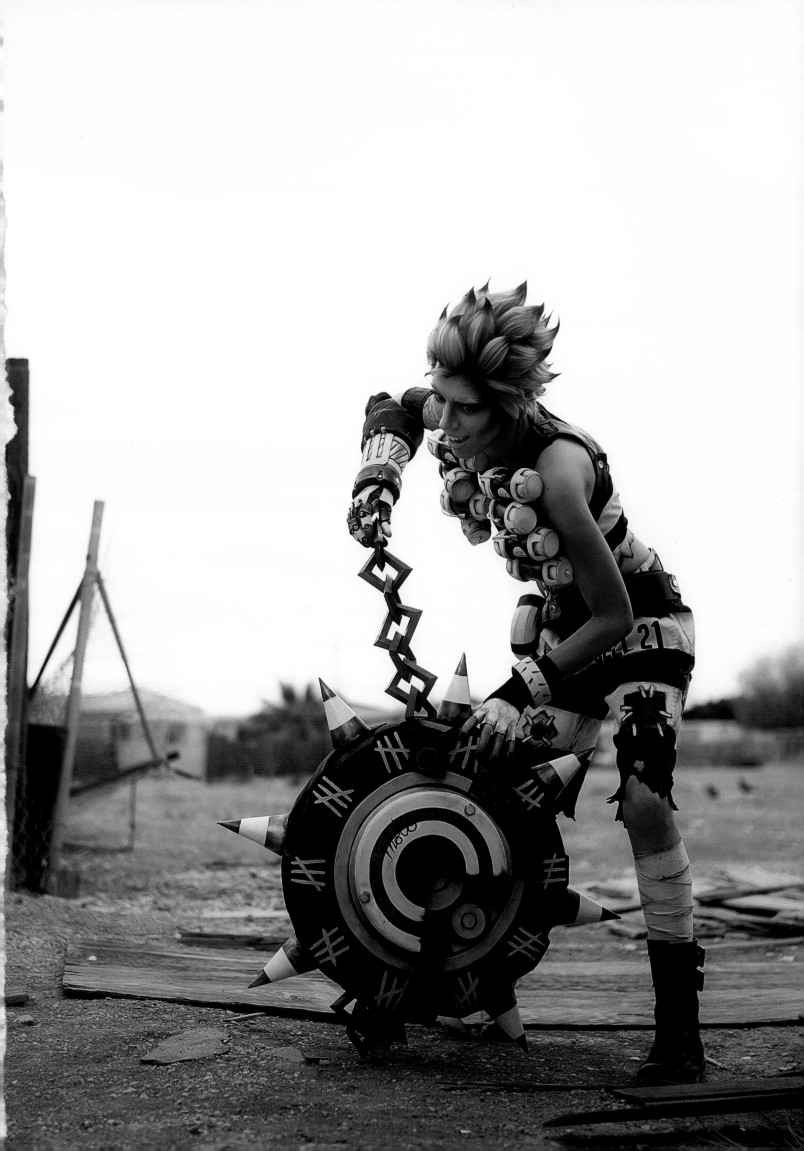

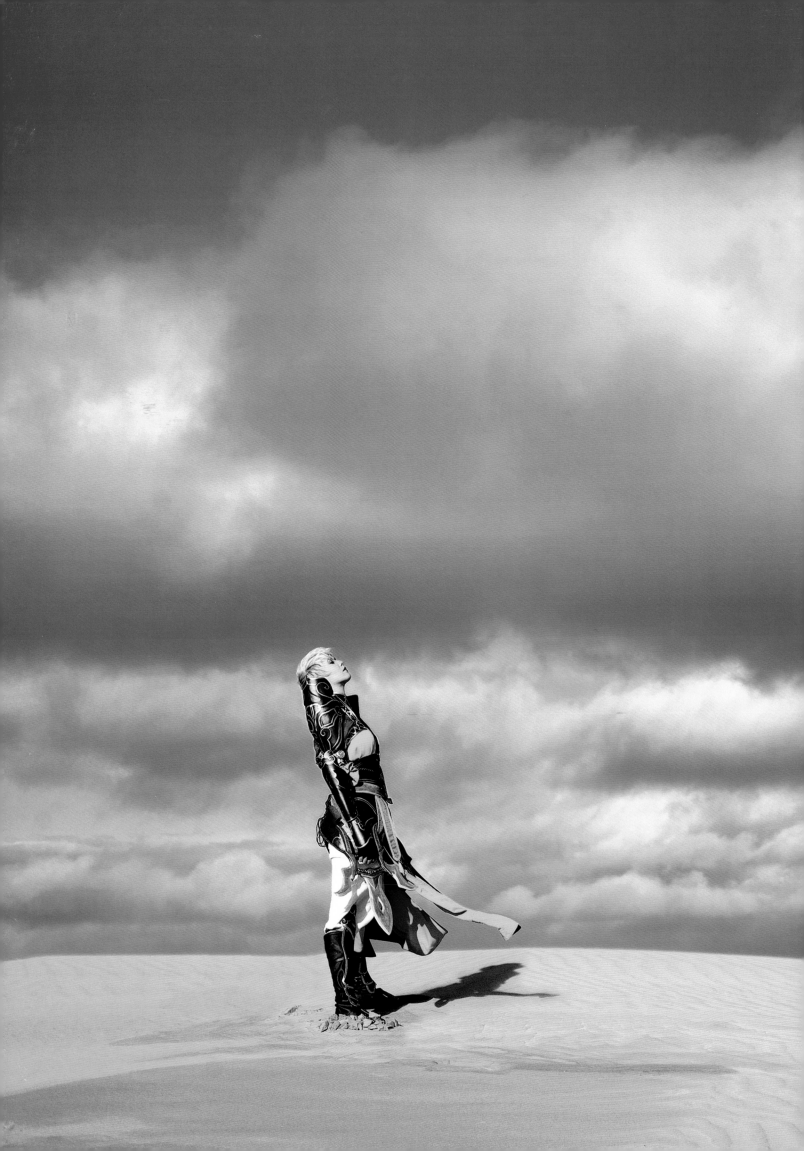

# BLIZZARD
### TIPS, TRICKS, AND HINTS
# COSPLAY

**BLIZZARD ENTERTAINMENT**
**Additional Writing By:** Matt Burns
**Editors:** Allison Irons, Paul Morrissey, David Wohl
**Art Direction:** Bridget O'Neill
**Creative Consultation:** Alex Ackerman, Megan Embree, Lorraine M. Torres
**Lore Consultation:** Sean Copeland, Christi Kugler, Justin Parker
**Production:** Diandra Lasrado, Brianne M. Loftis, Timothy Loughran, Alix Nicholaeff, Charlotte Racioppo, Derek Rosenberg, Cara Samuelsen, Jeffrey Wong
**Director, Consumer Products:** Byron Parnell
**Director, Creative Development:** Ralph Sanchez
**Special Thanks:** Hector Bolanos, Andrew English, Erik Jensen, Julie Kimura, Pablo Lloreda, Ty Stevens

**DESIGN BY CAMERON + COMPANY**
**Publisher:** Chris Gruener
**Creative Director:** Iain R. Morris
**Art Director:** Suzi Hutsell
**Design Assistant:** Amy Wheless

Library of Congress Cataloging-in-Publication Data available.

ISBN-13: 978-1-945683-22-0
Printed in China
10 9 8 7 6 5 4 3 2 1

Cover
**NATALIA KOCHETKOVA A.K.A. NARGA** ▪ JAINA
*Photographer: Kira*

Page 1
**SARAH SPURGIN** ▪ JUNKRAT
*Photographer: Tim Vo*

Pages 2–3
**CHRISTINA MIKKONEN A.K.A. ZERINA** ▪ *DIABLO III* MONK
*Photographer: Tim Vo*

Opposite
**TSUNAMI JENN** ▪ ANA AMARI
*Photographer: BriLan Imagery*

Overleaf
**NATALIA KOCHETKOVA A.K.A. NARGA** ▪ TYRANDE
*Photographer: Kira*

Page 240
**JESSICA NIGRI** ▪ DEATHWING
*Photographer: Carlos Guerrero*
*Costume designed by Zach Fischer*

Back Cover
**DORASAE A.K.A. AKAKIOGA COSPLAY** ▪ SYMMETRA
*Sara Lynn Photography*

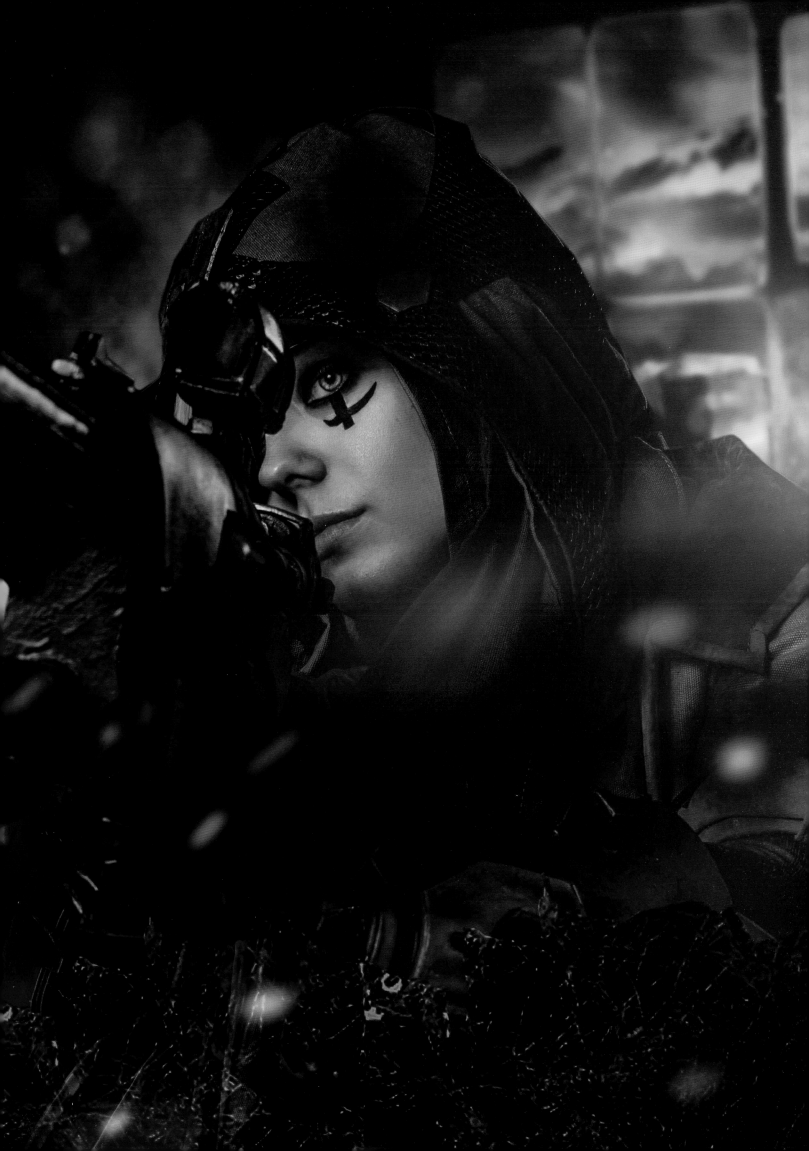

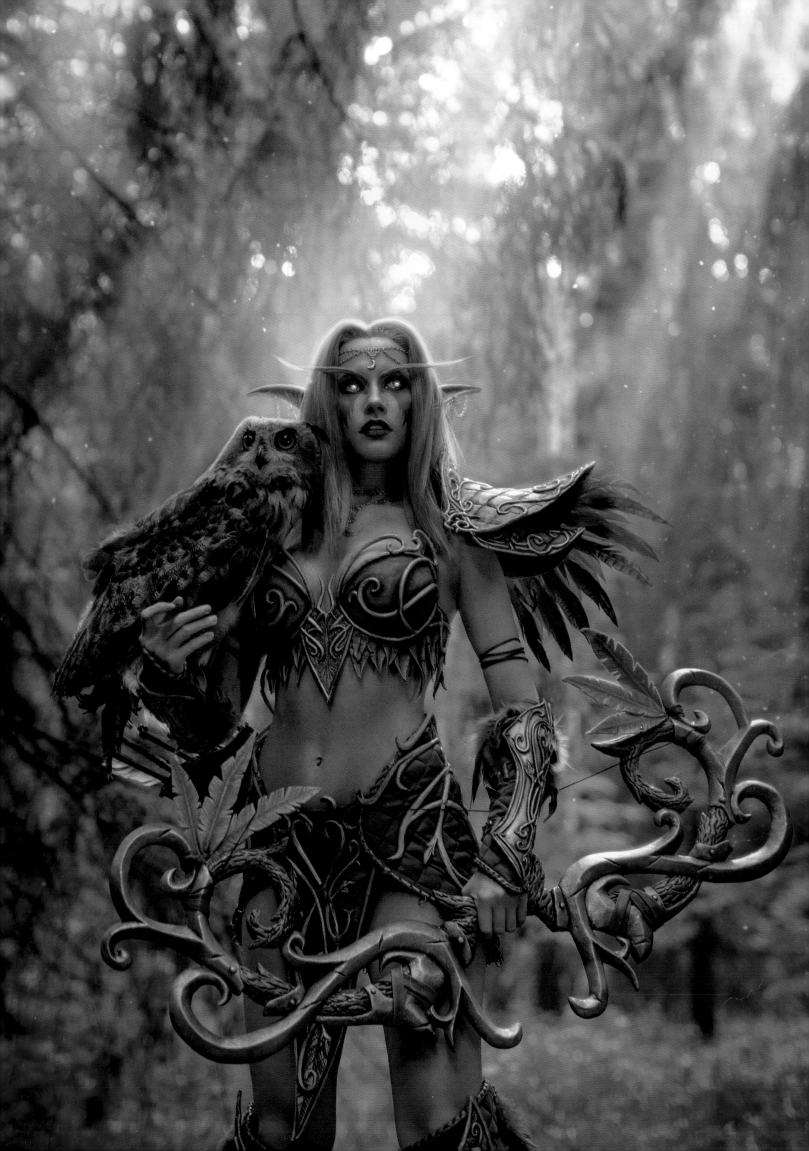

**NEARLY EVERY YEAR SINCE 2005, WE HAVE HOSTED OUR OWN CONVENTION—BLIZZCON—TO SHOWCASE OUR GAMES, MAKE ANNOUNCEMENTS, AND BRING MEMBERS OF OUR COMMUNITY TOGETHER FROM ACROSS THE GLOBE.**

One of the first things attendees see upon their arrival are cosplayers—people who have painstakingly put together imaginative costumes of their favorite characters. They roam the convention halls dressed as various personalities from Warcraft, StarCraft, Overwatch, Diablo, Heroes of the Storm, and Hearthstone. They make us smile. They make us laugh. And most of all, they leave us in awe of their talent.

Cosplayers can spend months—or even years—crafting their outfits, using skills as varied as graphic design, engineering, painting, and metalworking. They face challenge after challenge during the process, but they always find a way to improvise and push themselves forward to get the job done. After they've made their costumes, they pack them into suitcases—often a herculean task in itself—and travel great distances to show them off at BlizzCon and other conventions around the world. Then it's on to the next project. The next challenge.

But what drives them? What does cosplay mean to them?

We interviewed some of the most talented cosplayers around to learn why they do it, the methods they use, and the trials they have faced. They each have their own perspective and story to tell, but what they all share is a deep passion and dedication to their craft.

The love they put into cosplay always inspires us, and we hope it will inspire you too.

**PIXELPANTZ ▪ *DIABLO III* WITCH DOCTOR**
*Photographer: Alec Rawlings*

"I got into cosplay when I was a freshman in high school. Back then, I was a bit of an undercover nerd. I had very few friends that enjoyed the same things I did. Cosplay allowed me to express my love for all the geeky things I would have otherwise hidden."
—*PixelPantz*

**KATRINA FOX COSPLAY** ·
VALEERA SANGUINAR
*Photographer: Carlos Guerrero*

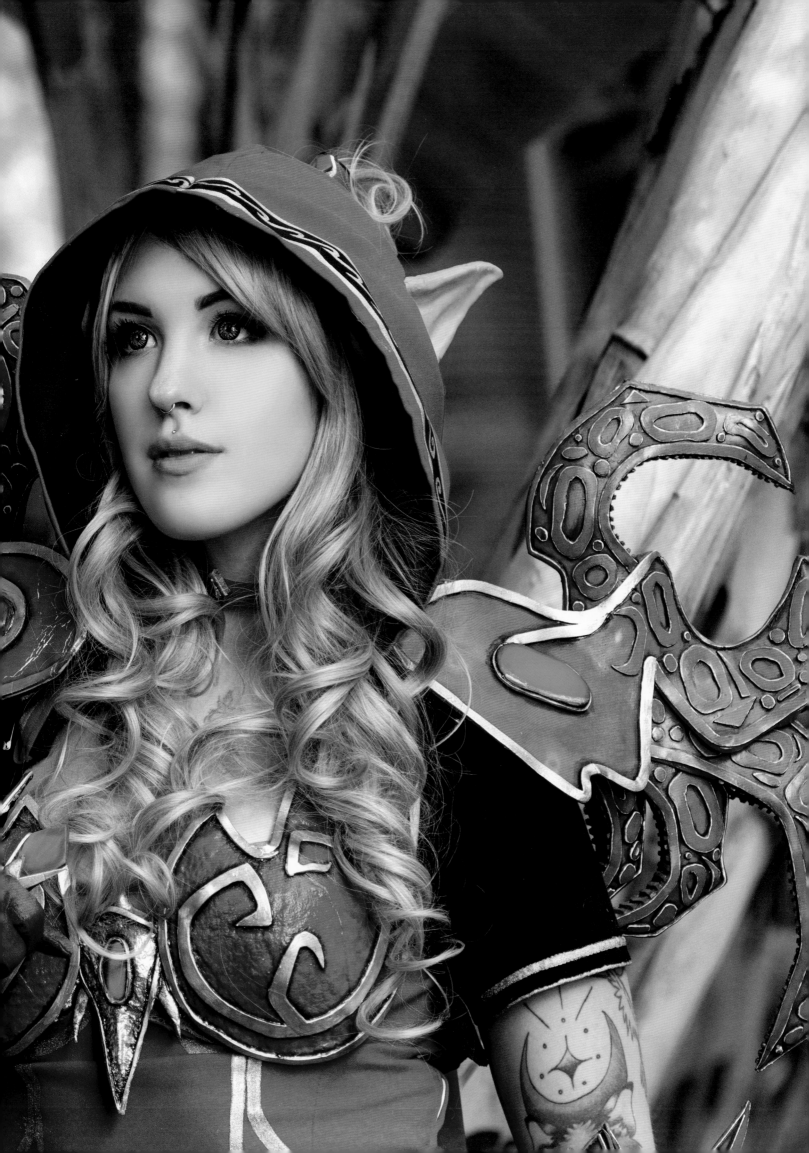

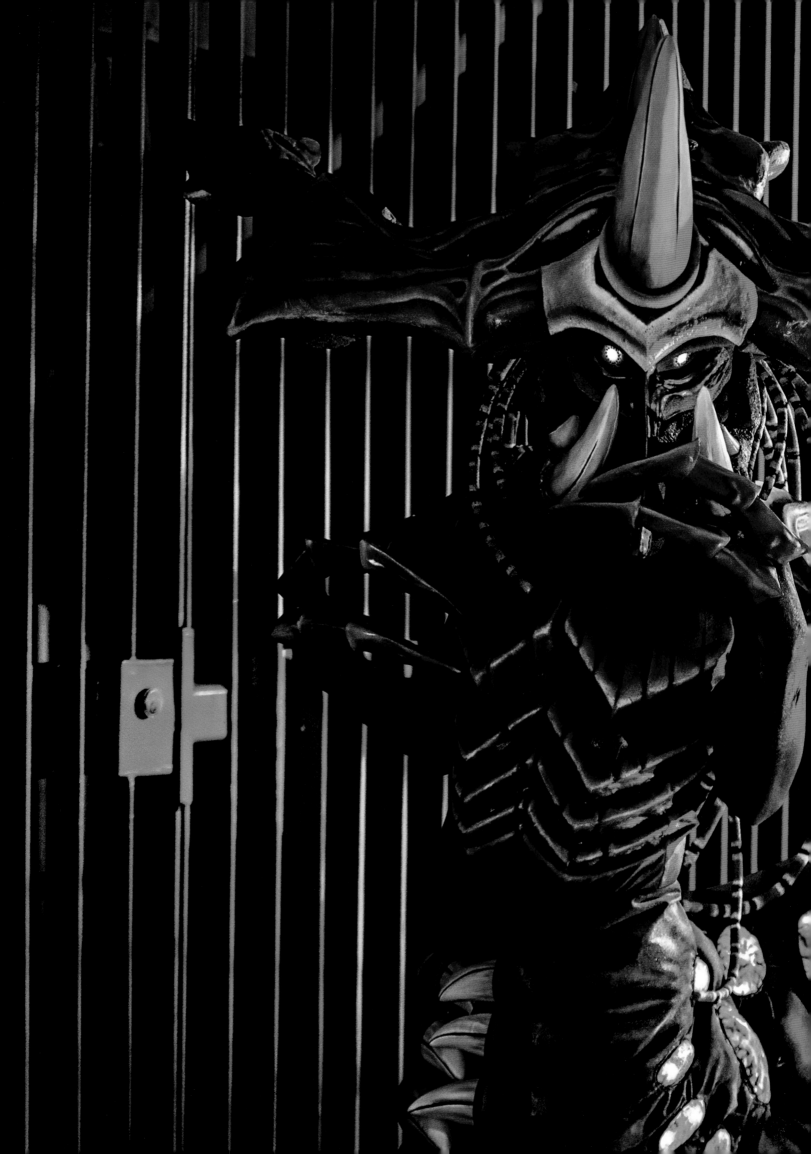

**LOUICE ADLER A.K.A. LANISAZ** ▪ ZAGARA
*Photographer: Tony Julius*

"I have always had a passion for creating characters, so when I learned about cosplay, my curiosity was piqued. It gave me the opportunity to not only draw and visualize a character but to fully realize them."
—*Louice Adler a.k.a. Lanisaz*

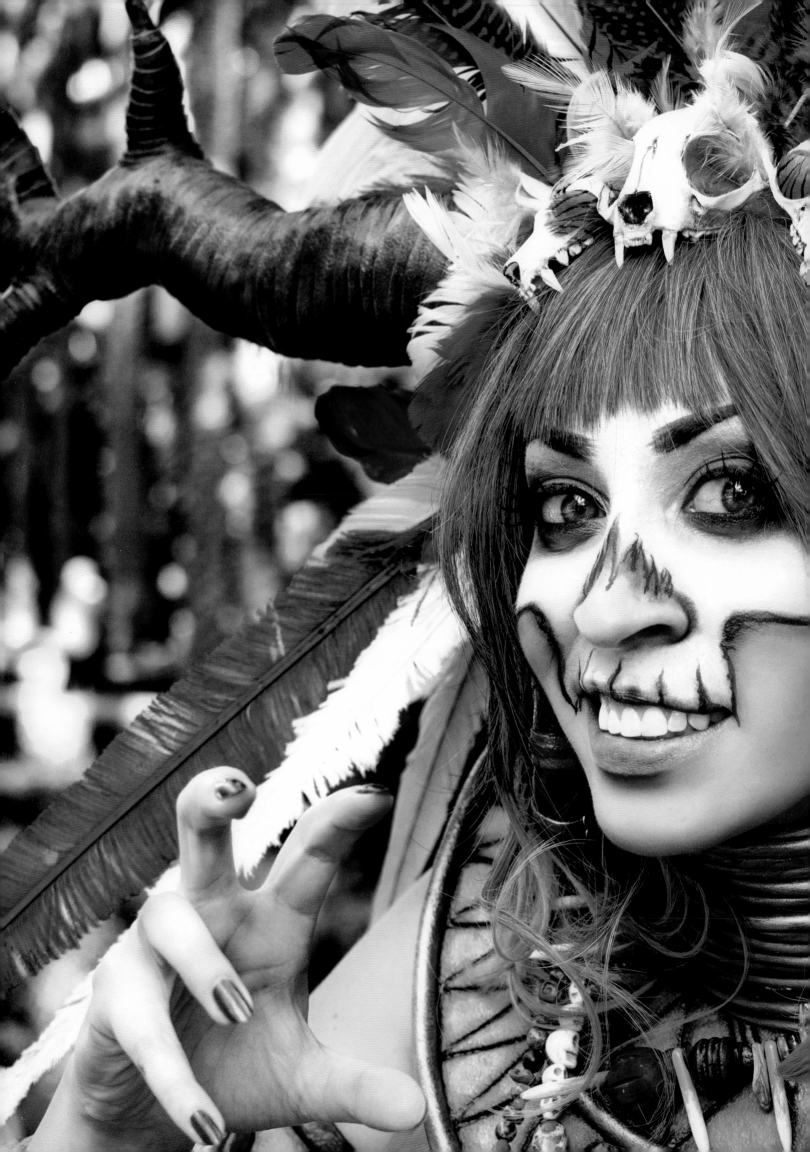

**VIVID VIVKA** · *DIABLO III* WITCH DOCTOR
Photographer: Carlos Guerrero

**ALINA GRANVILLE A.K.A. SPOON MAKES •** TORBJÖRN
*Photographer: John Jiao*

"I made my first costume so I wouldn't feel out of place while attending anime conventions. I wore that costume a ton; it made me happy to just fit in. I didn't really get into cosplay proper until a few years after that when I needed a fun and creative outlet. It helped me deal with stressful and depressing life events. Cosplay impacted my life in a positive way with new friends, skills, and confidence."
—*Alina Granville a.k.a. Spoon Makes*

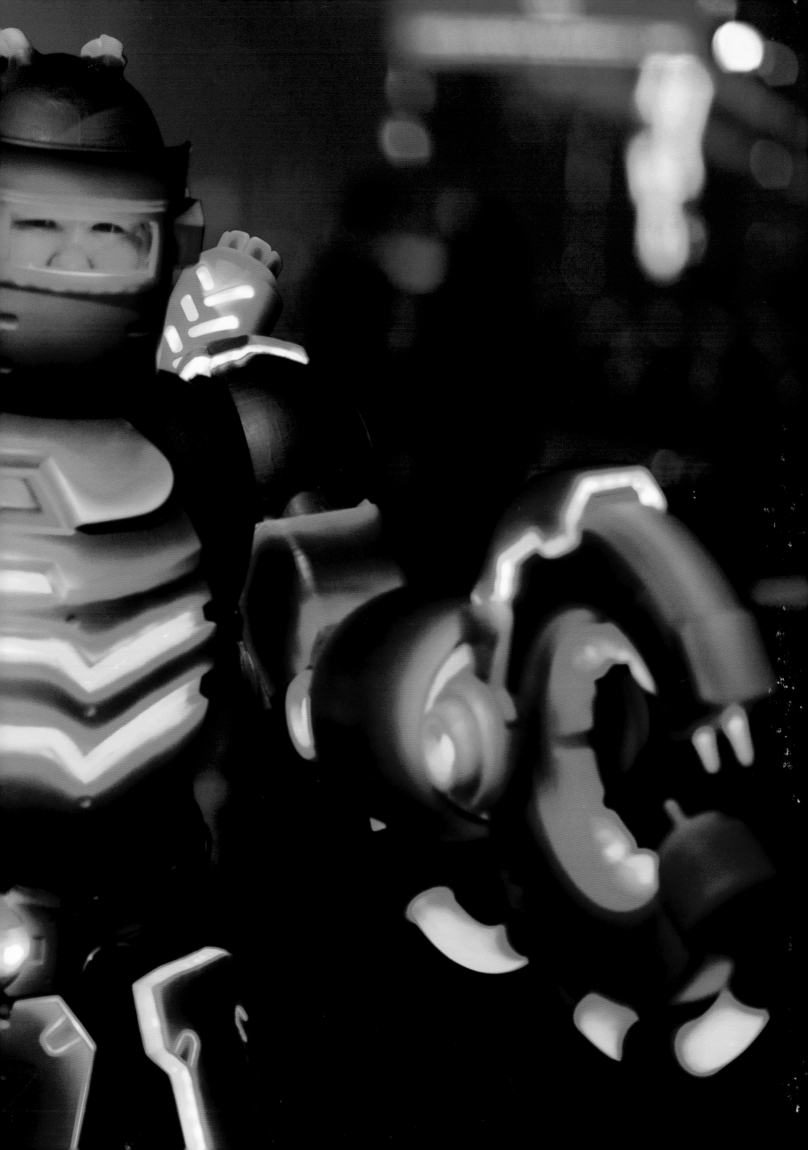

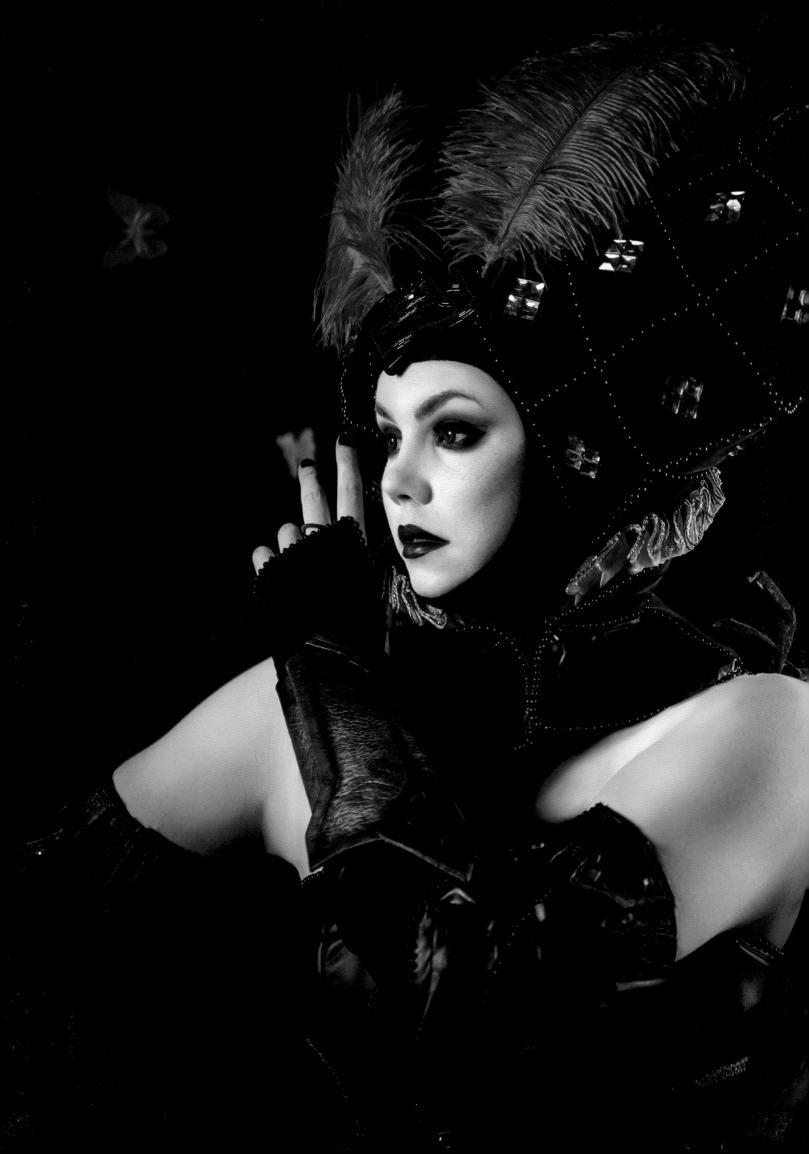

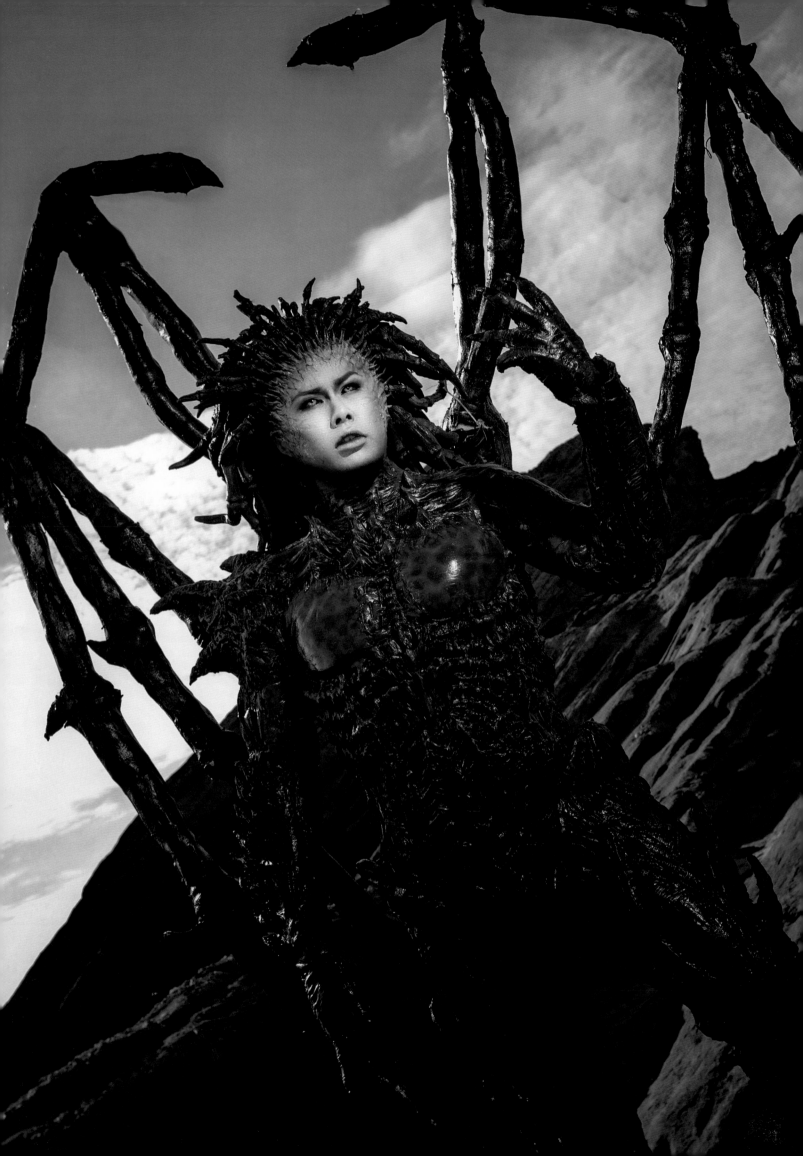

## KELTON CHING (KELTONFX) ▪
## KERRIGAN
*Alive Alf Photography*

"I first started making my own clothes at age fourteen. I was very into the DIY (do-it-yourself) aesthetic popular in the goth and Japanese visual kei scenes. I later discovered that people handmade costumes of their favorite video game characters. I thought that was really neat, and I wanted to do it too. My background in fine arts helped me with my crafting skills, and cosplay became another outlet for me to create art."
*—Kelton Ching (KeltonFX)*

**RALF FROM LIGHTNING COSPLAY** • MALFURION
*Photographer: eosAndy*

**LAURA & RALF FROM LIGHTNING COSPLAY · MALFURION & TYRANDE**
*Photographer: Martin Hola*

"In 2011, I visited a German convention and got in touch with cosplay for the first time. I was so impressed by all the costumes and creative people, so I said to myself, 'Next year I want to make a cosplay too!' And that is where it all started."
—*Laura & Ralf from Lightning Cosplay*

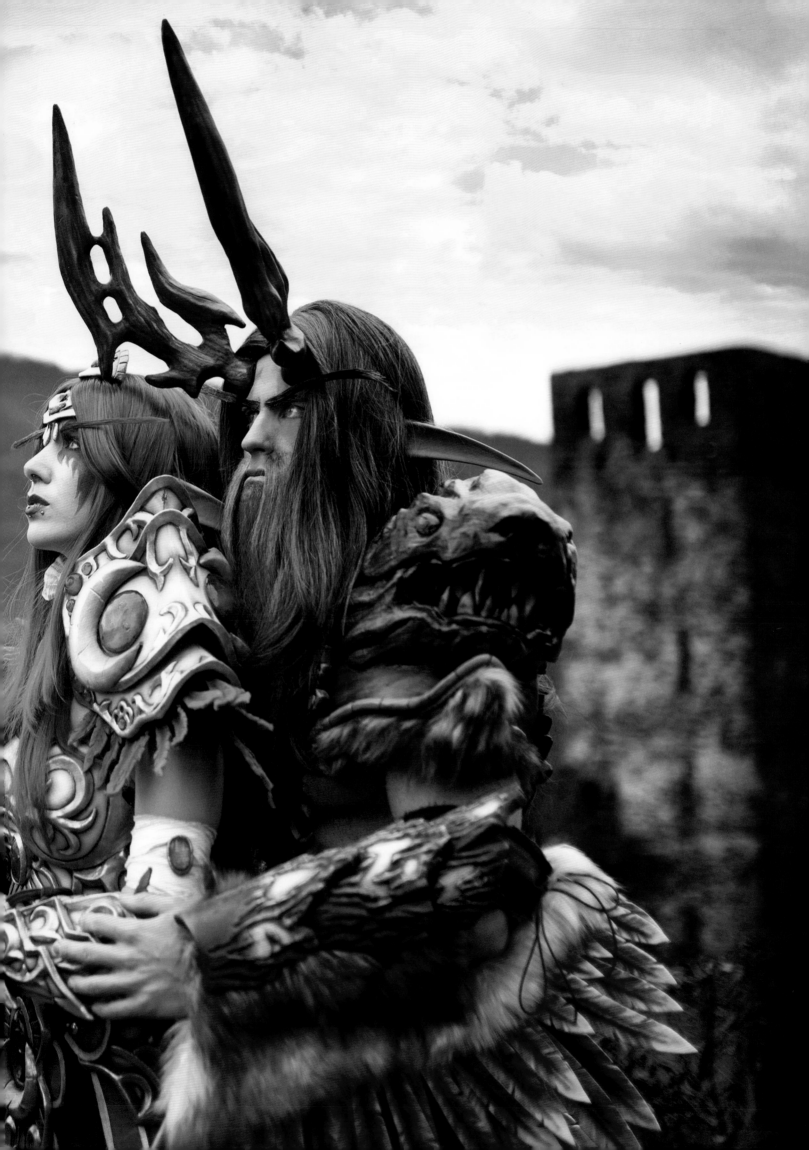

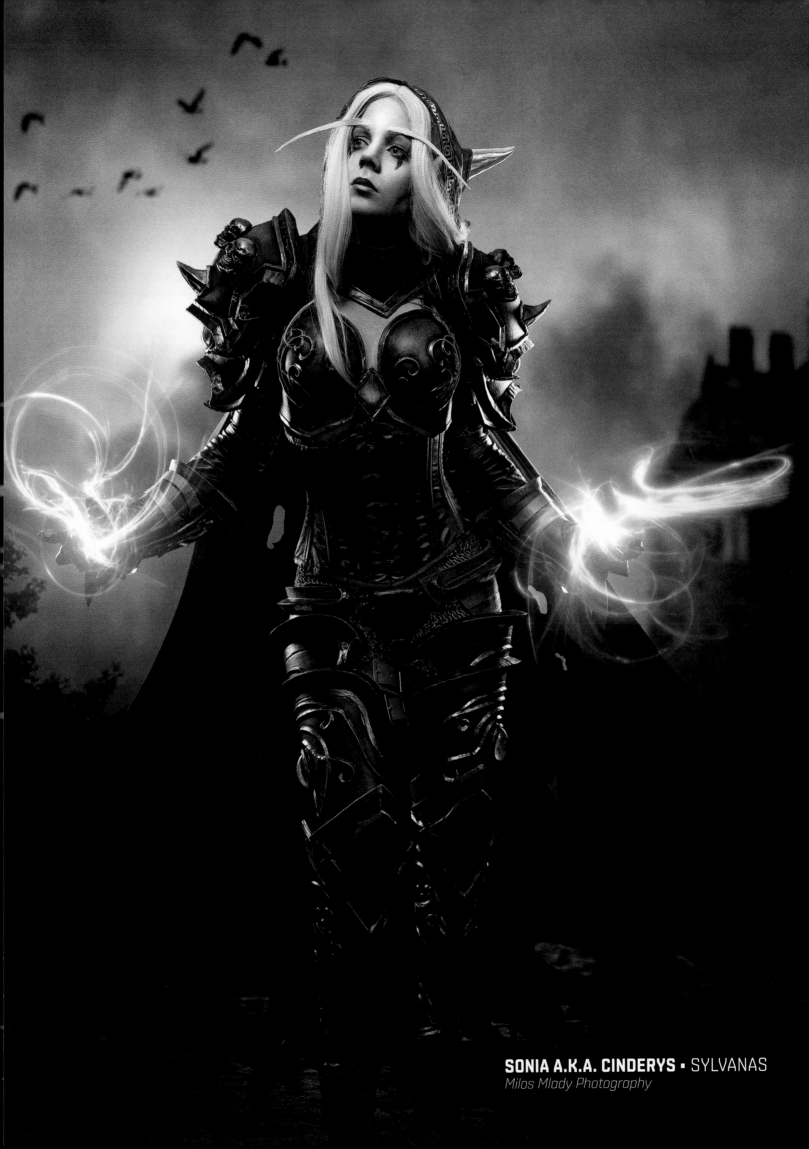

SONIA A.K.A. CINDERYS · SYLVANAS
*Milos Mlady Photography*

## ASHLEY O'NEILL A.K.A. OSHLEY COSPLAY •
### *WORLD OF WARCRAFT* HUNTER
*Photographer: Studio Henshin*

"I got involved with cosplay when my friend and I were daydreaming about how we wished our favourite places in World of Warcraft were real, and she linked me photos of WoW cosplayers. It amazed me that this kind of art existed, and that 'cosplay' was a thing where people made their favourite in-game items and clothing in real life. Then a thought crossed my mind that said, 'I can do that'. So, I did! The next day I started looking up tutorials, browsing for costume-making techniques that sparked my interest, and looking at what other WoW cosplayers had made in the past!"
—Ashley O'Neill a.k.a. Oshley Cosplay

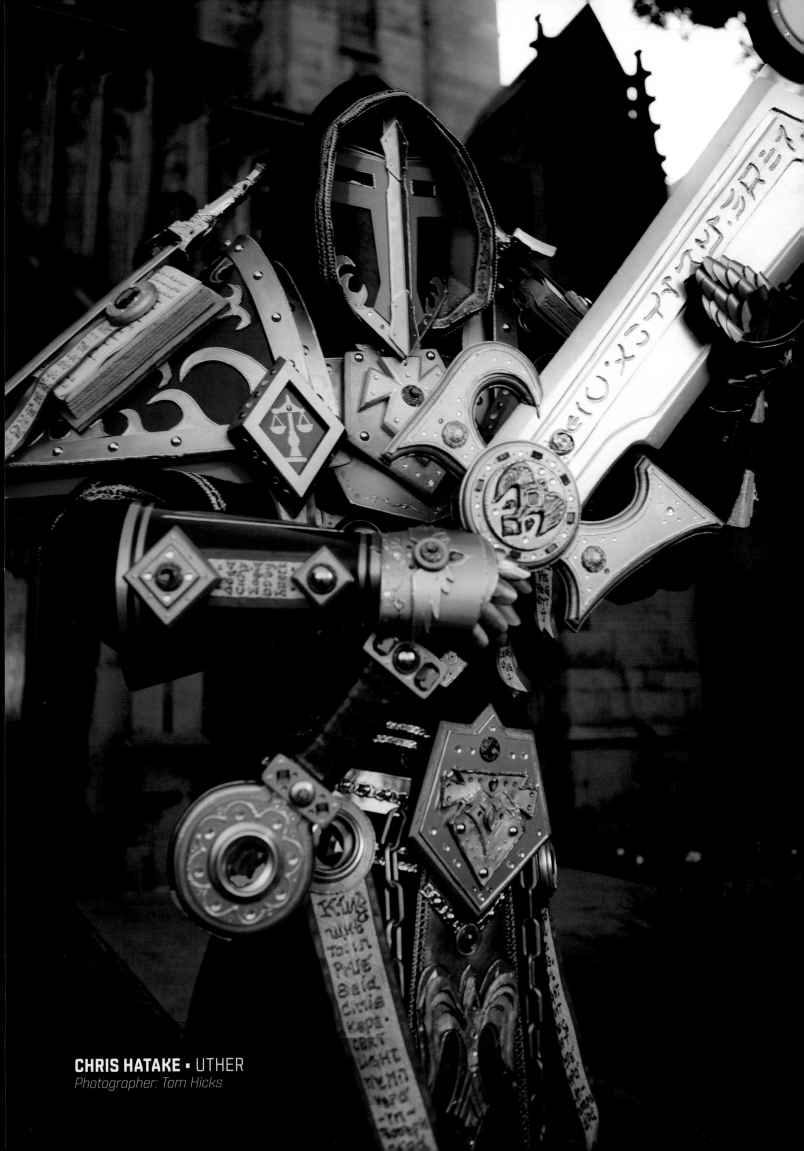

**CHRIS HATAKE • UTHER**
*Photographer: Tom Hicks*

**VICKYBUNNYANGEL COSPLAY** ·
ZUNIMASSA WIZARD
*Martin Wong Photo*

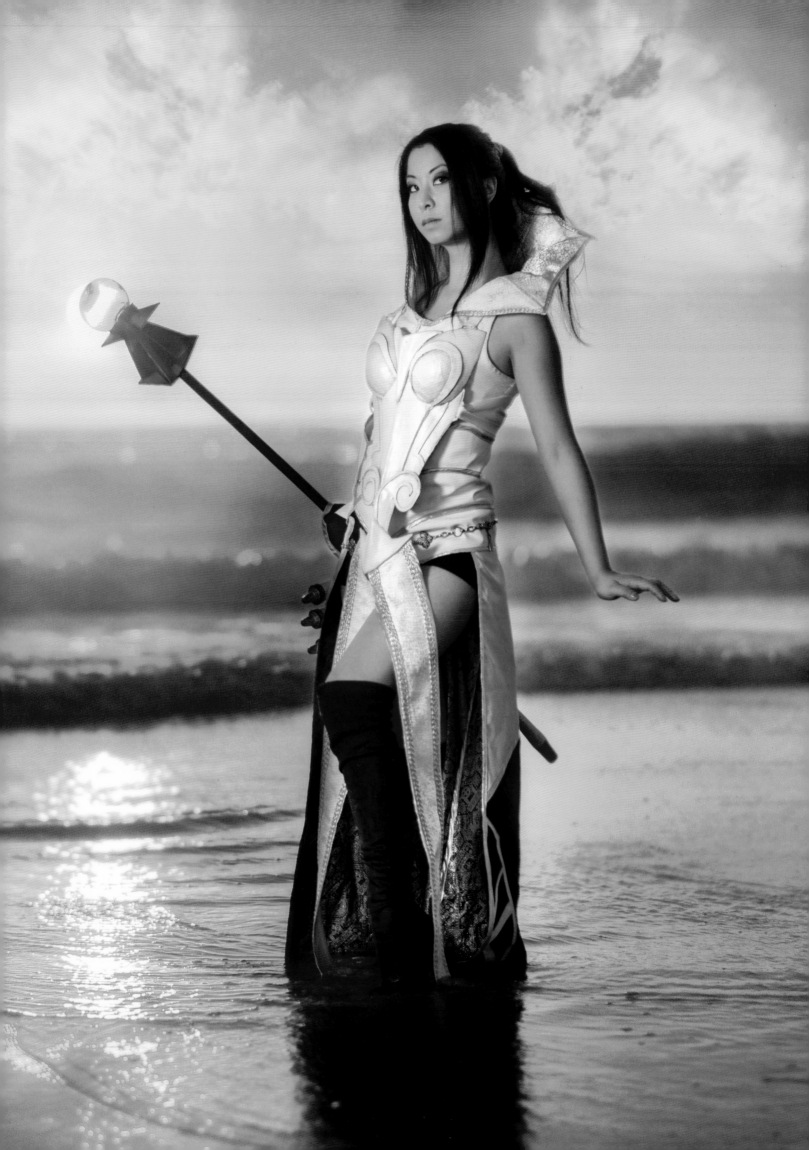

SERAPH COSPLAY • MALTHAEL
Photographer: Jayce Williams a.k.a. Photo NXS

**SPIF ZAYA · *DIABLO III* CRUSADER**
*Eric Ng a.k.a. Bigwhitebazooka Photography*

"I got into cosplay out of simple interests in Halloween and costumes. From there it spiraled out of control and into conventions and anime culture. Now I stick with cosplay as a form of expression, fandom, and nerd socialization. I'm free to express what is not deemed 'normal' through costumes and character."
—*Spif Zaya*

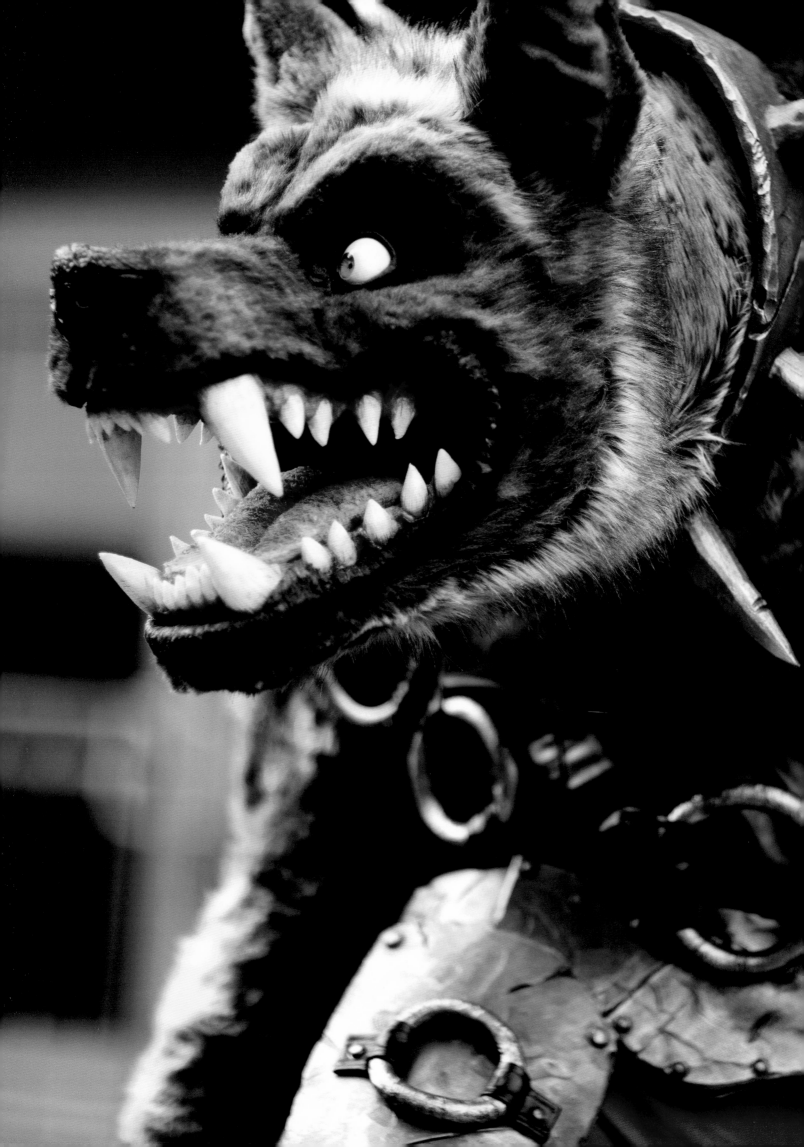

**LAURA "KAZUL" MERCER ·**
HOGGER
*Photographer: John Jiao*

"When I am looking for a character to cosplay, I start by gathering a list of all the characters and creatures that I have ever had an 'oh, that's a cool design!' or 'they're so cool!' moment with in game. I slowly narrow the list to the best of the best and start thinking about each option in terms of how I can actually build it. I also have other goals in mind, like certain techniques I'd like to use or features that I'd like to have included."
—*Laura "Kazul" Mercer*

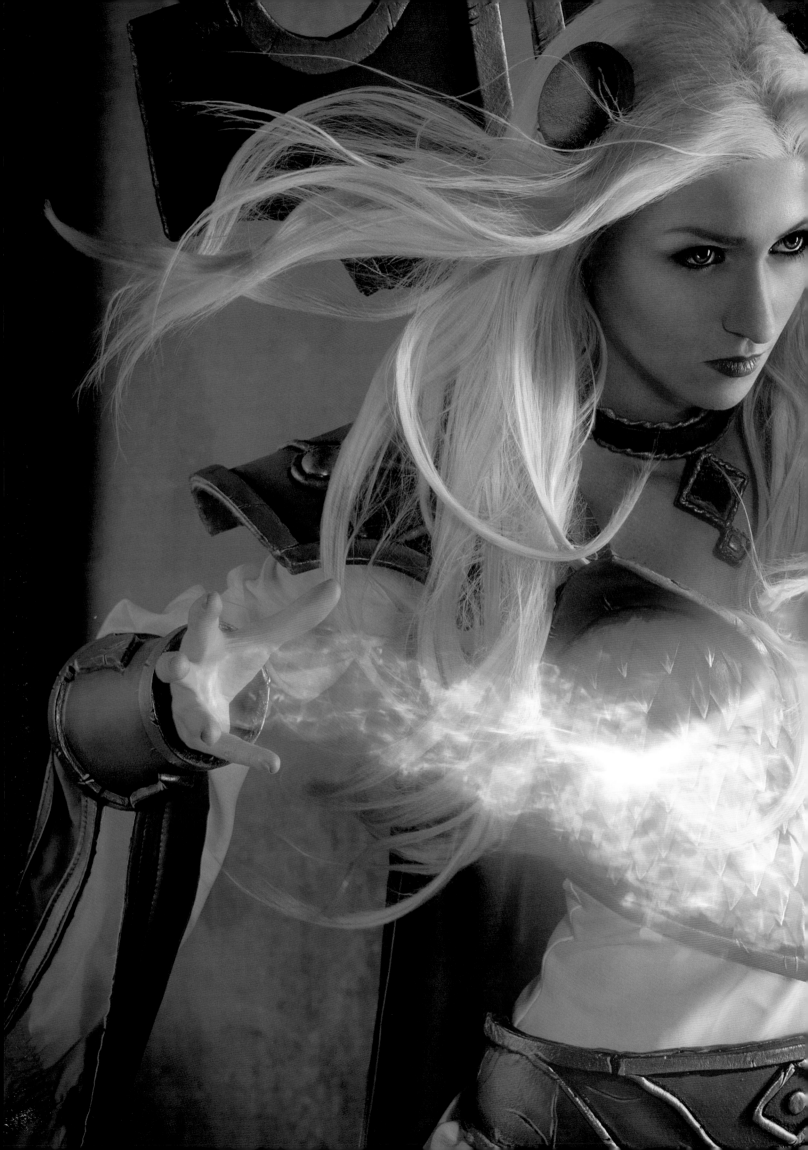

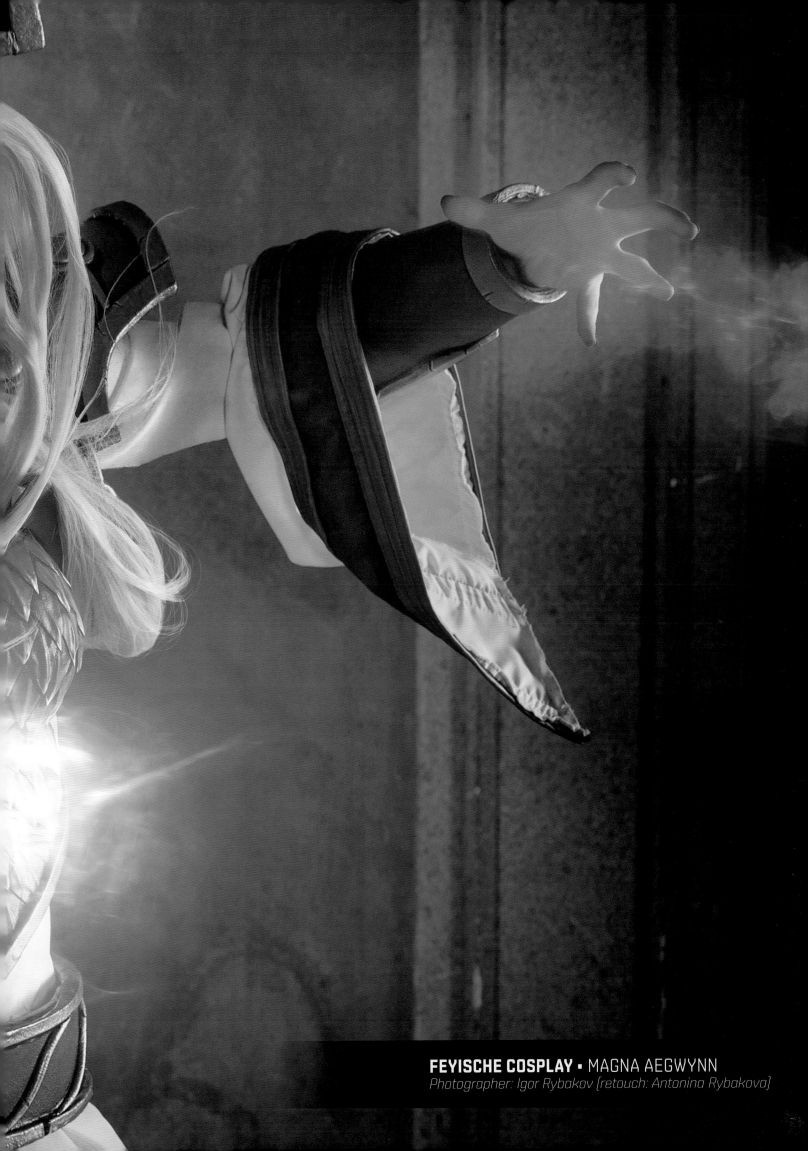

**FEYISCHE COSPLAY** • MAGNA AEGWYNN
*Photographer: Igor Rybakov (retouch: Antonina Rybakova)*

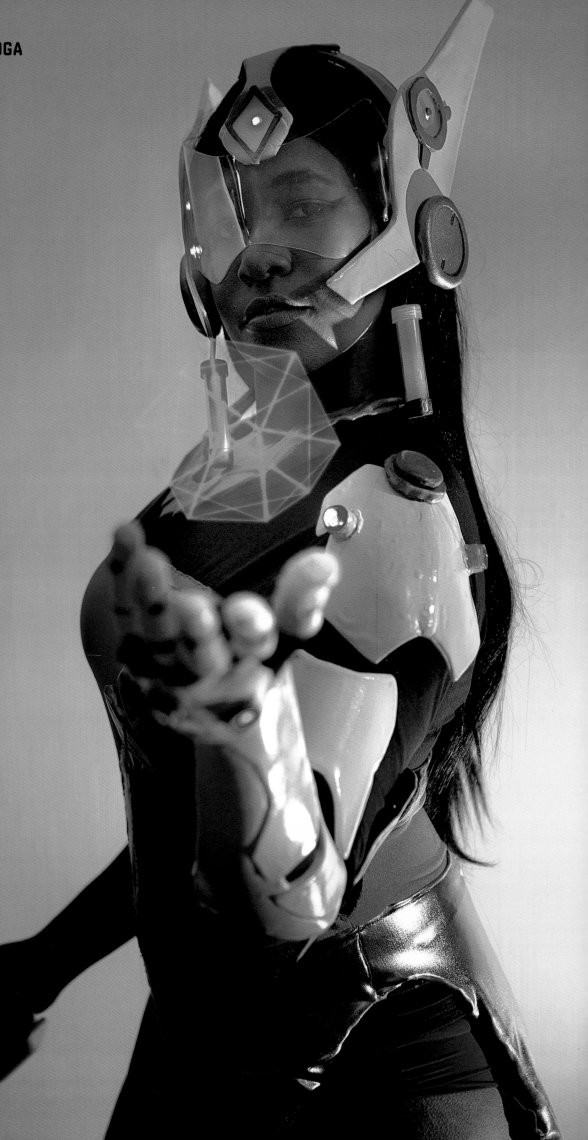

**CHAD HOKU A.K.A. HOKU PROPS · UTHER**
*Photographer: Gil Riego*
*Costume designed by Zach Fischer*

"I think it's incredibly important to have an emotional connection with the character you wish to cosplay. I might even go so far as to say it's one of the prerequisites for something to really be considered a cosplay. That emotional connection gives you insight into who they are and gives you a much better chance of successfully portraying that character."
—*Chad Hoku a.k.a. Hoku Props*

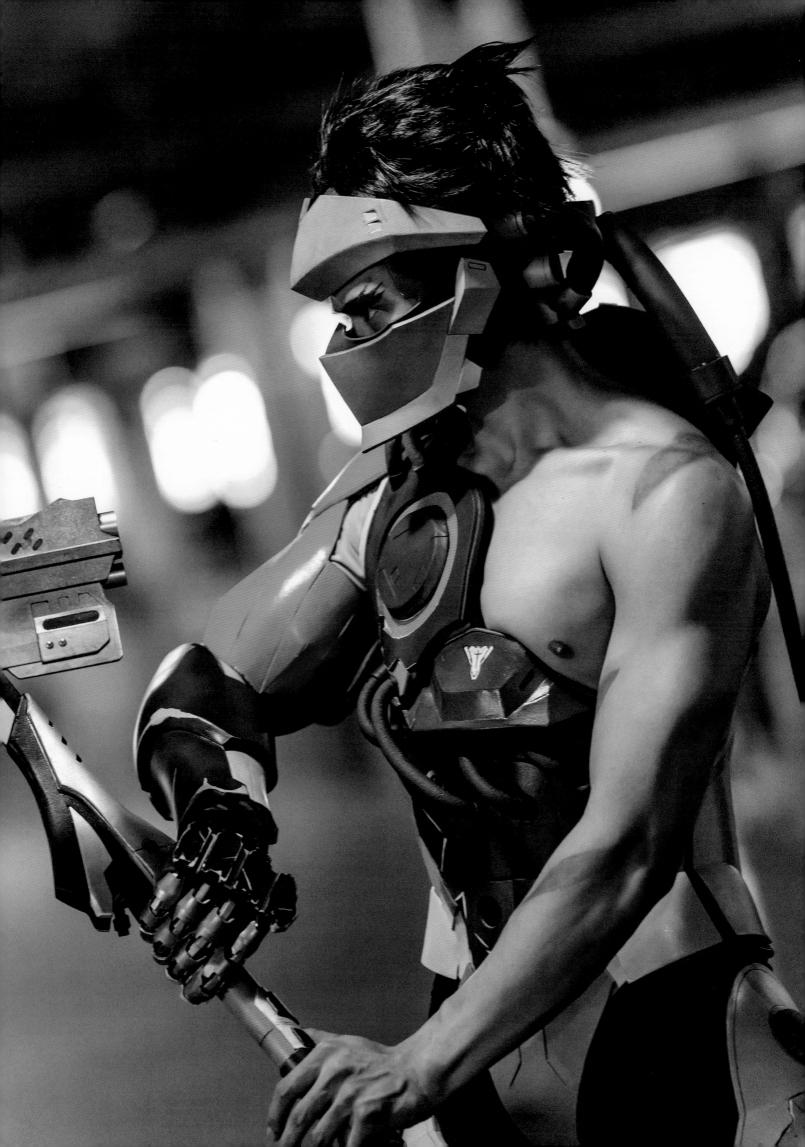

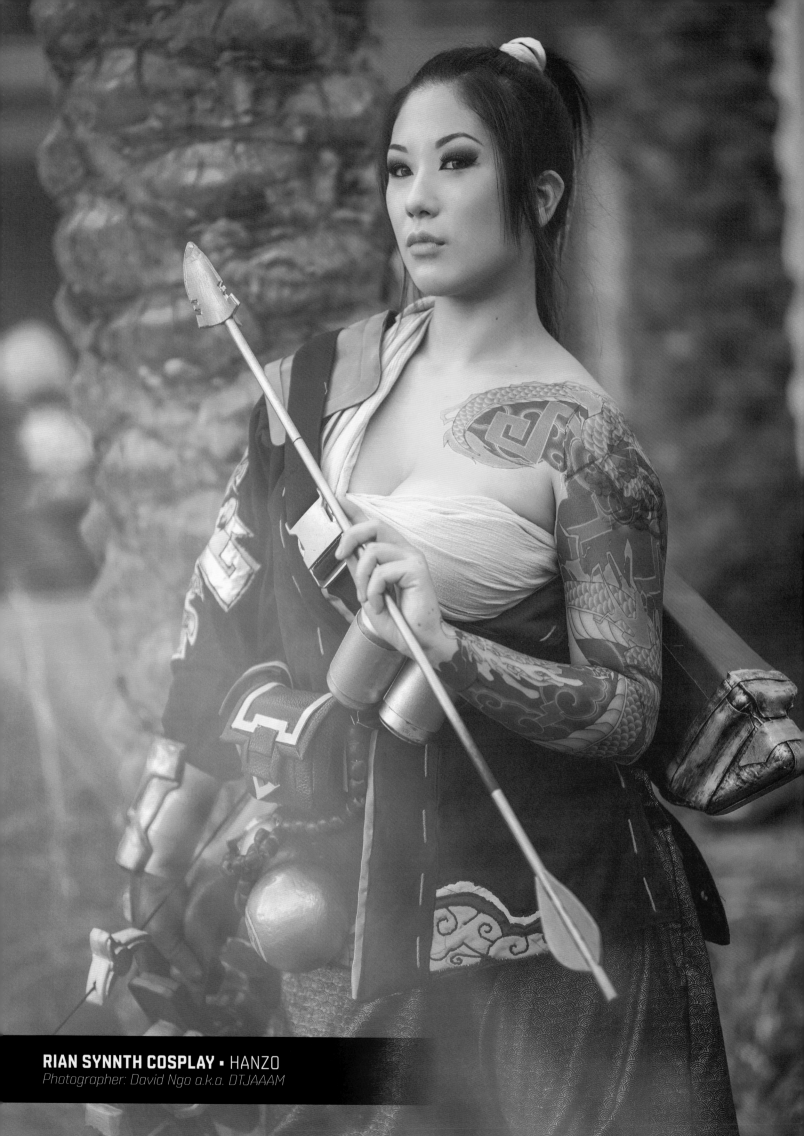

**RIAN SYNNTH COSPLAY ▪ HANZO**
Photographer: David Ngo a.k.a. DTJAAAM

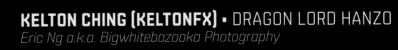

**KELTON CHING (KELTONFX) ▪ DRAGON LORD HANZO**
*Eric Ng a.k.a. Bigwhitebazooka Photography*

"I'm drawn to characters that have dark, brooding personalities and are maybe a little misunderstood. I was always a bit of a loner and an outcast when I was younger, so I identify with those types of characters more. Characters like Kerrigan and Hanzo, for example, whom I have cosplayed."
—*Kelton Ching (KeltonFX)*

島田半蔵

龍将軍

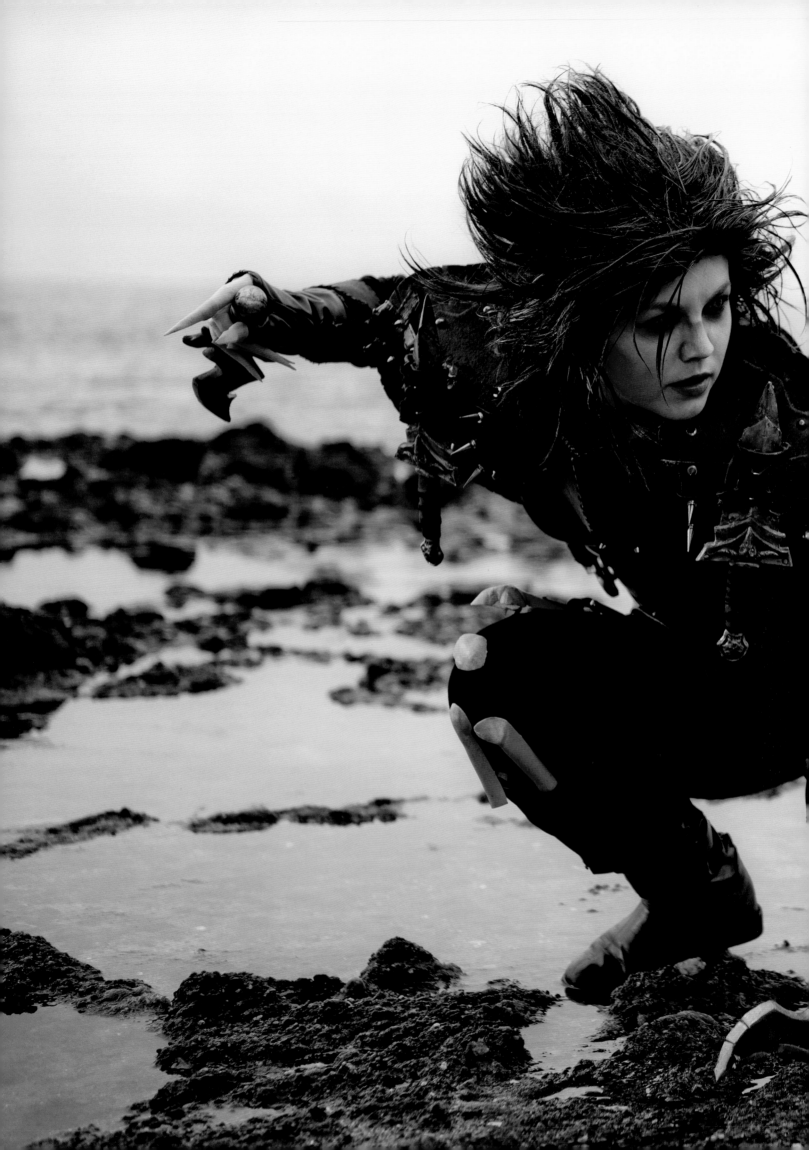

**SVETLANA QUINDT A.K.A. KAMUI COSPLAY ·**
*WORLD OF WARCRAFT WARRIOR TIER 5*
*Photographer: Kamui Cosplay*

"I personally love to portray strong, independent female characters in huge armor and with massive weapons. So, the Barbarian from *Diablo III* was just perfect for me—my Warrior Tier 5 armor set from World of Warcraft too! I feel strong and independent myself, so I mostly choose characters that fit my own personality. Additionally, I'm highly attracted to challenging designs and outfits with plenty of details."
—*Svetlana Quindt a.k.a. Kamui Cosplay*

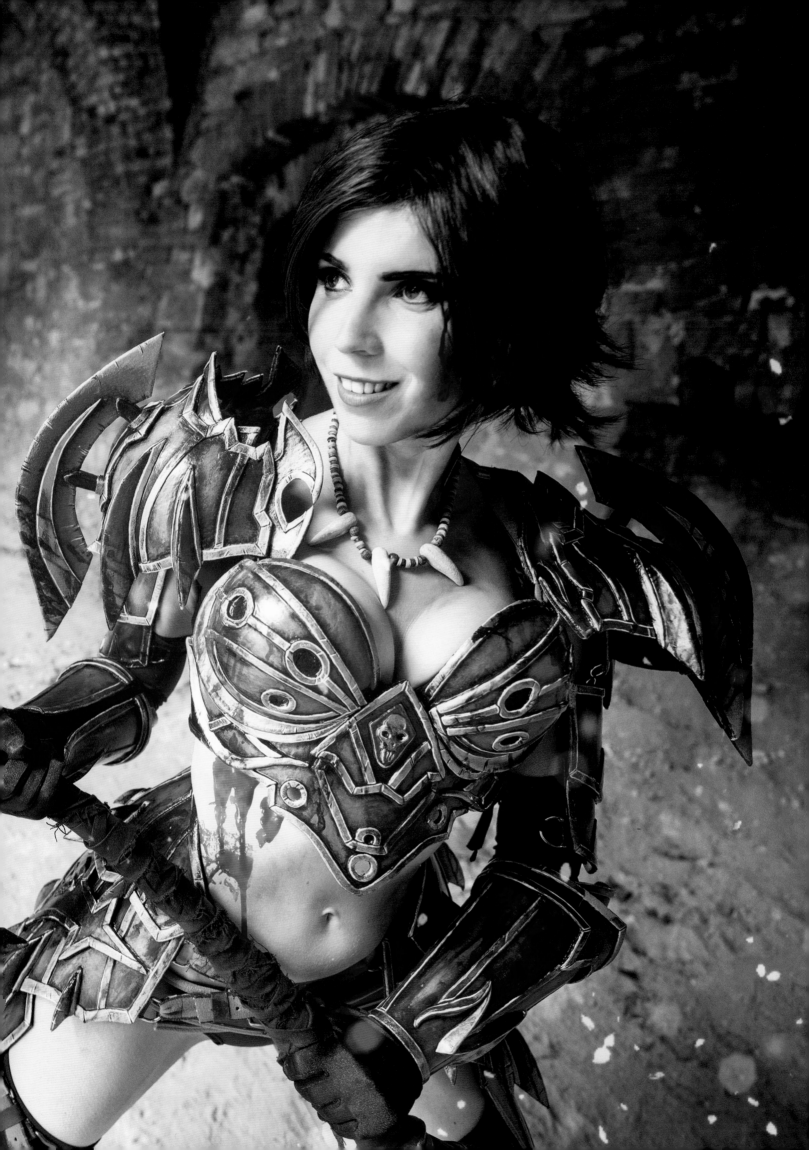

**MADIMON** • MEI
*Photographer: BriLan Imagery*

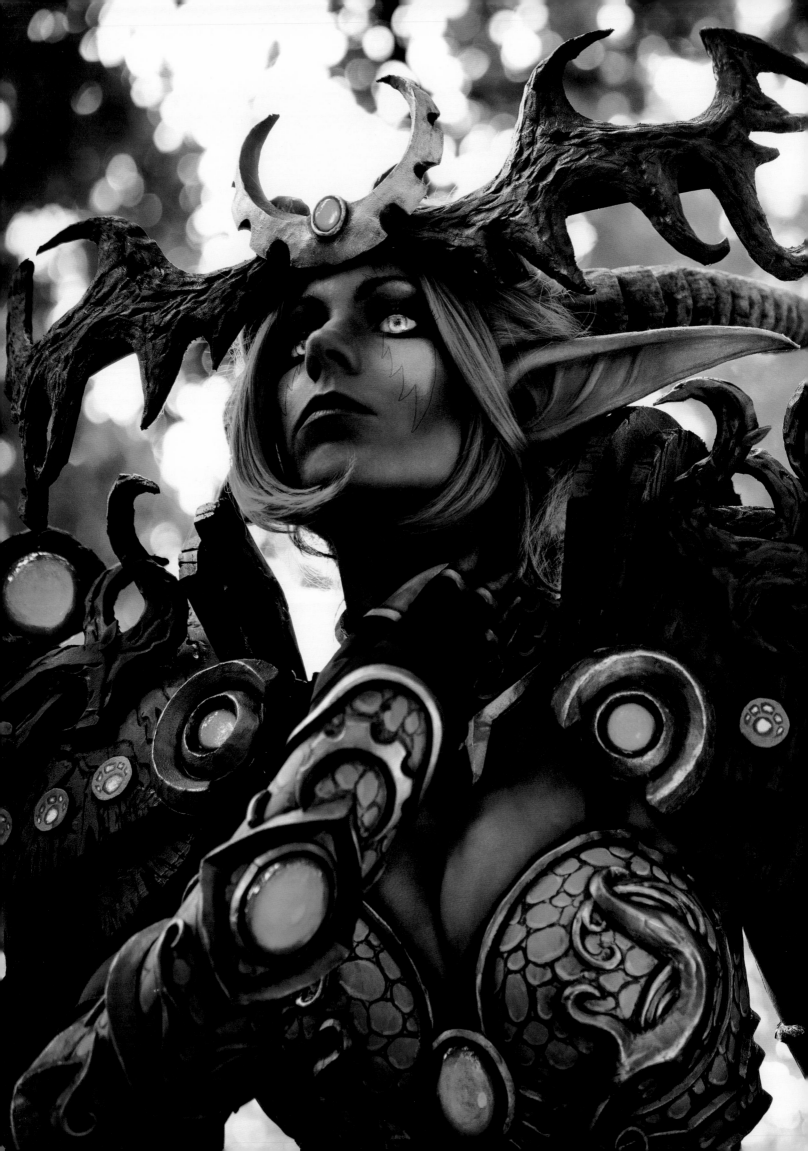

**SONIA A.K.A. CINDERYS** • YSERA
*Photographer: Sinclair Quatrefages*

"I like characters that represent who I am. In general they are strong, independent people. I find it inspiring to identify with them. I think a lot of people find themselves in the trials their characters go through."
—*Sonia a.k.a. Cinderys*

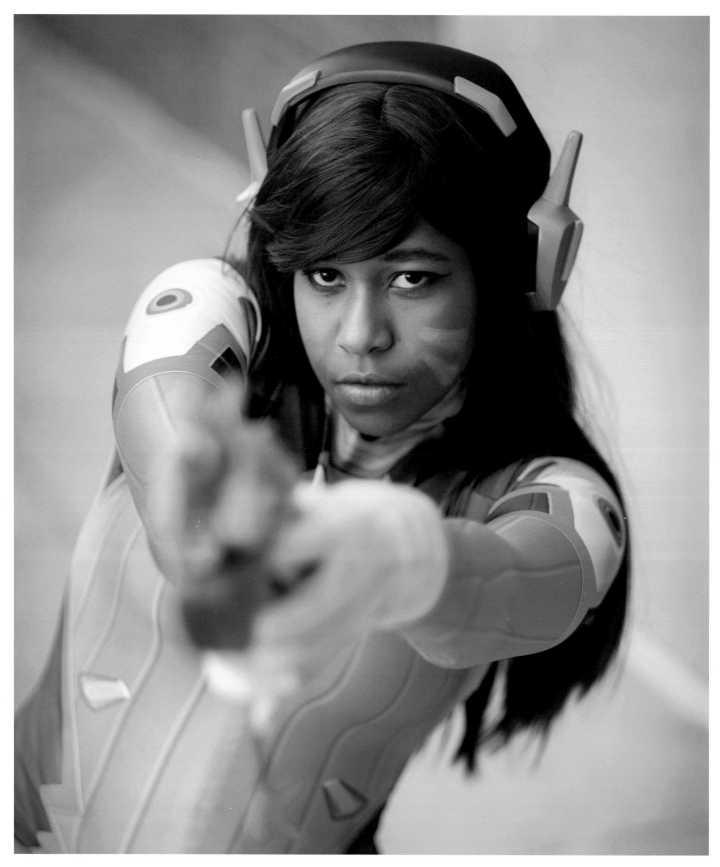

**DORASAE A.K.A. AKAKIOGA COSPLAY ▪ D.VA**
*Photographer: Cosfame*

"Usually when I choose a character, I find myself resonating with them a lot. Their personality, their outfits, how they represent themselves—all play a part in how and who I pick. Recently, I have also taken into account if their features resemble mine, but that is not the end-all-be-all to how I choose characters. I honestly just pick characters I really like and go from there! If I only chose them because they look like me, I don't think I would have as big of a drive to get the costume done versus picking a character that really inspires me for who they are."
—*Dorasae a.k.a. Akakioga Cosplay*

**STELLA CHU** ▪ WIDOWMAKER
*Eric Ng a.k.a. Bigwhitebazooka*
*Photography*

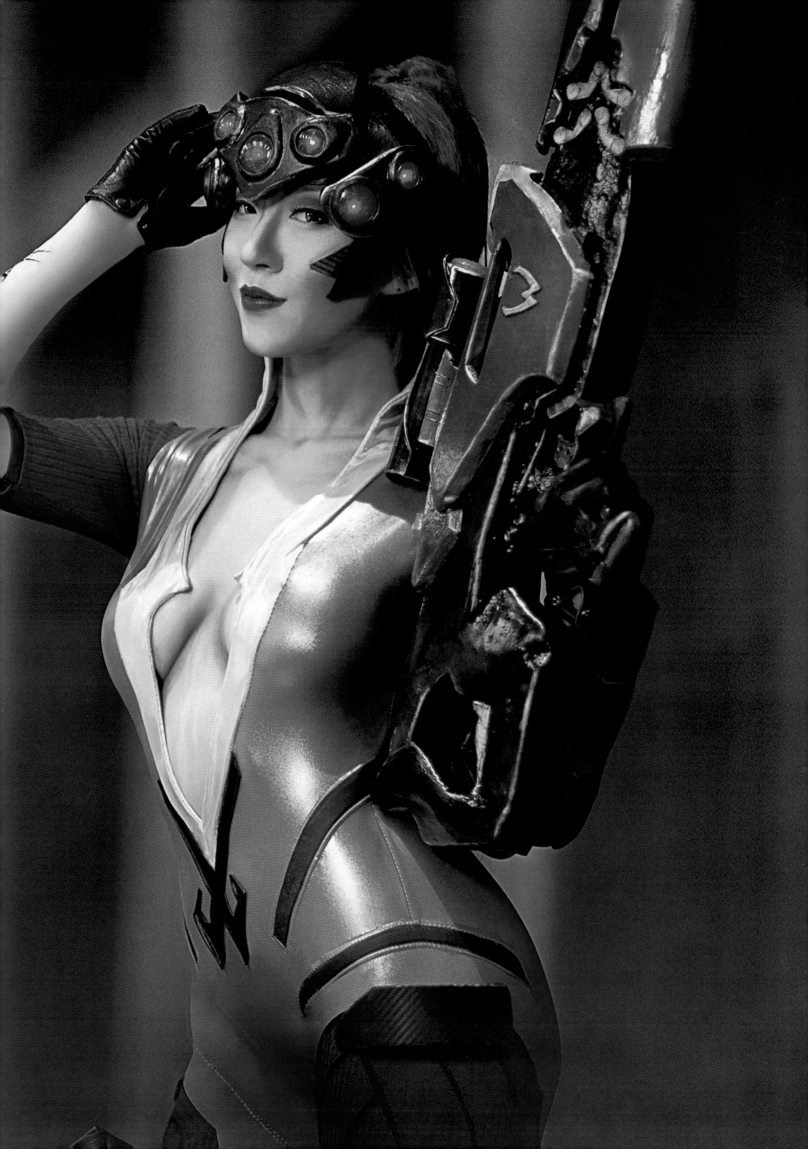

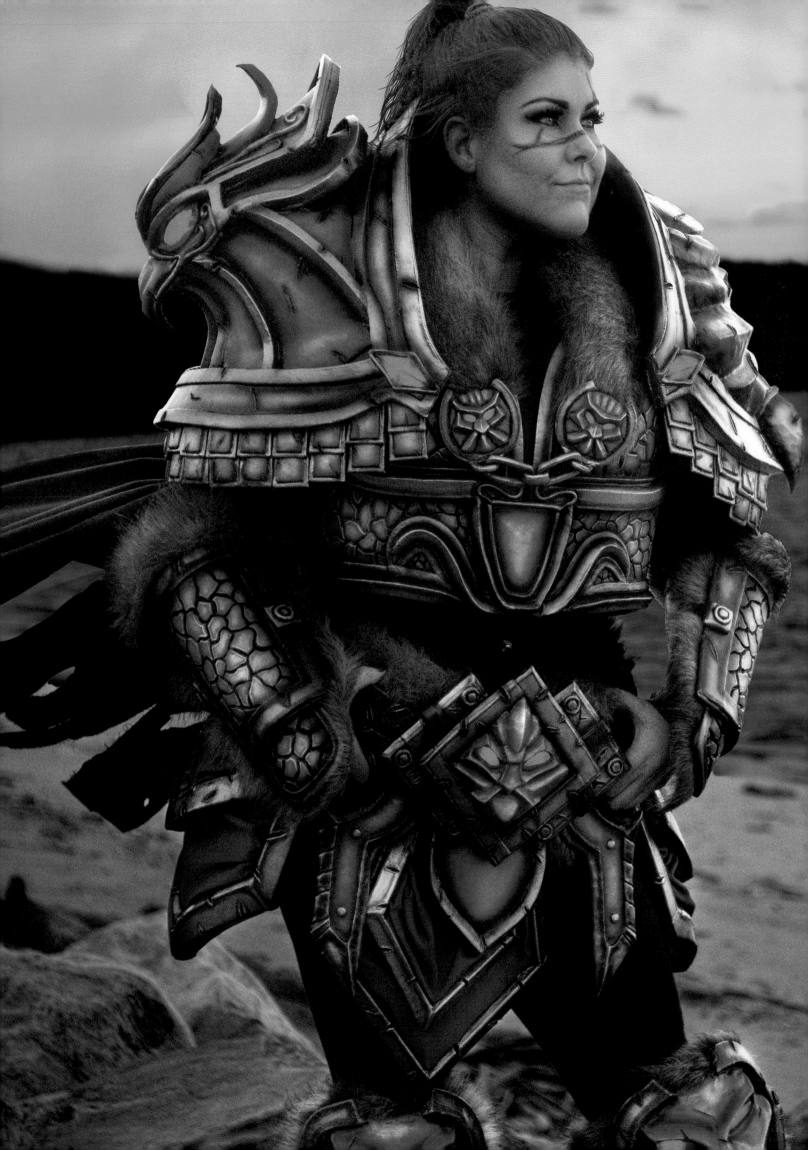

**JACKIE CRAFT A.K.A.
JACKIE CRAFT COSPLAY ·**
VARIAN WRYNN
*Photographer: Alexandra Lee Studios*

"I choose costumes and characters based
on my love of their story, beautiful visuals,
or—more often—a life experience that formed
around them. For example, I chose the Lich
King because I got my server's first kill back
when raiding in *Wrath of the Lich King* and that
was a really special time in my life. I sought out
King Varian Wrynn as my next armor build after
reading some of the Warcraft books."
—*Jackie Craft a.k.a. Jackie Craft Cosplay*

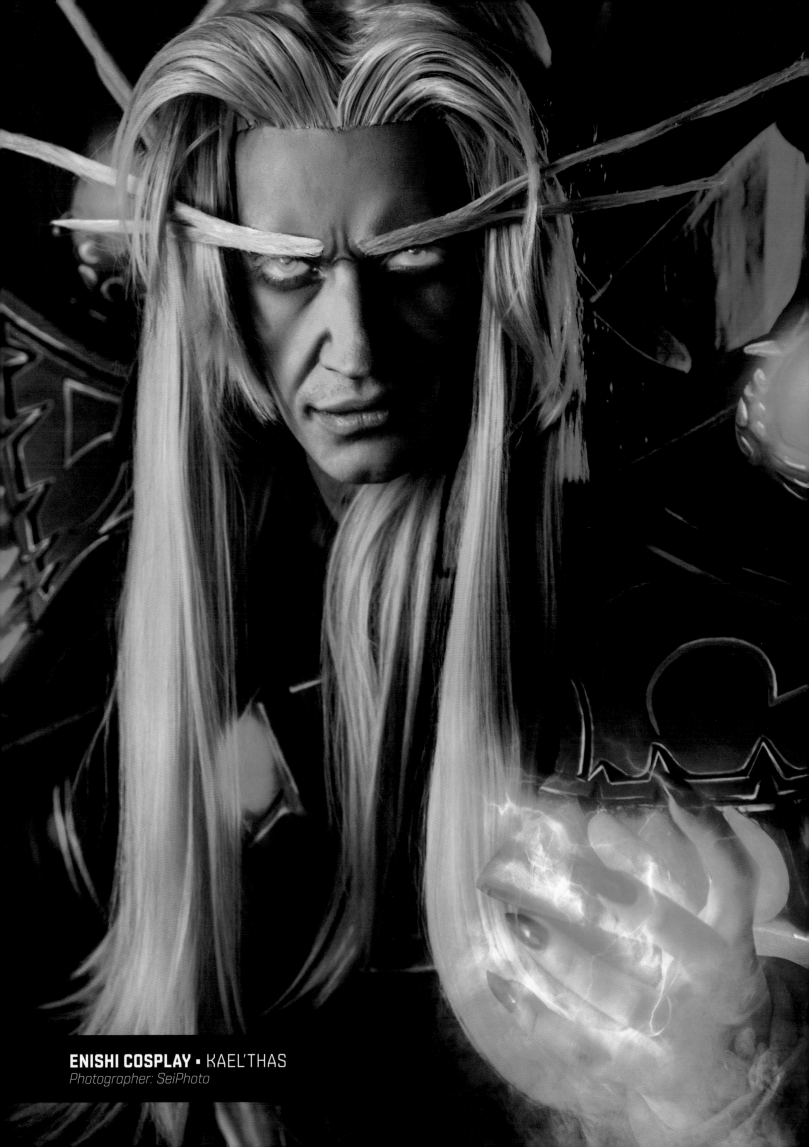

**ENISHI COSPLAY** ▪ KAEL'THAS
*Photographer: SeiPhoto*

**FEYISCHE & ENISHI COSPLAY** •
KAEL'THAS & SYLVANAS
*Photographer: SeiPhoto*

"We choose characters with the most interesting and complicated designs for our cosplays. Every time we make costumes, we try to improve our skills in prop making, sewing, and makeup. It is very important for us to always surpass our previous works."
—Feyische & Enishi Cosplay

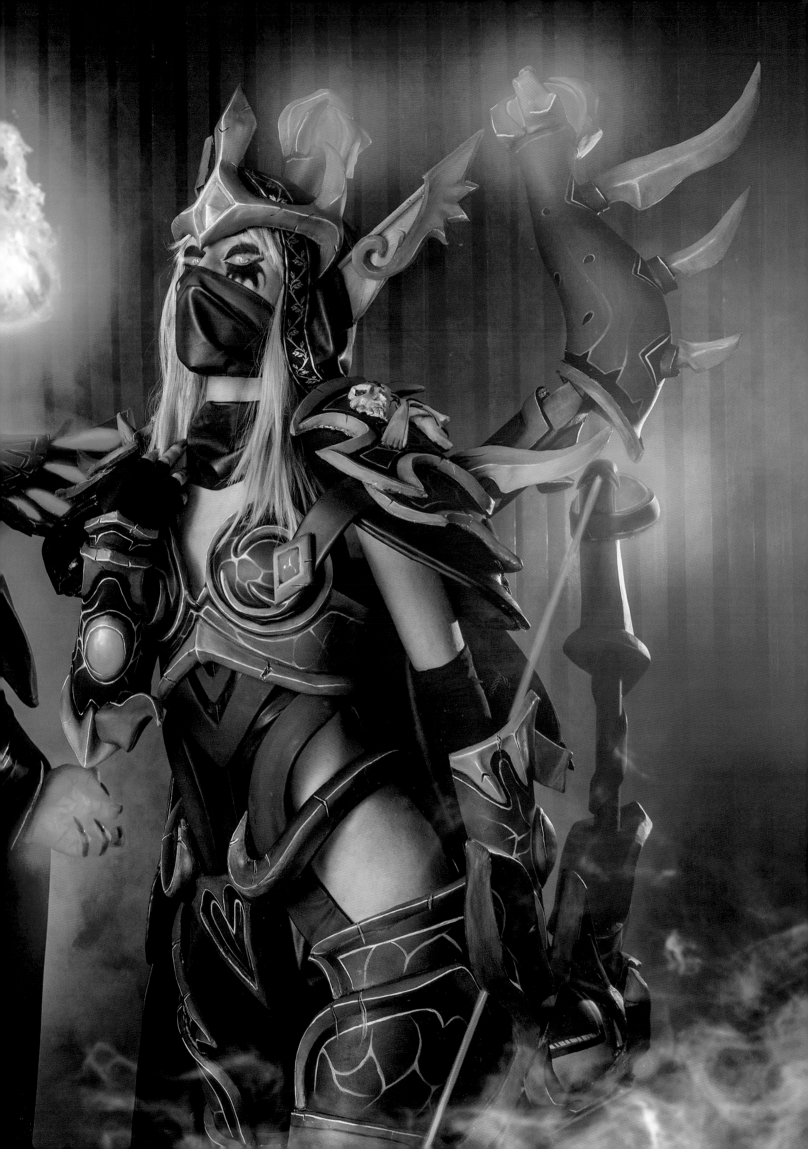

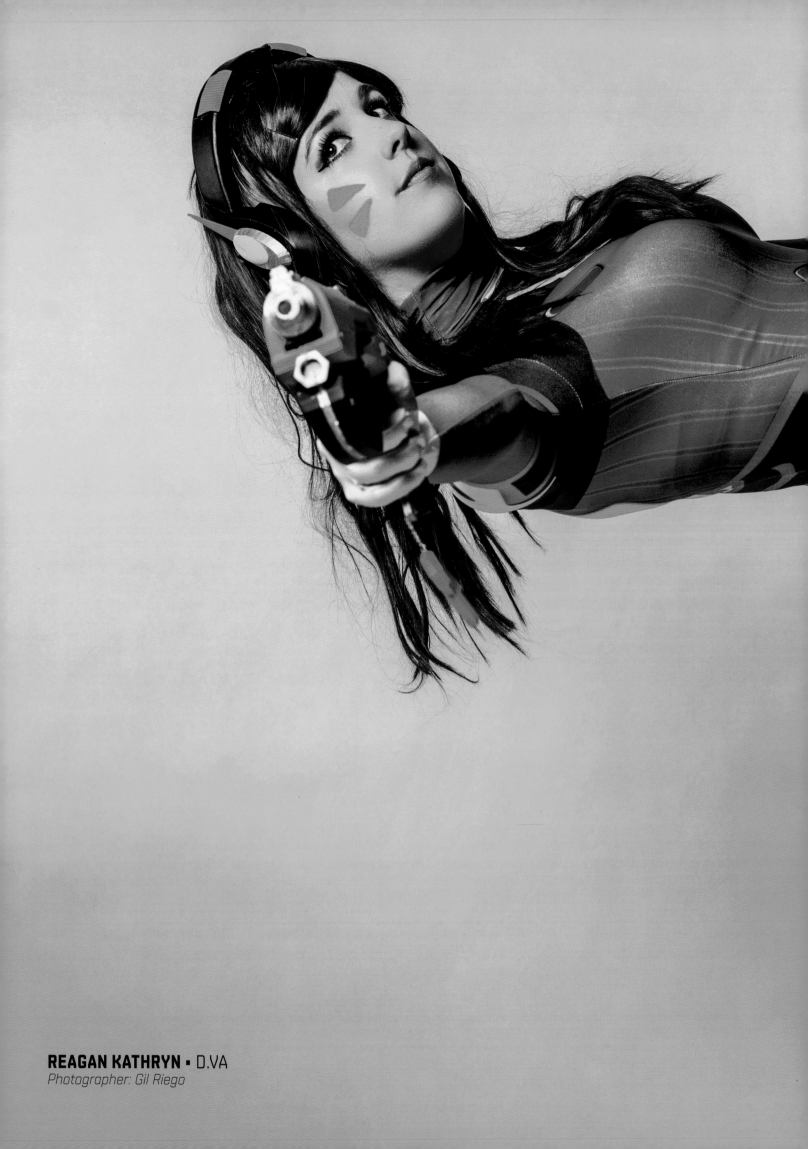

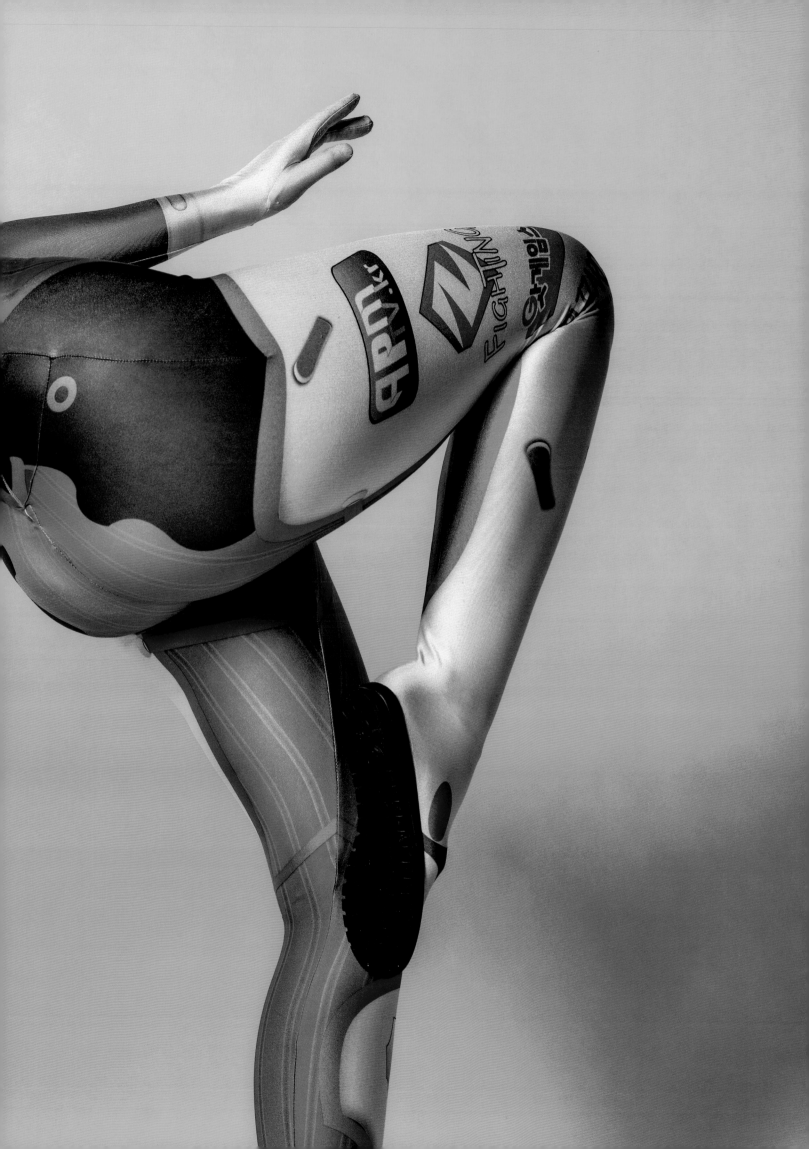

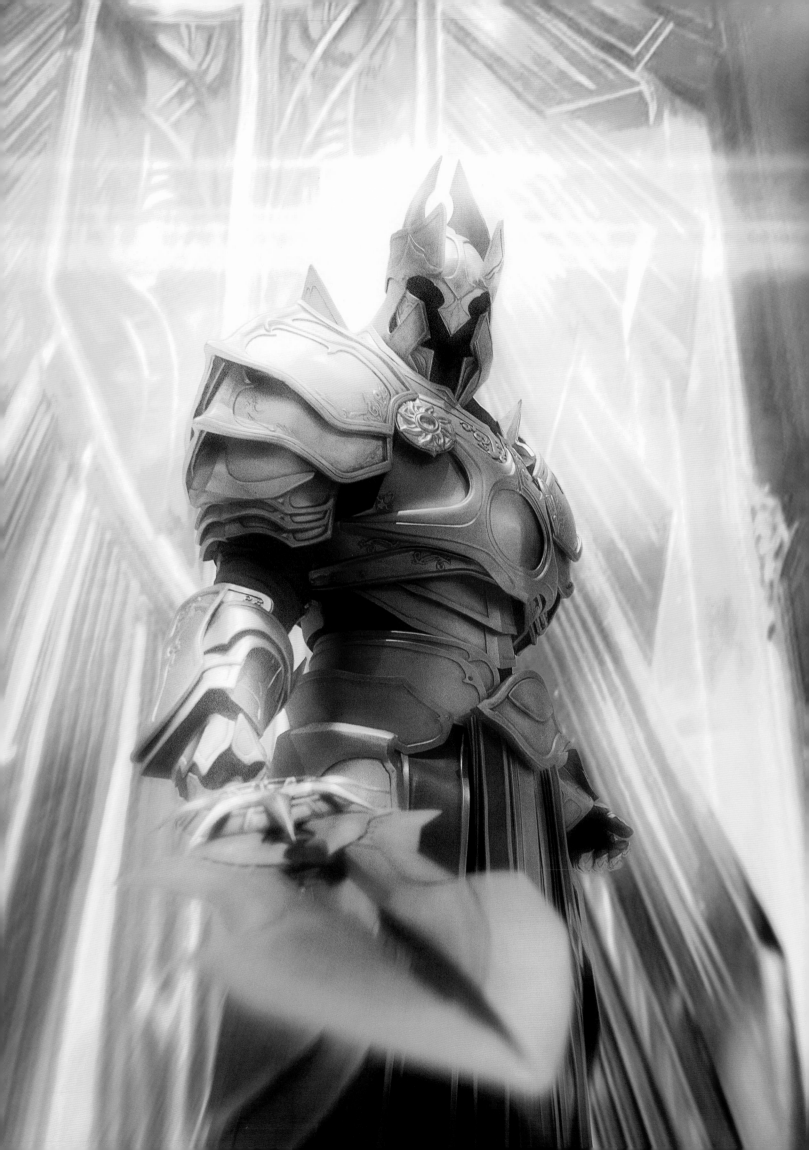

**CALEB NEAL A.K.A.**
**FABRICATOR DJINN ▪ IMPERIUS**
*Photographer: Tim Vo*

"The 'rule of cool' is law around these parts. I choose characters that look awesome and have an imposing presence. If the outfit has pieces that require me to learn something new, that is also a plus. The first time I saw Imperius in a cinematic for *Diablo III*, I said to myself, 'That costume would be impossible.' I had to prove myself wrong."
—*Caleb Neal a.k.a. Fabricator Djinn*

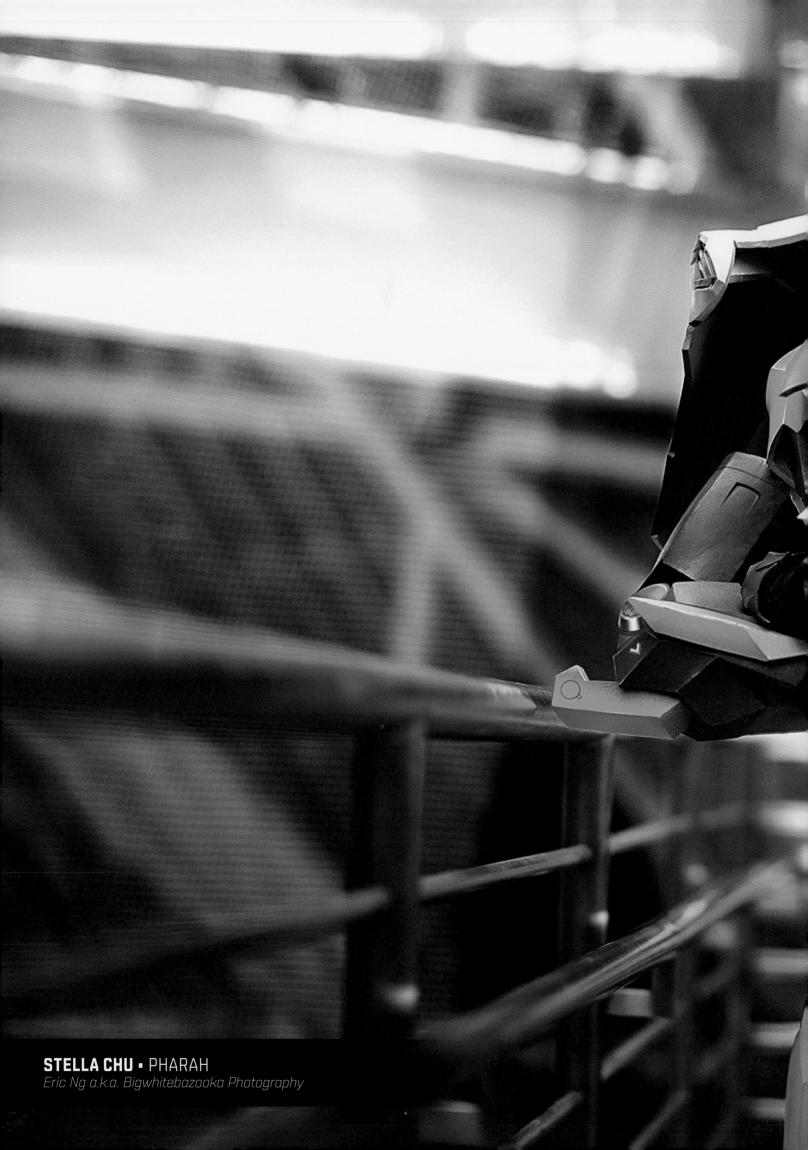

**STELLA CHU** • PHARAH
*Eric Ng a.k.a. Bigwhitebazooka Photography*

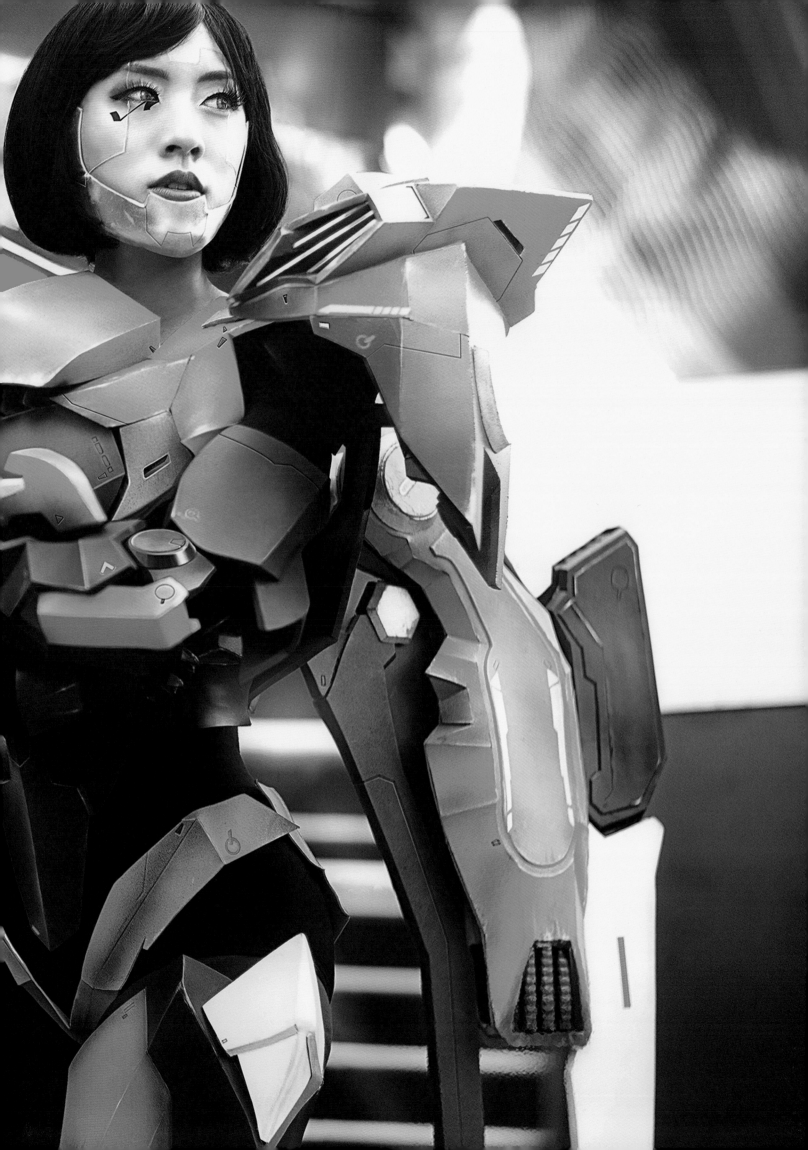

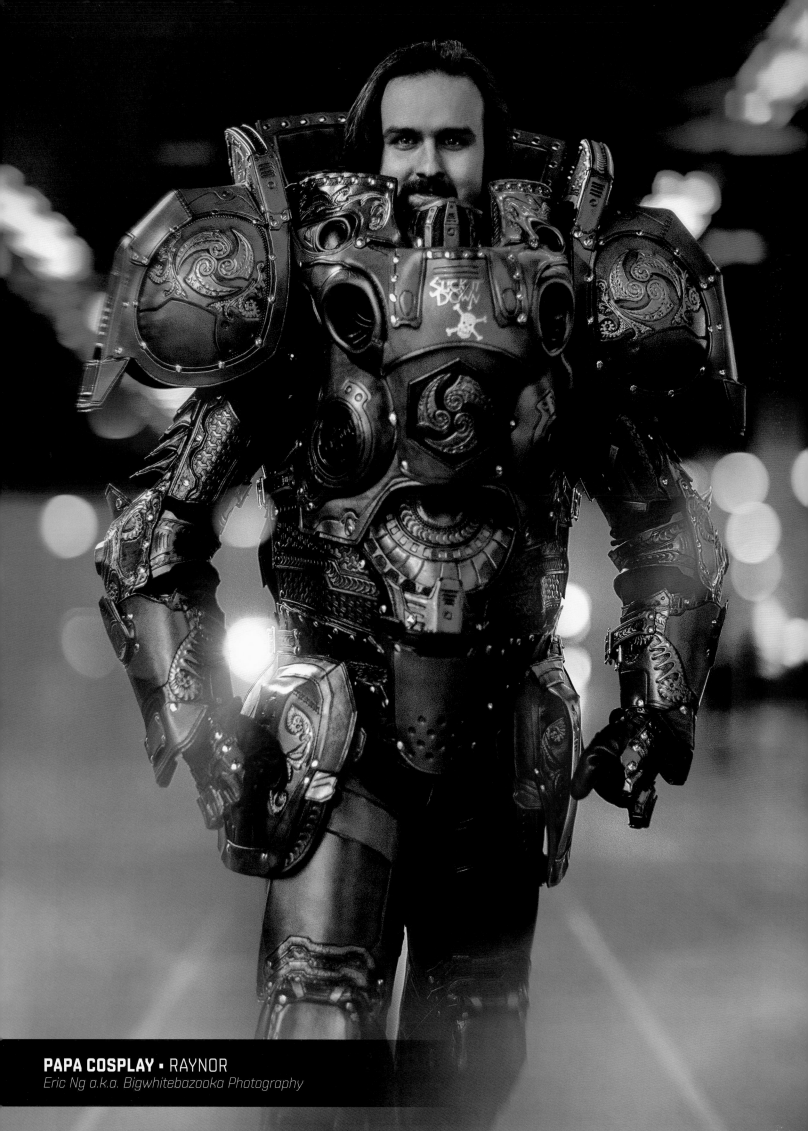

**PAPA COSPLAY** • RAYNOR
*Eric Ng a.k.a. Bigwhitebazooka Photography*

## SARA MCMUNN A.K.A.
## C'EST LA SARA ▪ LI MING
*Photographer: Carlos Guerrero*

"I like to see how popular the character is.
The less hype a character generates, the
more likely I am to cosplay that character.
These kinds of characters need more
cosplay love, and I like being unique!"
—*Sara McMunn a.k.a. C'est La Sara*

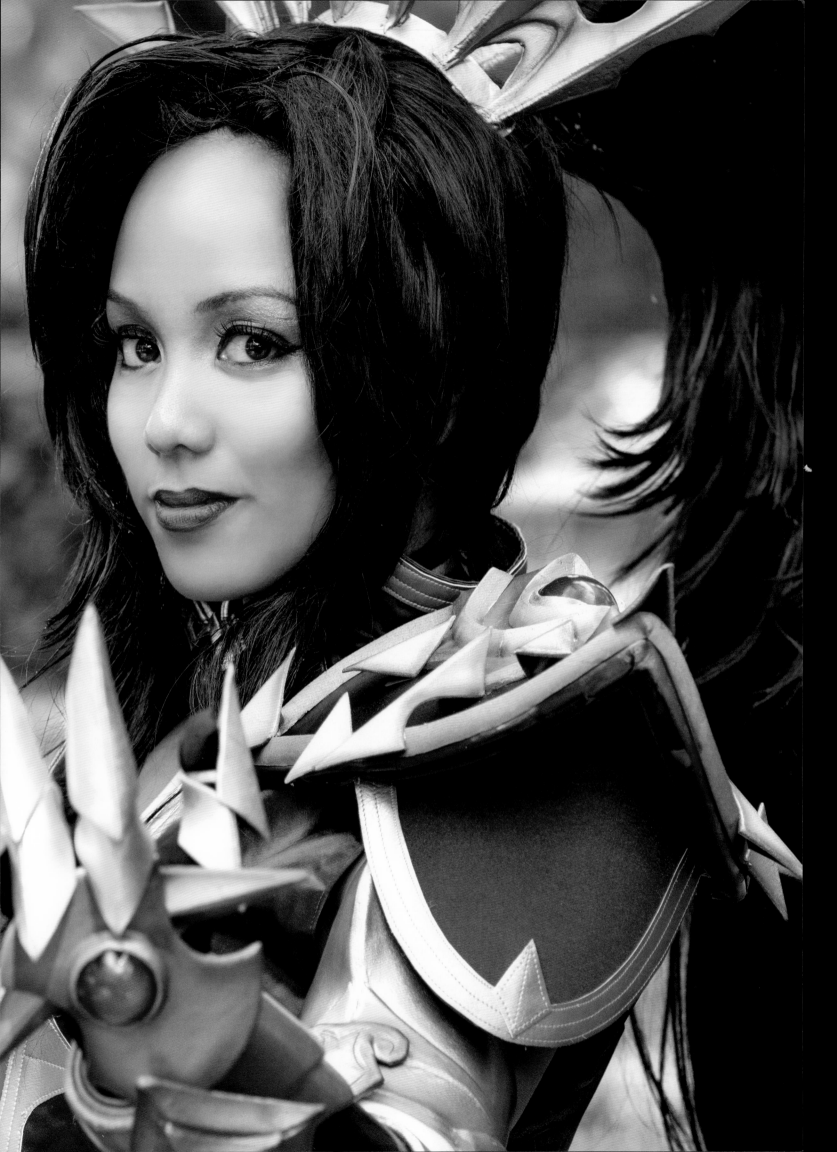

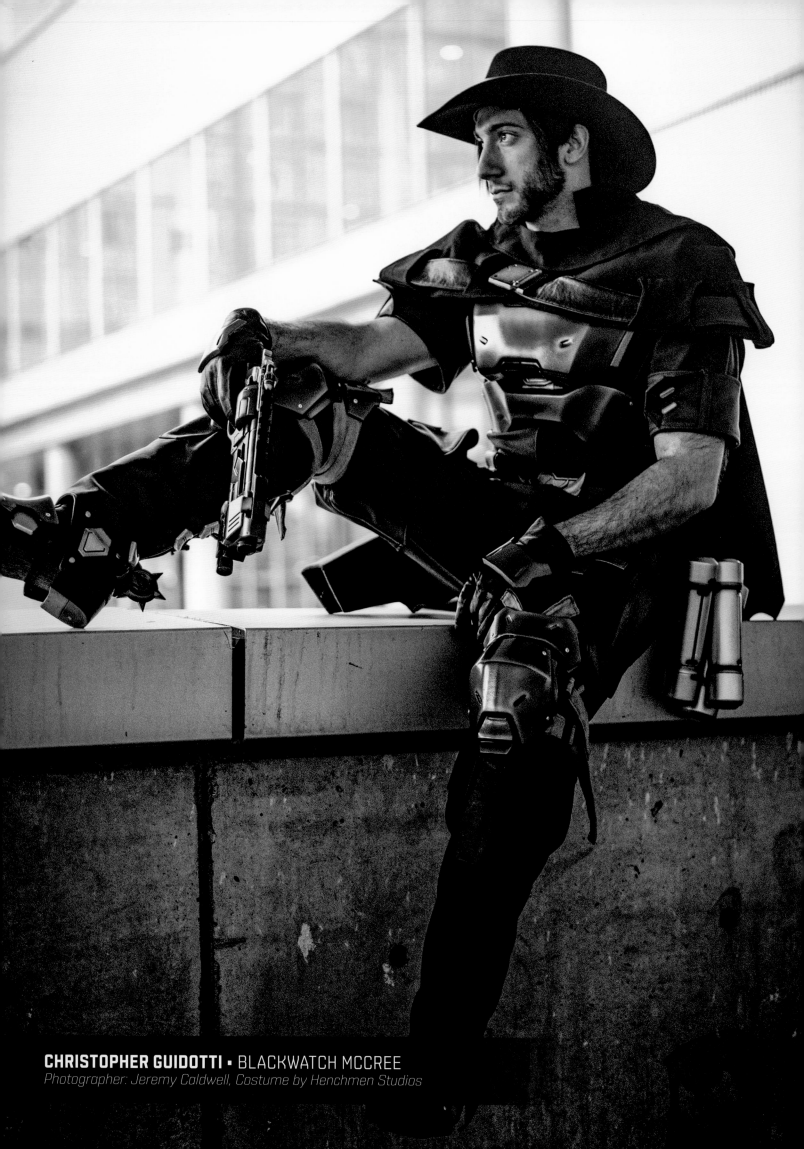

**CHRISTOPHER GUIDOTTI ▪ BLACKWATCH MCCREE**
*Photographer: Jeremy Caldwell, Costume by Henchmen Studios*

**ROHAIN ARORA** ·
BLACKWATCH REYES REAPER
*Photographer: Jeremy Caldwell*
*Costume by Henchmen Studios*

"The early stages of any project can often be the
most exciting but also the most daunting times.
It's always critical to be extremely thorough in
breaking down and planning how a costume
will be designed and created; troubleshooting
and planning around foreseeable obstacles
can prevent a ton of headaches down the road.
Projects always present unique challenges, but
having a solid plan for how each of the pieces
will be created then integrated together will help
things go smoothly if (when) it gets down to
crunch time to finish a build."
—*Jordan Duncan of Henchmen Studios*

**NATALIA KOCHETKOVA A.K.A. NARGA • JAINA**
*Photographer: Kira*

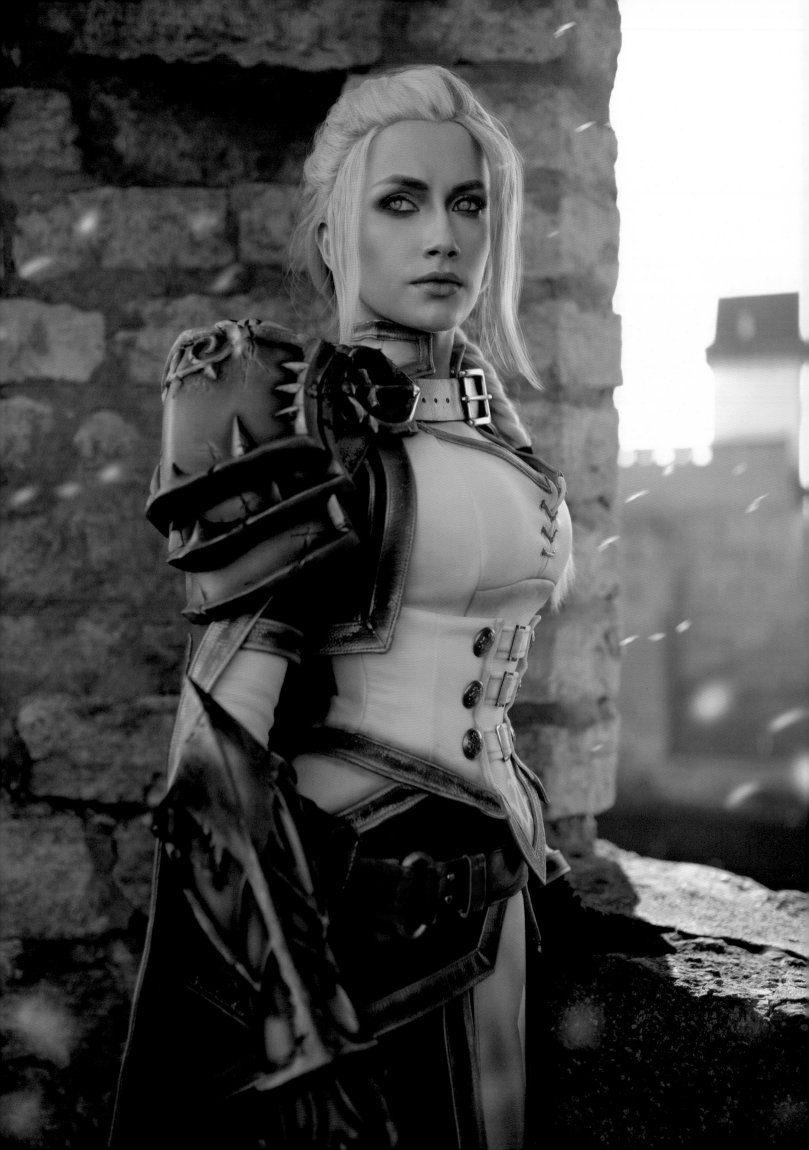

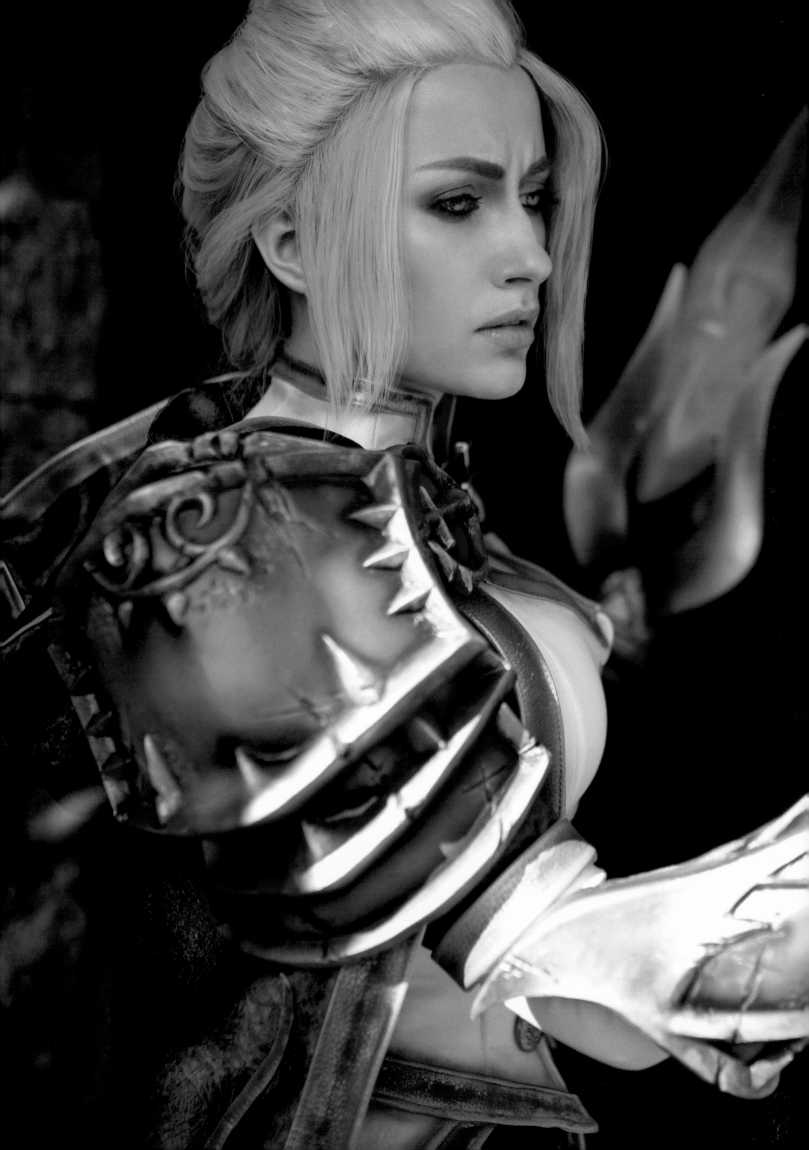

**NATALIA KOCHETKOVA**
**A.K.A. NARGA ▪** JAINA
*Photographer: Kira*

**DANA HOLMES-MCGUIRE & COURTNEY HOLMES A.K.A. EGG SISTERS COSPLAY ·**
BLACKHARDT
*Photographer: David Ngo a.k.a. DTJAAAM*

*"There are so many things that can and will go awry. We've had molds break, paint peel off, foam melt..."*
—Dana Holmes-McGuire & Courtney Holmes
a.k.a. Egg Sisters Cosplay

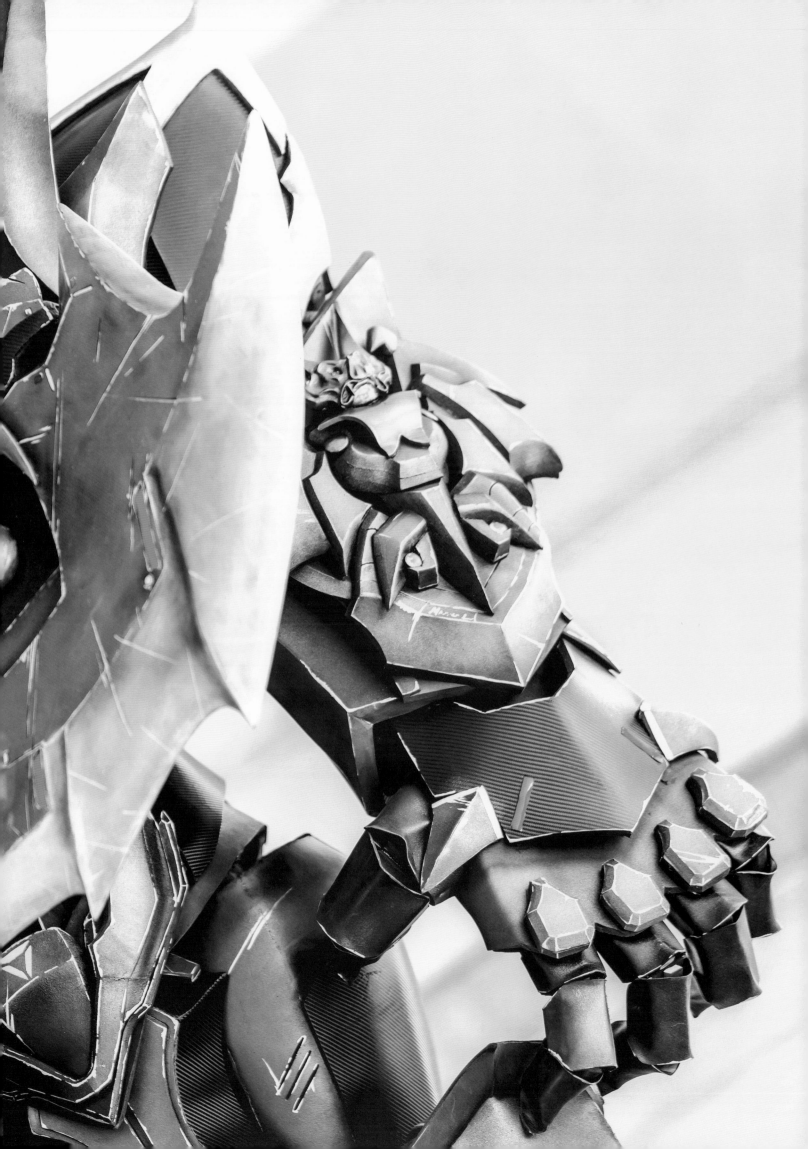

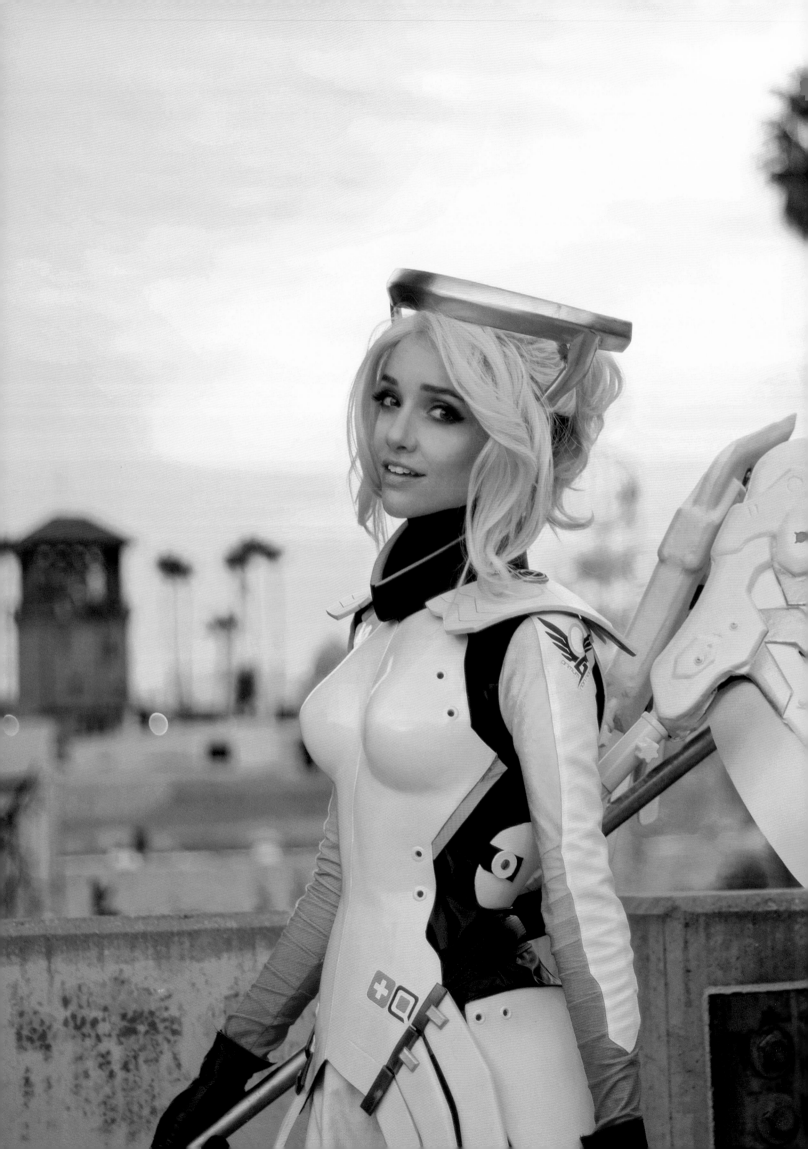

**LYZ BRICKLEY ▪ MERCY**
*Photographer: Bear*

"I gather as many reference photos as possible. During this process I start thinking about the materials I want to use for each piece. It's pretty fun, and it gets me hyped up to begin crafting."
—*Lyz Brickley*

**JIIDRAGON · JUNKRAT**
*Photographer: BriLan Imagery*

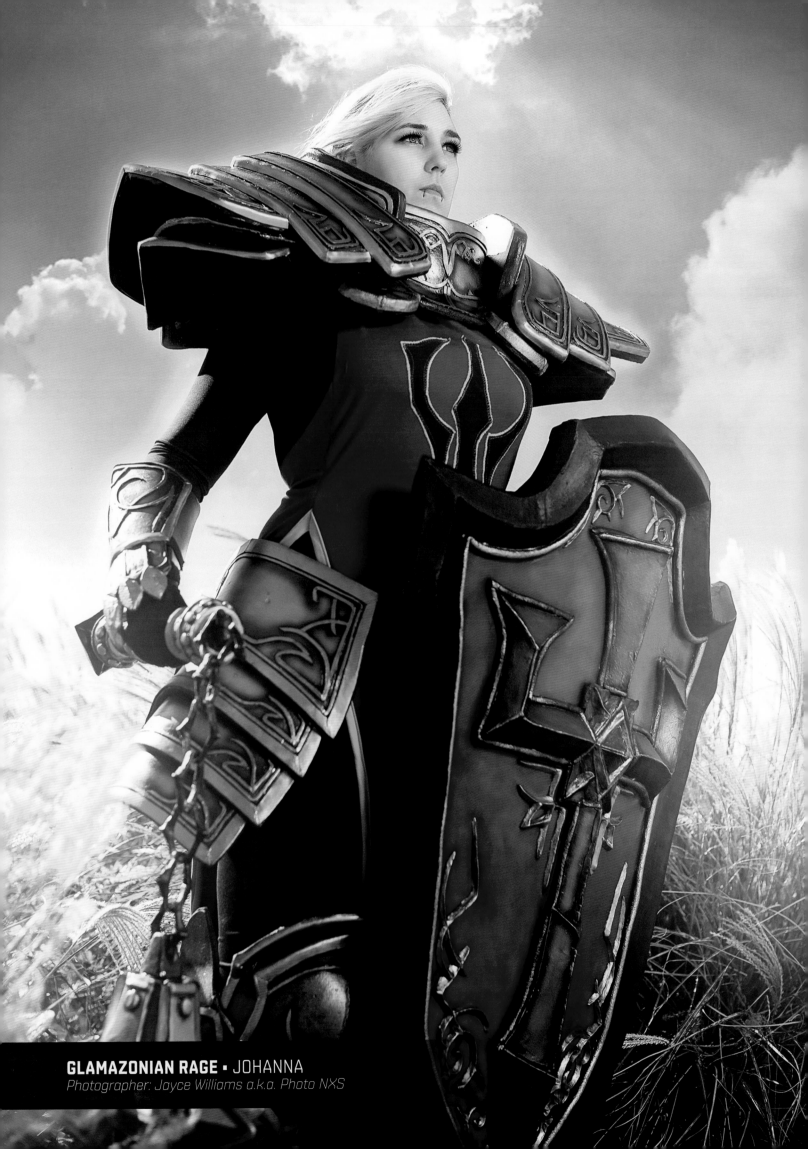

GLAMAZONIAN RAGE • JOHANNA
*Photographer: Jayce Williams a.k.a. Photo NXS*

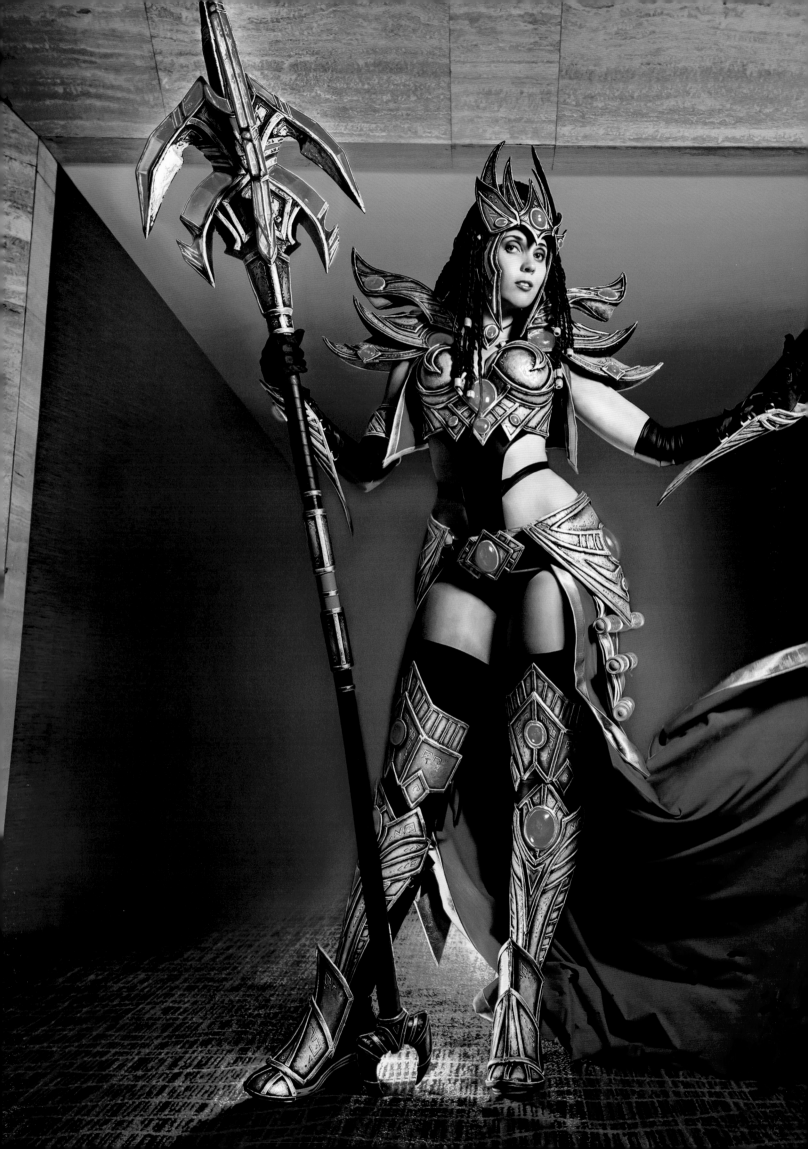

## SVETLANA QUINDT A.K.A. KAMUI COSPLAY ▪
## PROTOSS WIZARD
*Martin Wong Photo*

"The main problem with my Protoss Wizard was probably the limited amount of reference material. I only had a portrait of the head from the game to use, which was supposed to be enough to give me an idea of the design, the armor, and the whole look of the character. It was obviously a mash-up of a high templar protoss from StarCraft and the wizard from Diablo—and I really liked the idea. So, I started drawing a few designs to complete the idea of this mixed character. Having no experience in drawing original concepts, it was a struggle. I actually had to rebuild a few costume pieces since I wasn't happy with the overall look."
—*Svetlana Quindt a.k.a. Kamui Cosplay*

**NATALIA KOCHETKOVA**
**A.K.A. NARGA** ▪ TYRANDE
*Photographer: Kira*

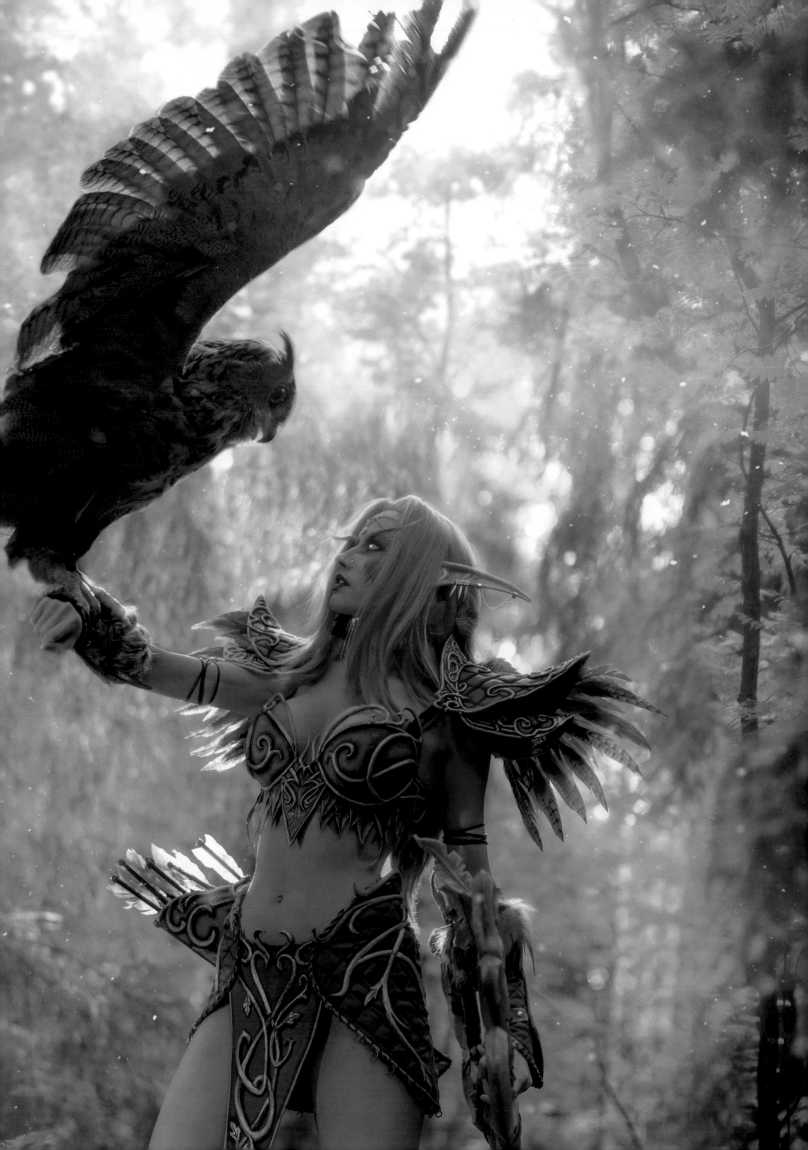

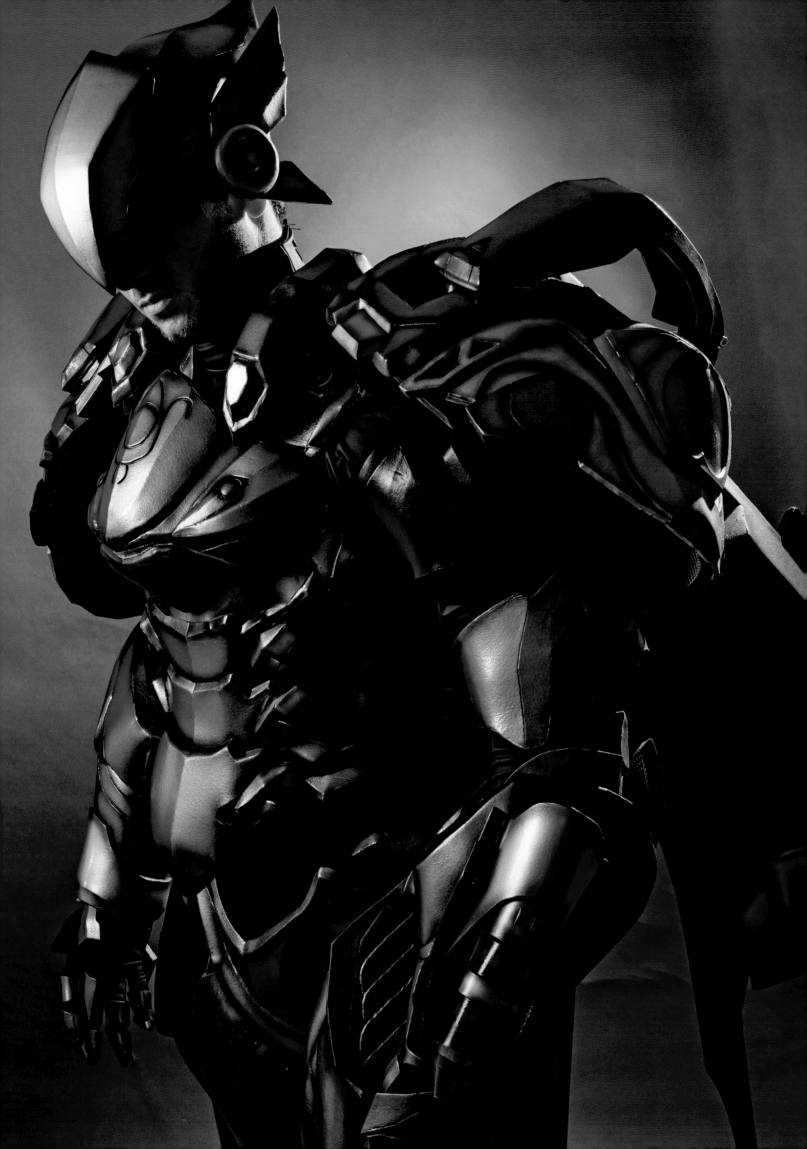

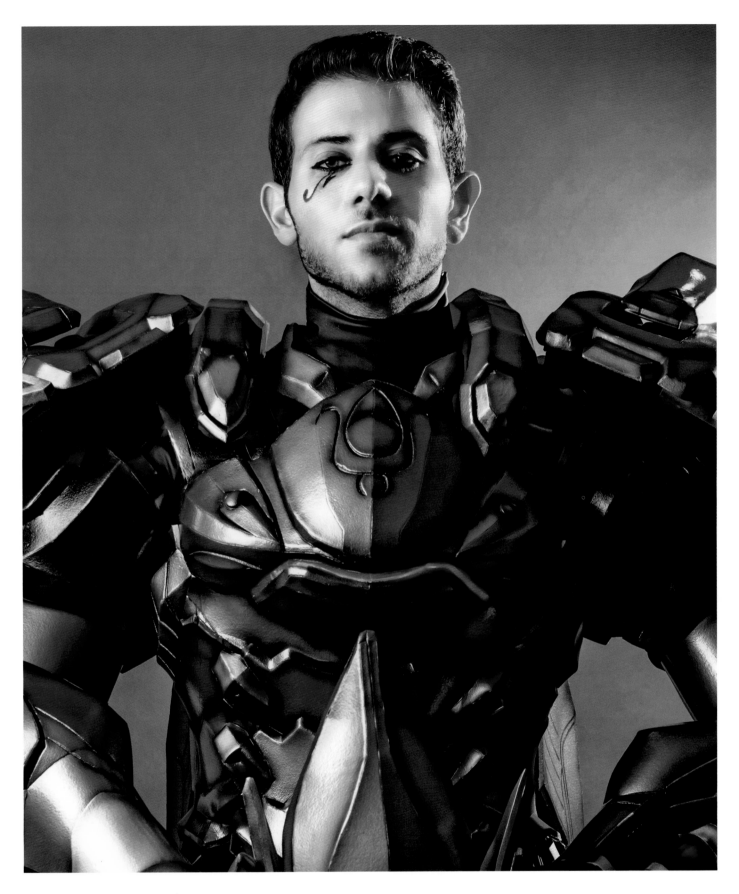

**JUSTIN HADEED A.K.A. JUSCOSPLAY** ▪ PHARAH
*Photographer: BriLan Imagery*

"When trying new methods and materials in my cosplays, I expect a high chance of failure. I look forward to it because it allows me to see what went wrong, then find a better way to do it."
—*Justin Hadeed a.k.a. JusCosplay*

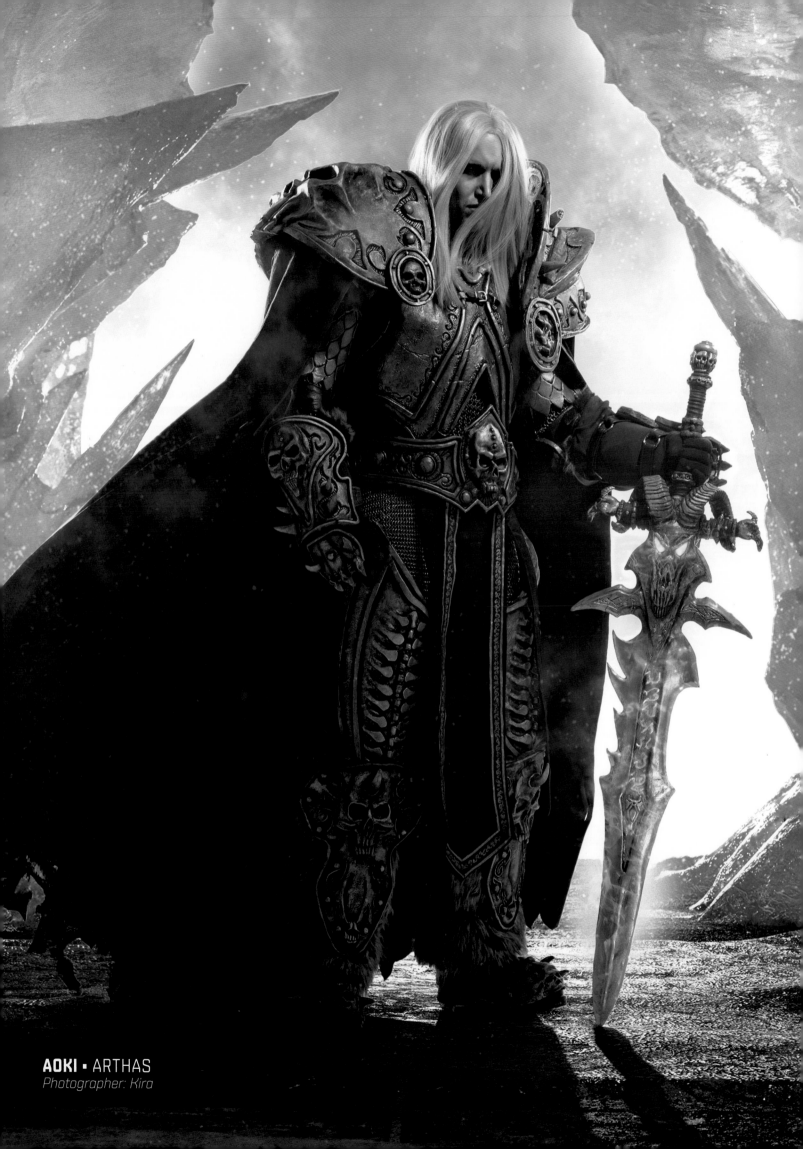

**AOKI · ARTHAS**
*Photographer: Kira*

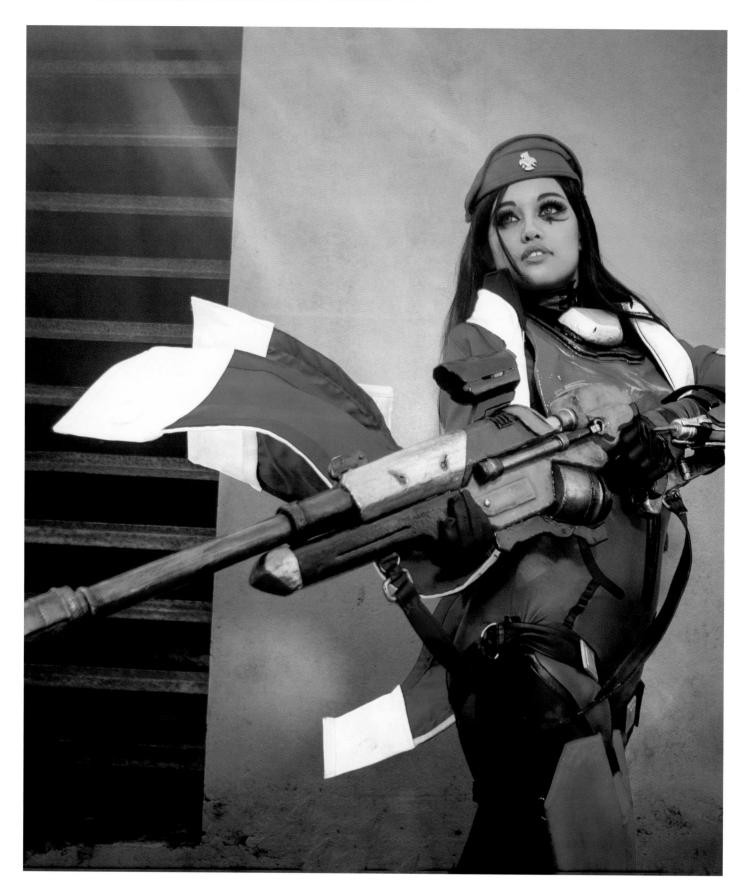

**JANYN MERCADO A.K.A. LUNAR CROW** • CAPTAIN AMARI
*Emilie Henriksen (Hanamaru Photography)*

"This may be silly to say, but fabric is really underrated in cosplay. A lot more people are impressed with big armor, so fabric and sewing skill in cosplay goes unnoticed sometimes. I wish more people appreciated sewing! When I'm creating a cosplay, you can always catch me at my sewing machine."
—Janyn Mercado a.k.a. LUNAR CROW

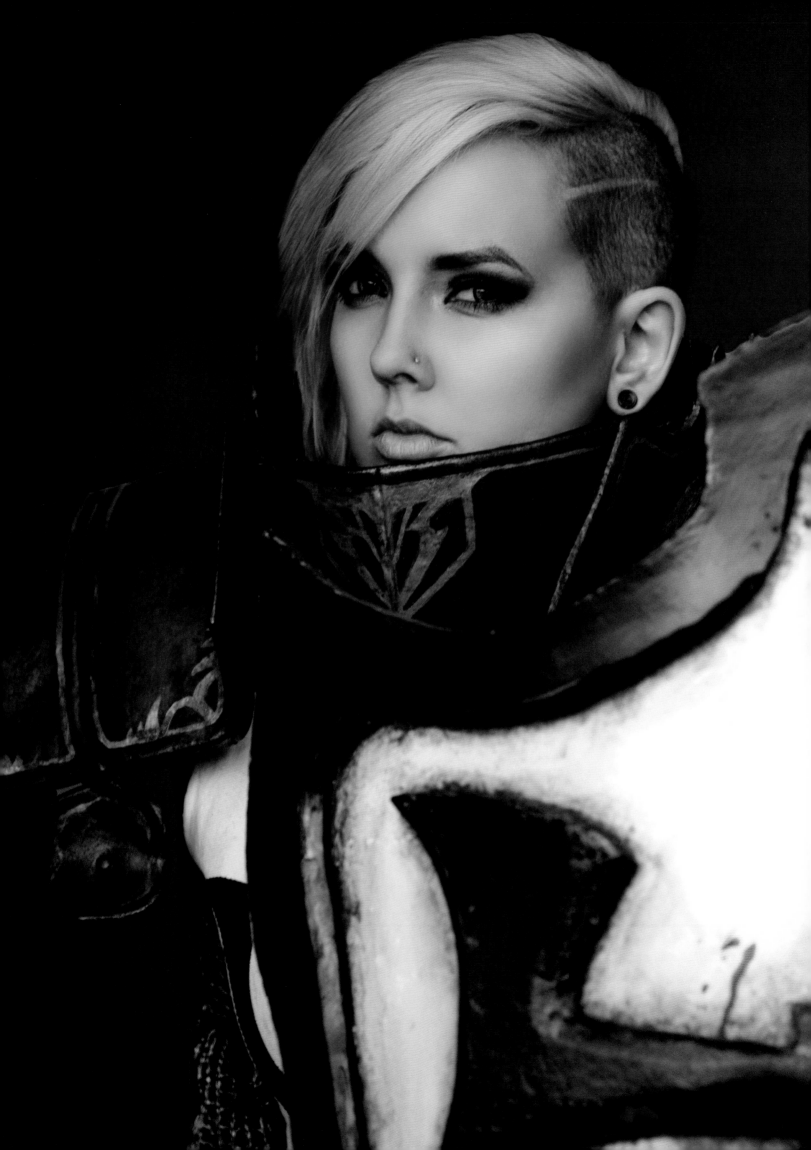

**DARSHELLE STEVENS ·**
JOHANNA
*Photographer: Carlos Guerrero*
*Costume by Lyz Brickley*

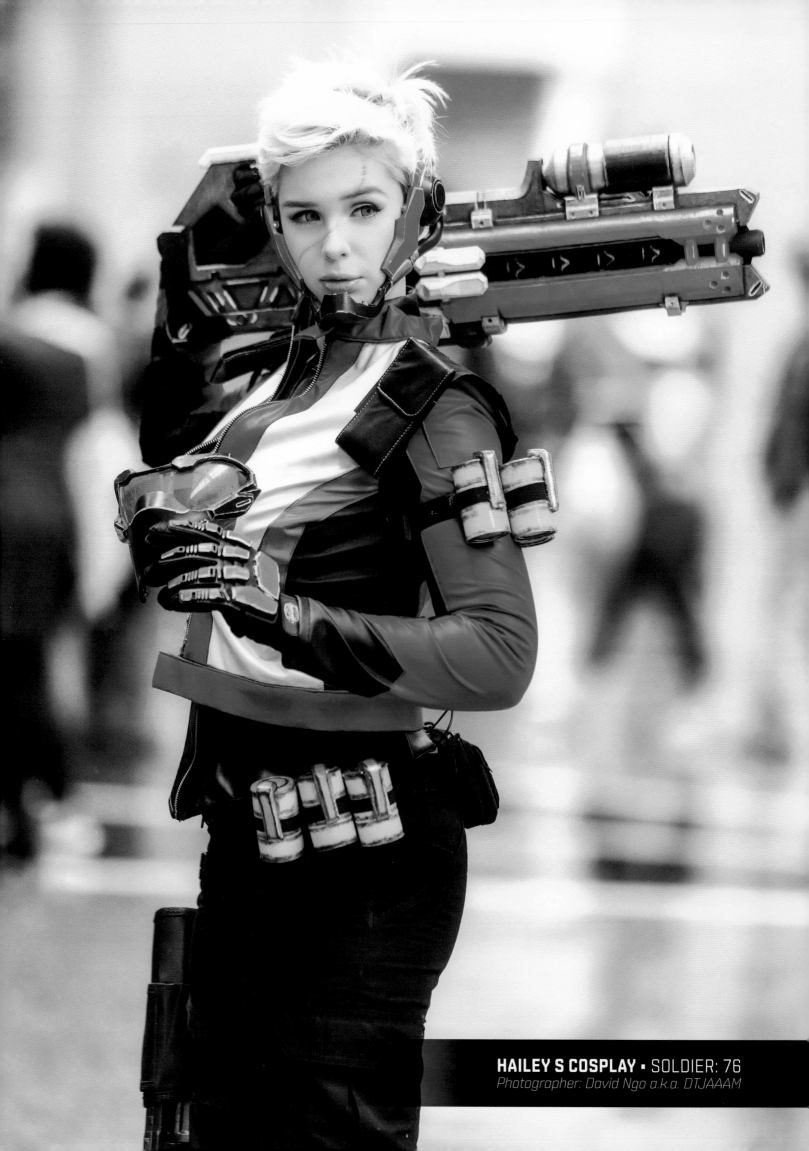

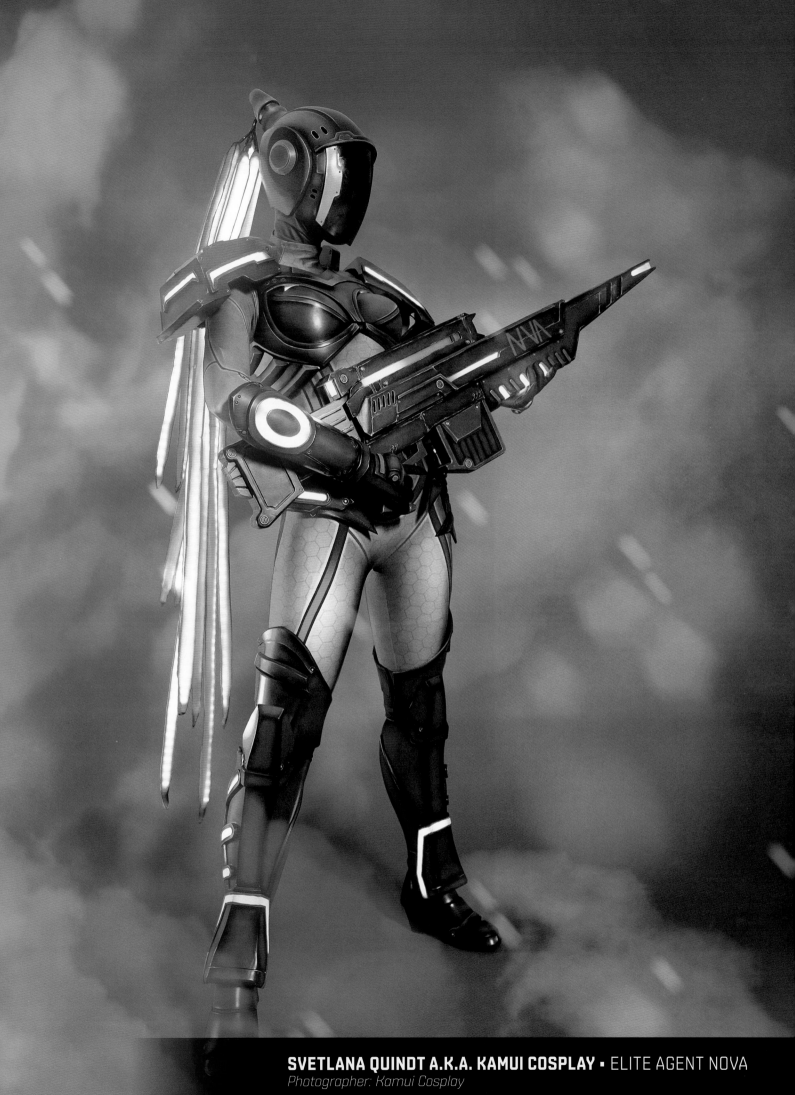

**SVETLANA QUINDT A.K.A. KAMUI COSPLAY** • ELITE AGENT NOVA
*Photographer: Kamui Cosplay*

**KRISTIN STUMPP A.K.A. LITTLE SPARKZ COSPLAY** ▪ CHROMIE
*Photographer: Kelvin Oh*

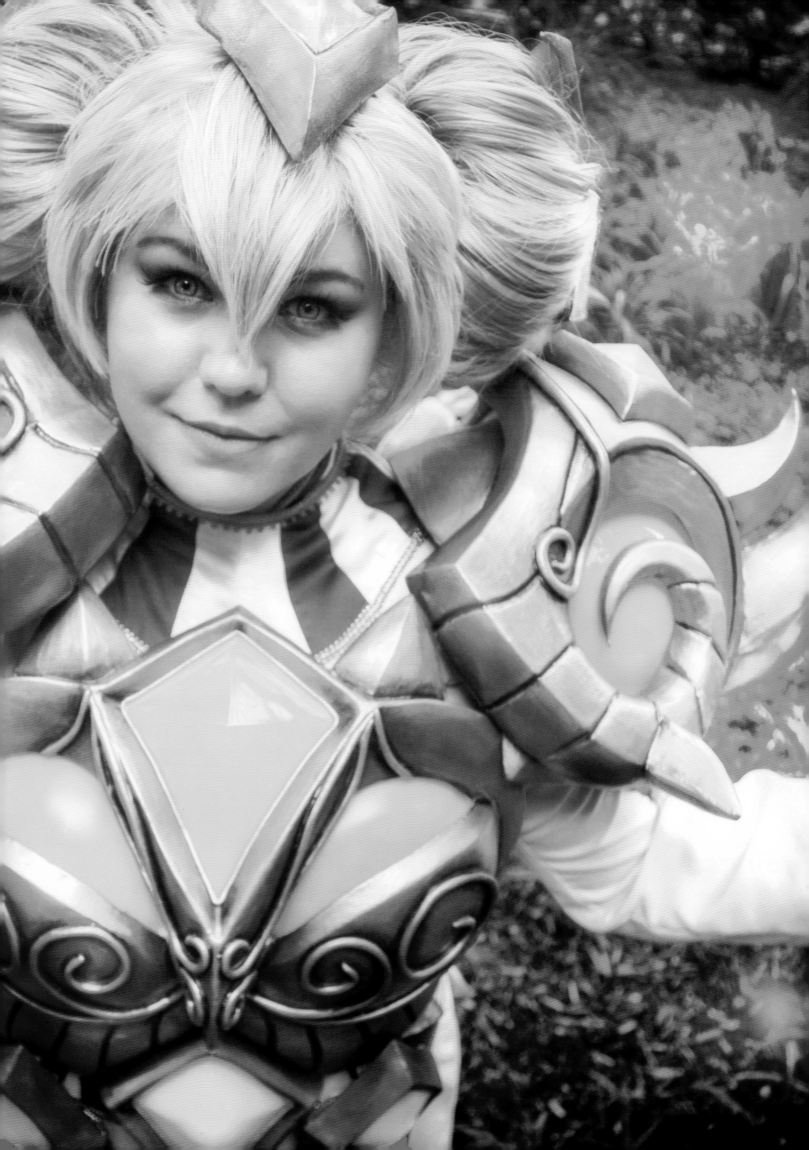

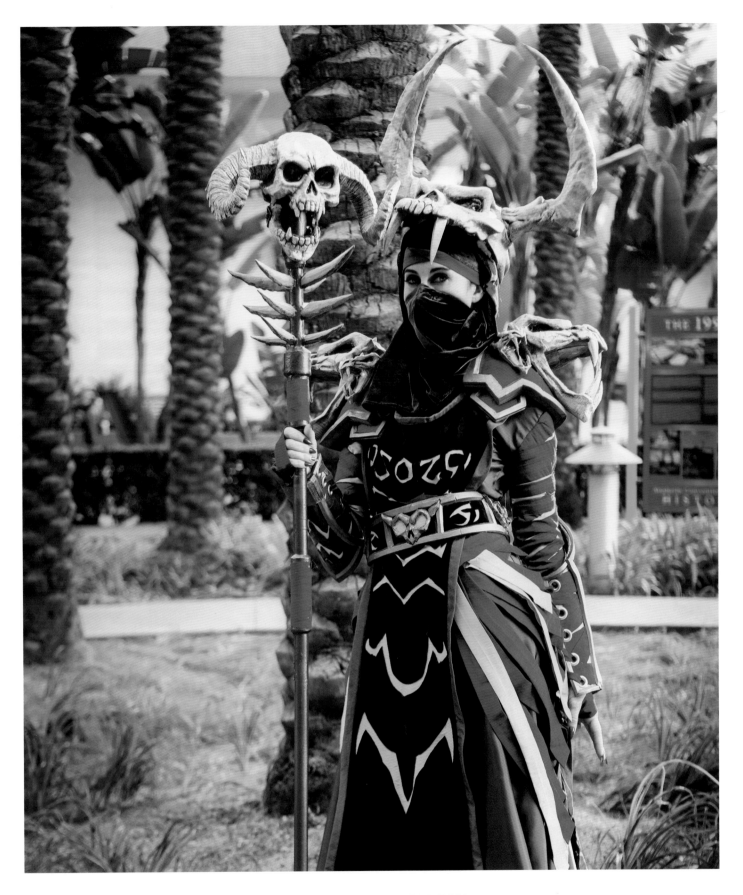

## MEGAN EMBREE A.K.A. VOLDE COSPLAY ▪ NEMESIS WARLOCK
*Photographer: Matthieu Roussotte*

"As I've started integrating 3-D printing technology into my costumes, I sometimes export character armor from the games to print armor pieces identical to the in-game model. My Nemesis Warlock and Sylvanas Windrunner costumes both feature armor pieces that have been directly exported from the game clients, sized to fit my body, and printed based on those models to create an accurate version of the costume."
—*Megan Embree a.k.a. Volde Cosplay*

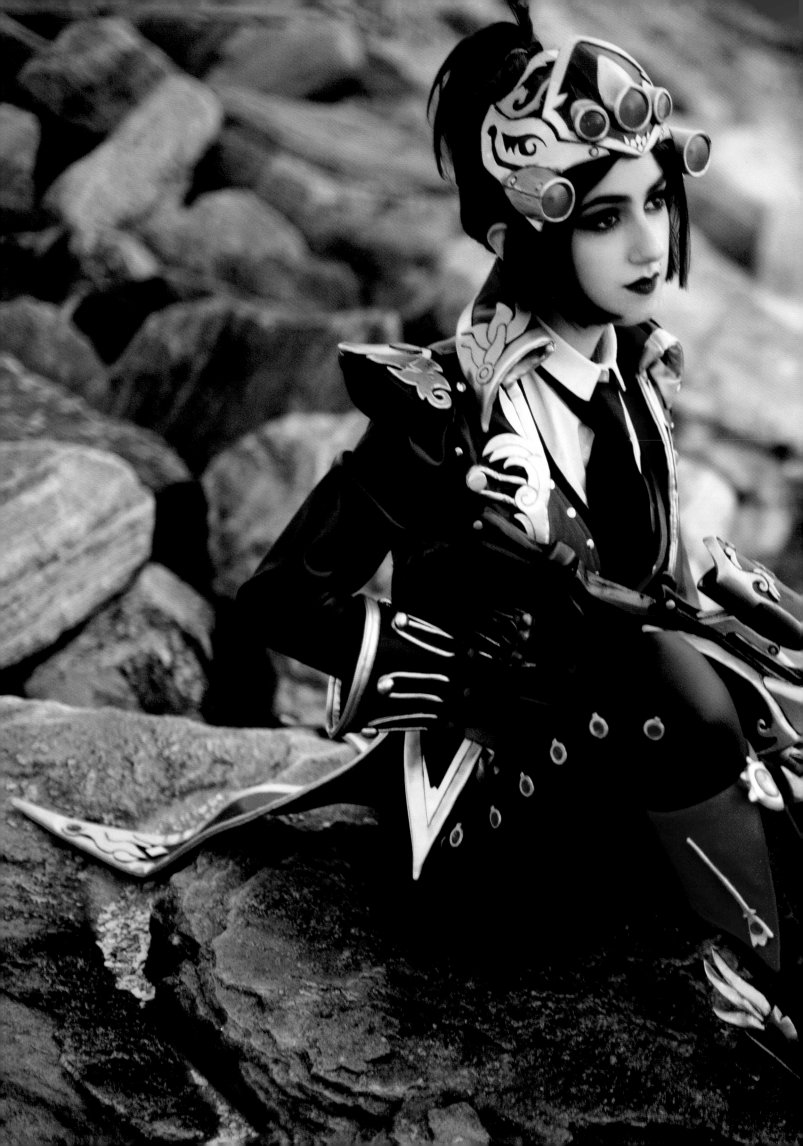

**ROXANNA LEE COSPLAY** ▪ HUNTRESS WIDOWMAKER
*Photographer: Joseph Chi Lin*

"Iron your costumes. It's the simplest way to improve how your cosplays look in photographs. Unless you're in full armor, ironing or steaming your costume will let it flow and reflect light better. It will also save your photographer a lot of headache from having to remove wrinkles while processing your images."
—Joseph Chi Lin

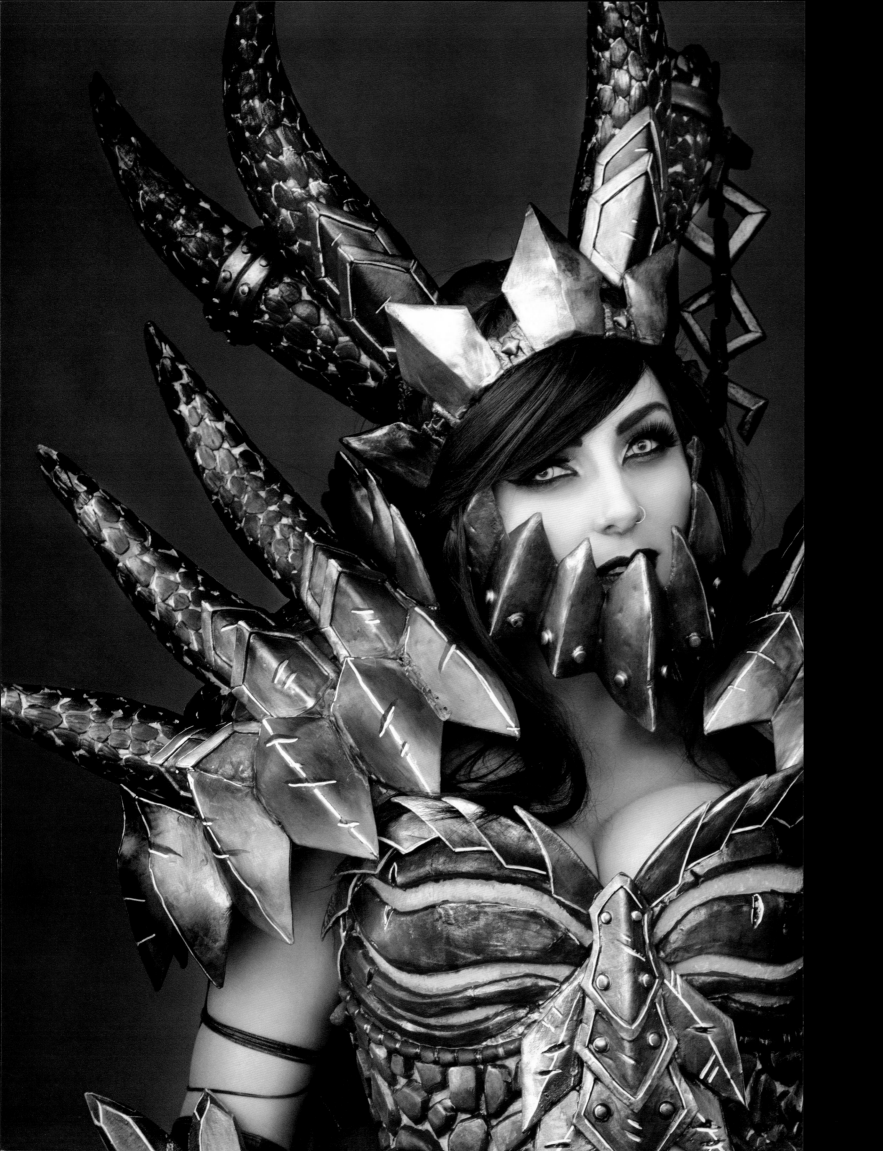

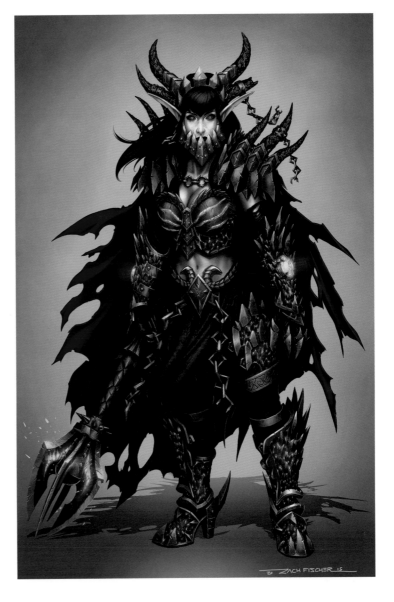

## JESSICA NIGRI • DEATHWING
*Photographer: Carlos Guerrero*
*Costume designed by Zach Fischer*

"Think about every part of your design, but take it one step at a time. It's very easy to get overambitious right out of the gate with a costume, and sometimes this can be an asset if you know how to pare down a design to what makes it most effective and appealing. It's a natural tendency for new designers and artists to think that 'more is better' when it comes to most aspects of designing. 'More details! Bigger shoulders! More spikes! More chains! More lights!' While this can be true sometimes, often it can ruin a design just as easily as it can make it better. Good design is about more than just 'more.' It's about economy of design. Placing your details and your 'more' where it will be the most effective and leaving some open space and simplicity in places to allow for the design to breathe and the eye to rest. Think about which details are most important and make sure they stand out. Let the rest serve as a nice base."
—Zach Fischer

**DANA HOLMES-MCGUIRE & COURTNEY HOLMES A.K.A. EGG SISTERS COSPLAY ·** *WORLD OF WARCRAFT* FORSAKEN ROGUE
*Five Rings Photography*

"Failing is really the best way to learn, and we completely expect it to happen. Sometimes we can work with what we've made, but other times we just need to start all over. We have a good laugh about it and like to share our epic fails online with fellow builders. Speaking of fellow builders, the cosplay community is full of friendly, knowledgeable people. We often reach out to others for help and advice."
—*Dana Holmes-McGuire & Courtney Holmes a.k.a. Egg Sisters Cosplay*

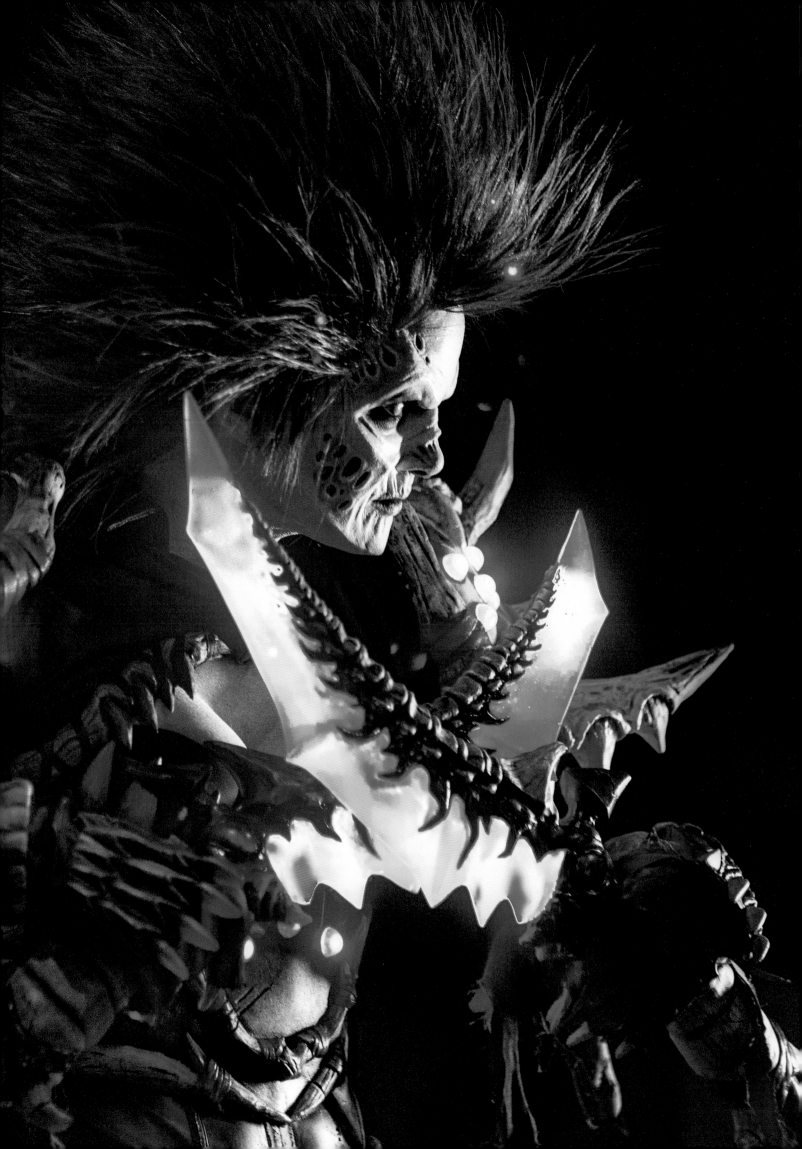

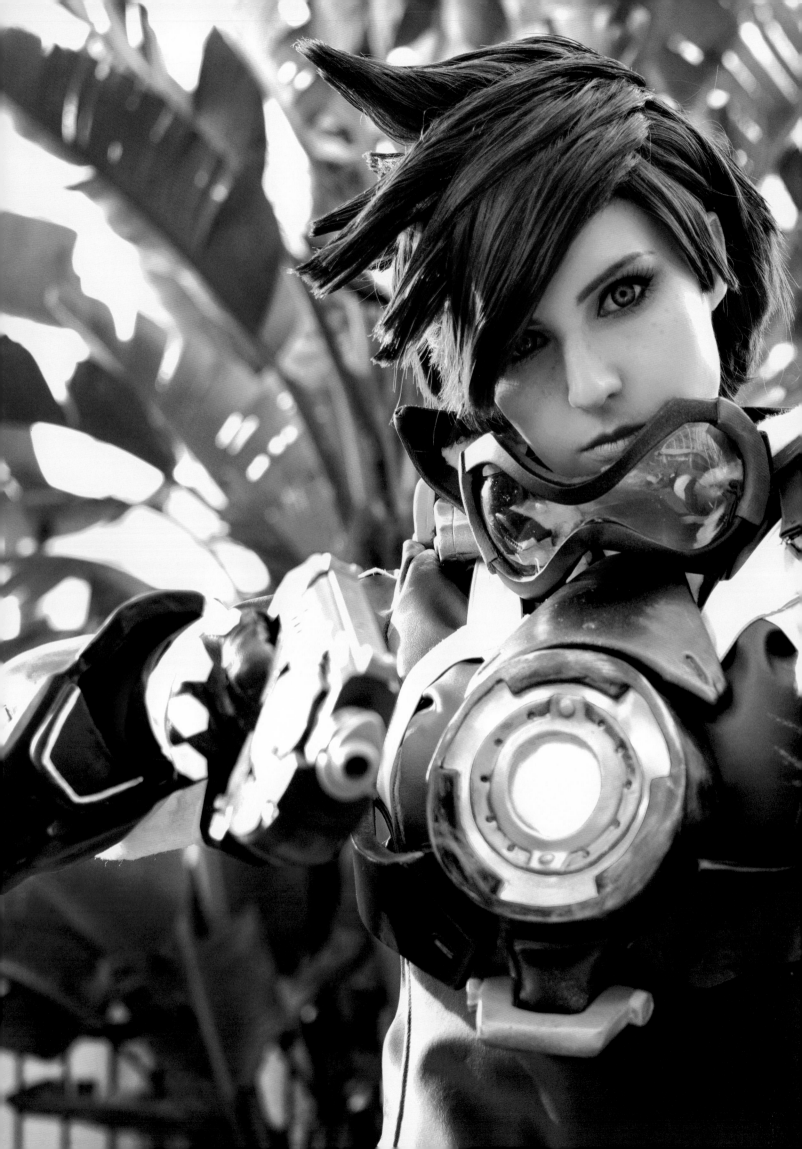

**MORGAN WANT** ▪ TRACER
*Photographer: Carlos Guerrero*

**ALICIA BELLAMY (VERTVIXEN)** ▪
ARTHAS
*Photographer: Carlos Guerrero*

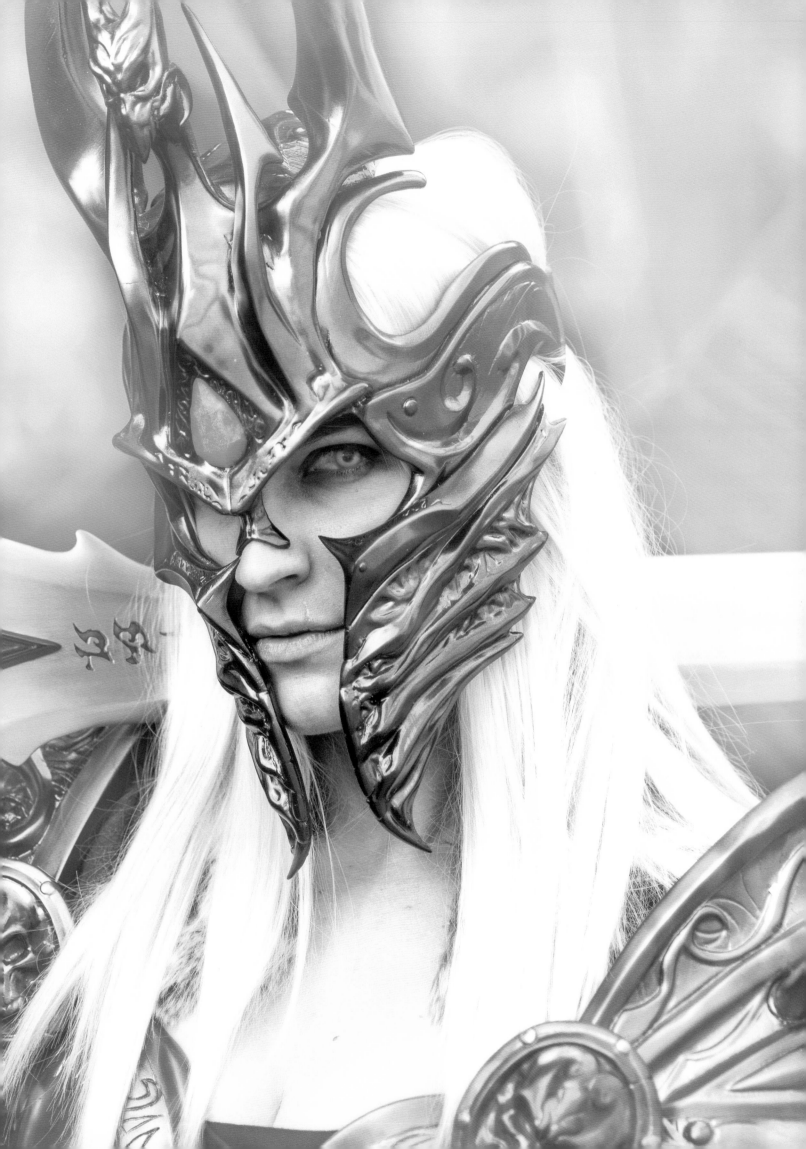

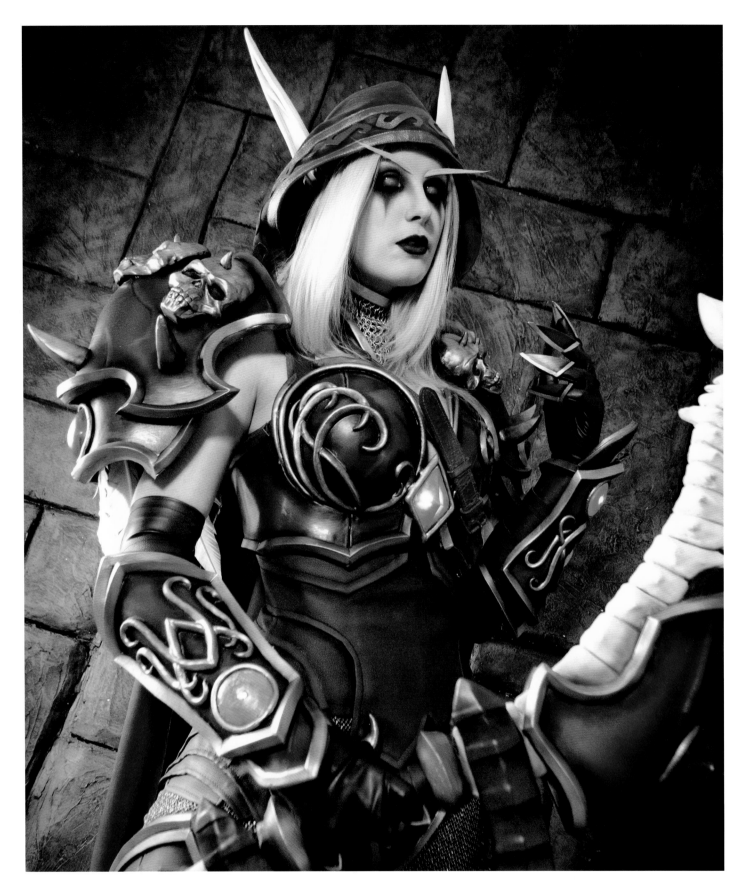

## TAYLA BARTER A.K.A. KINPATSU COSPLAY • SYLVANAS
*Photographer: Tayla Barter*

"I normally start by looking at all the individual pieces and making a list of exactly what is on the costume. Breaking it down like this can make it much easier to figure out what you need to make and how much work it's going to be. Sometimes I do my own sketches of the different pieces. I find that drawing them out helps me visualize the different layers and the base shapes of armor or other complex elements of the costume."
—*Tayla Barter a.k.a. Kinpatsu Cosplay*

**TAYLA BARTER A.K.A. KINPATSU COSPLAY** · VALEERA SANGUINAR
*Photographer: Tayla Barter*

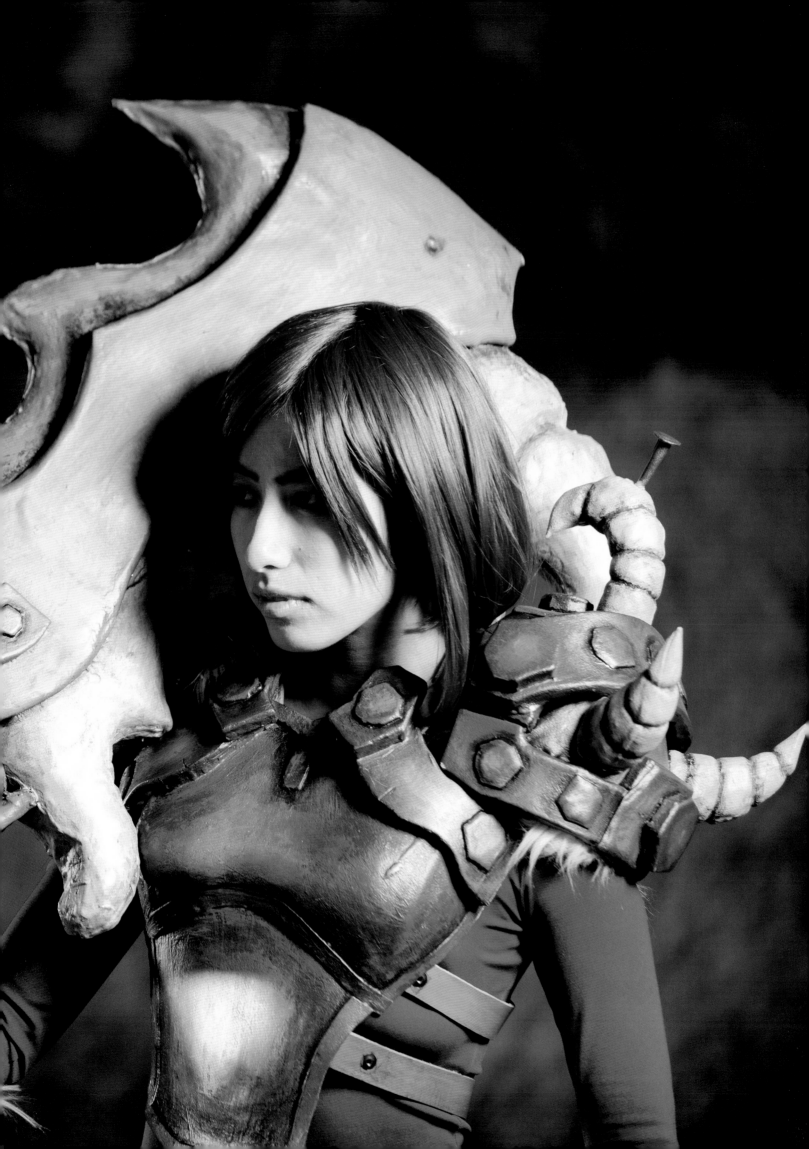

**LYZ BRICKLEY • NOVA**
*Beethy Photography*

"Nova was a bit of a collaboration. I made all of the armor pieces out of foam and lit them up with EL wire. The gun and goggles were made by Henchmen Props, and the bodysuit was designed by Nathan DeLuca."
—*Lyz Brickley*

**MICHELLE MACGIBBON A.K.A.**
**MOLDYCHEESE COSPLAY ·**
SHRIKE ANA
*Photographer: Daniel MacGibbon*

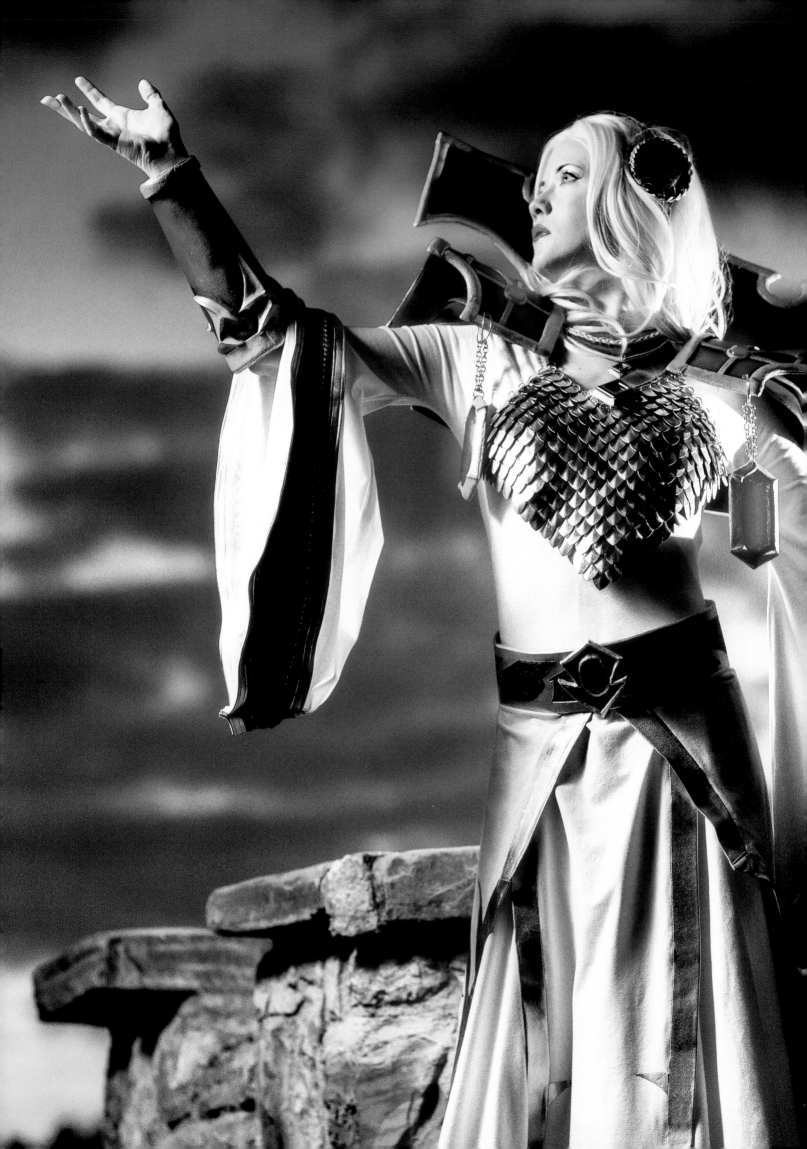

**CHRISTINA MIKKONEN**
**A.K.A. ZERINA** ▪ AEGWYNN
*Photographer: Tim Vo*

"Some pretty amazing things can be made
with the most basic materials if you take
the time to work on the details. Foam is
very underrated but can be one of the most
versatile and inexpensive materials to work
with. Acrylic paints are also inexpensive and
come in a wide variety of colors. Don't invest
in expensive materials just because you think
it may compensate for a lack of experience!"
—*Christina Mikkonen a.k.a. Zerina*

ILABELLE COSPLAY, HENDO ART, MAID OF MIGHT COSPLAY,
REAGAN KATHRYN, ELIZABETH RAGE · D.VA
Photographer: Carlos Guerrero

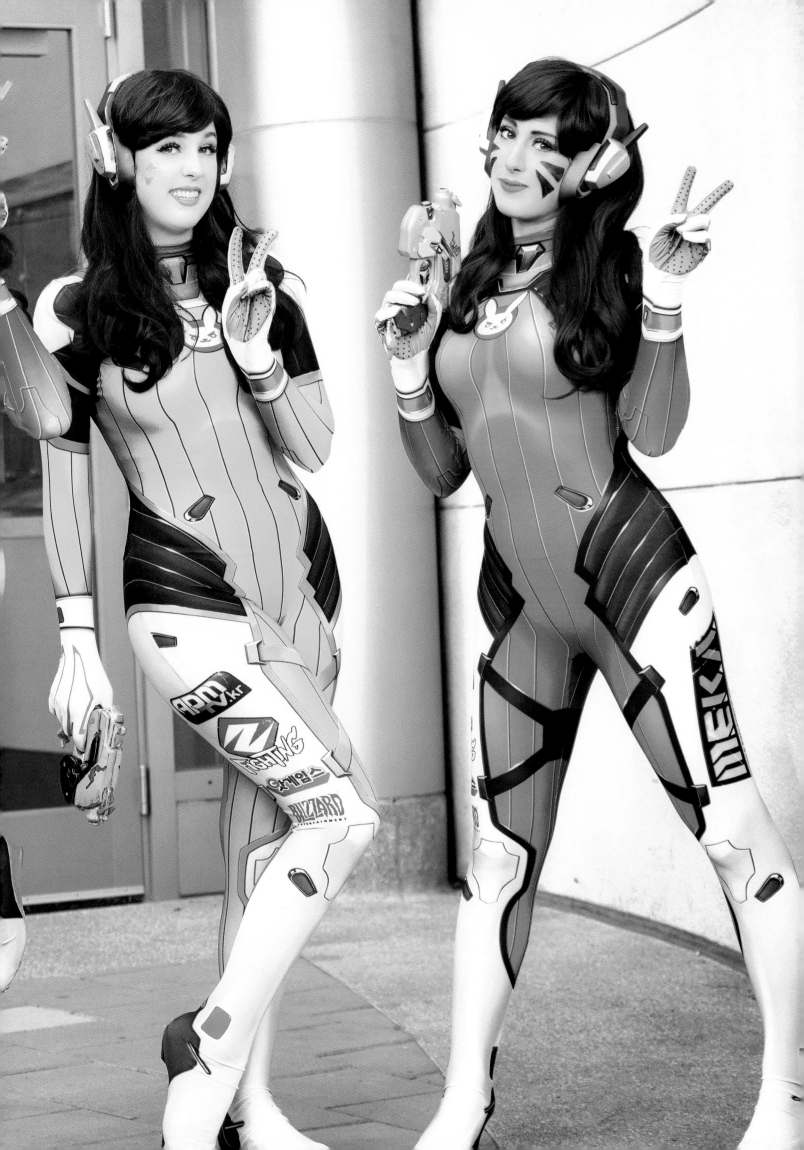

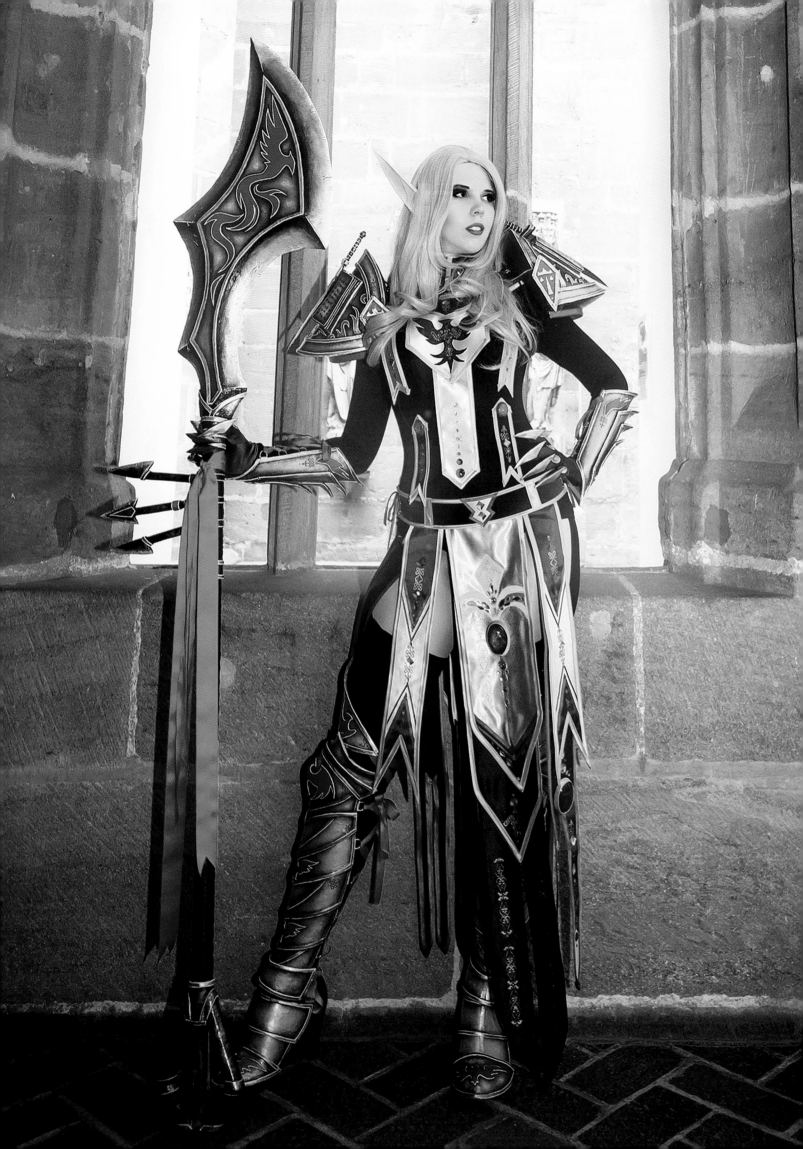

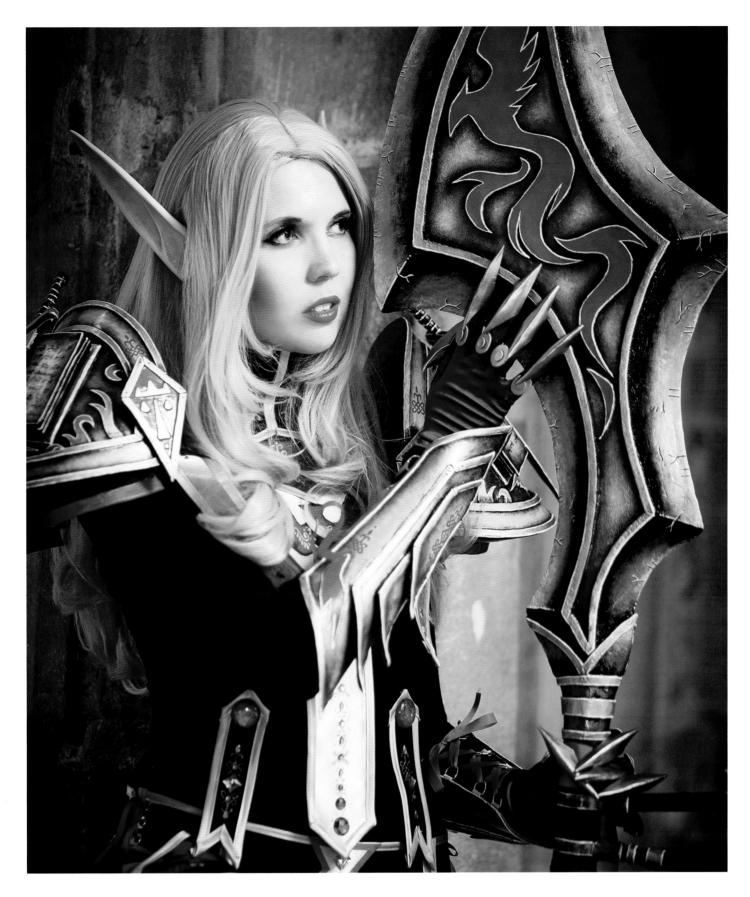

**SVETLANA QUINDT A.K.A. KAMUI COSPLAY** ▪
*WORLD OF WARCRAFT* PALADIN TIER 2
Photographer: Kamui Cosplay

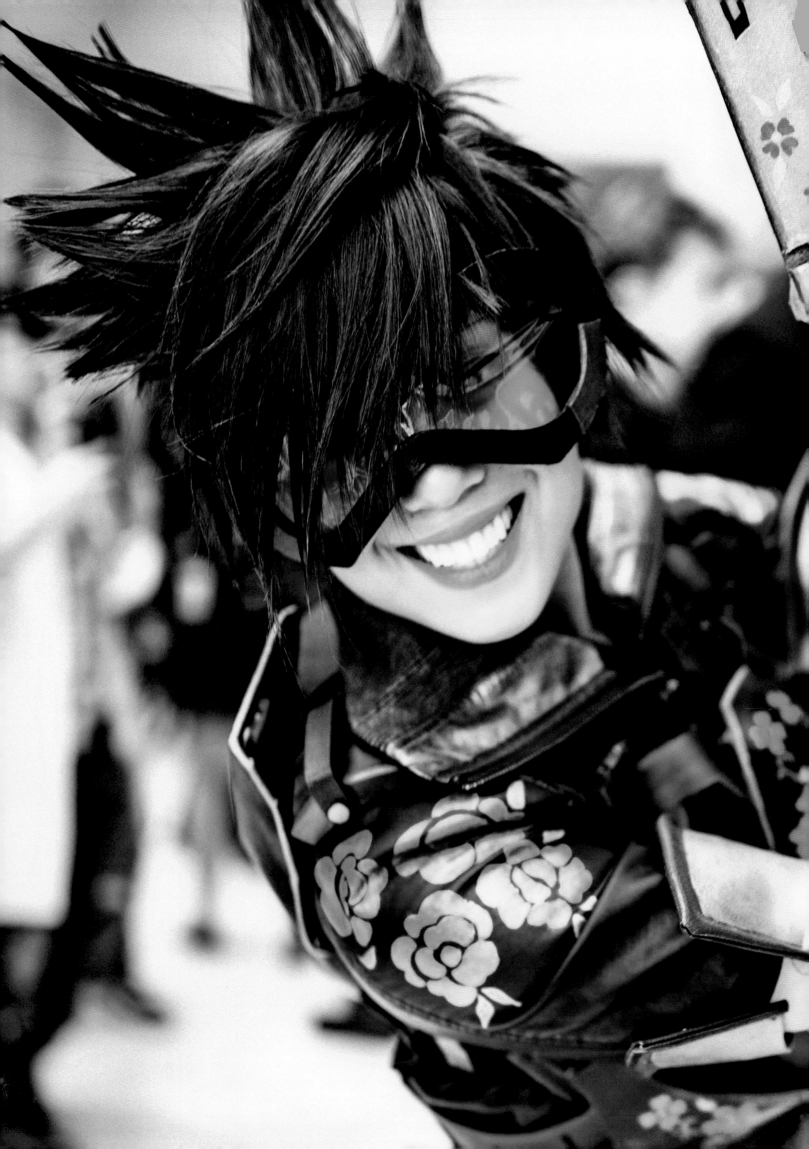

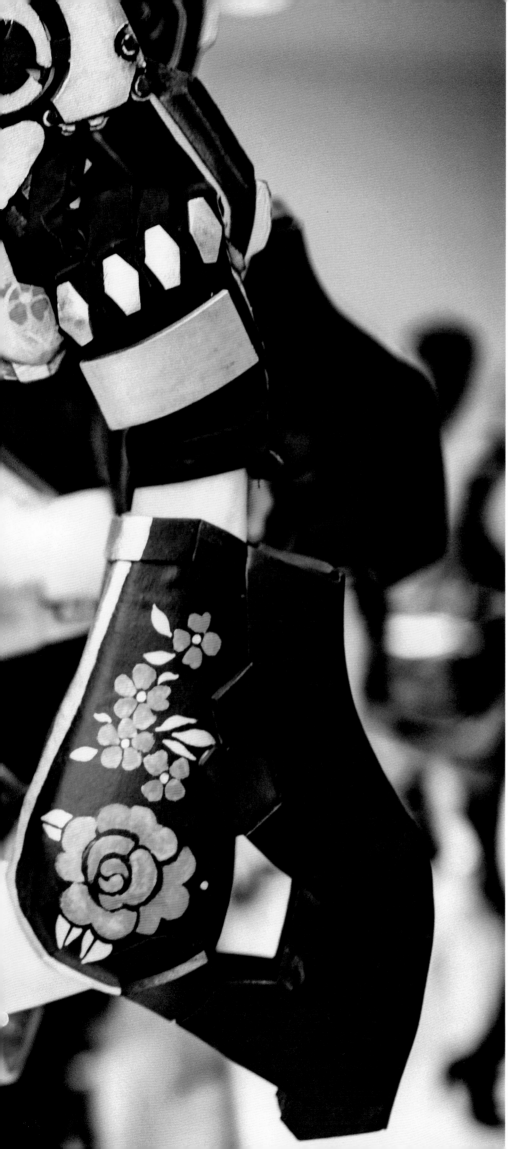

**TIGER LILY COSPLAY** ▪
ROSE TRACER
*Photographer: Missionfortysix*

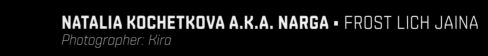

**NATALIA KOCHETKOVA A.K.A. NARGA** • FROST LICH JAINA
*Photographer: Kira*

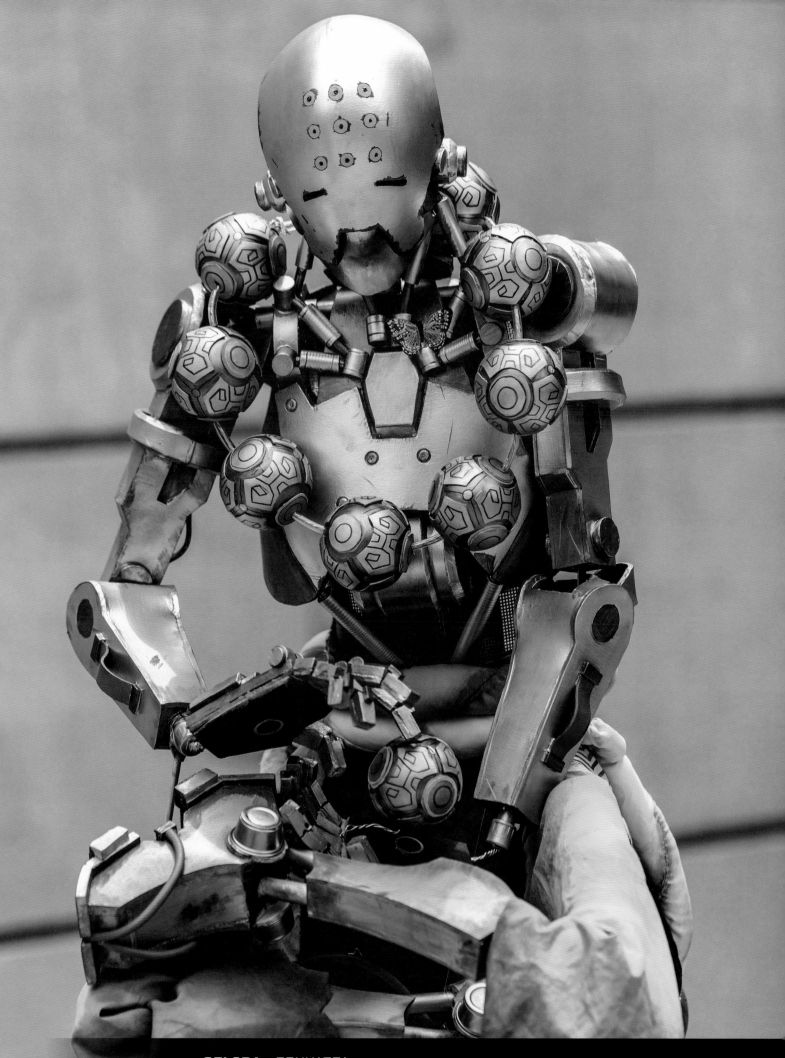

**OFLORA** ▪ ZENYATTA
*Photographer: David Ngo a.k.a. DTJAAAM, Costume made with help from Effekted Cosplay*

**CYNTHIA HALL A.K.A. ALUDIANA** · *DIABLO III* DEMON HUNTER
*Photographer: Tom Hicks*

"Most of my pieces are embroidered in beads, hand-dyed silk ribbons, various threads, and metal elements using techniques learned by studying historical and cultural pieces from around the world. Thread and bead embroidery are SEVERELY underrated and underutilized. Even little embroidered accents will stand out on camera and under stage lights with the right colors and textures. Never be afraid to put time into handwork—it's SO worth it!"
—*Cynthia Hall a.k.a. Aludiana*

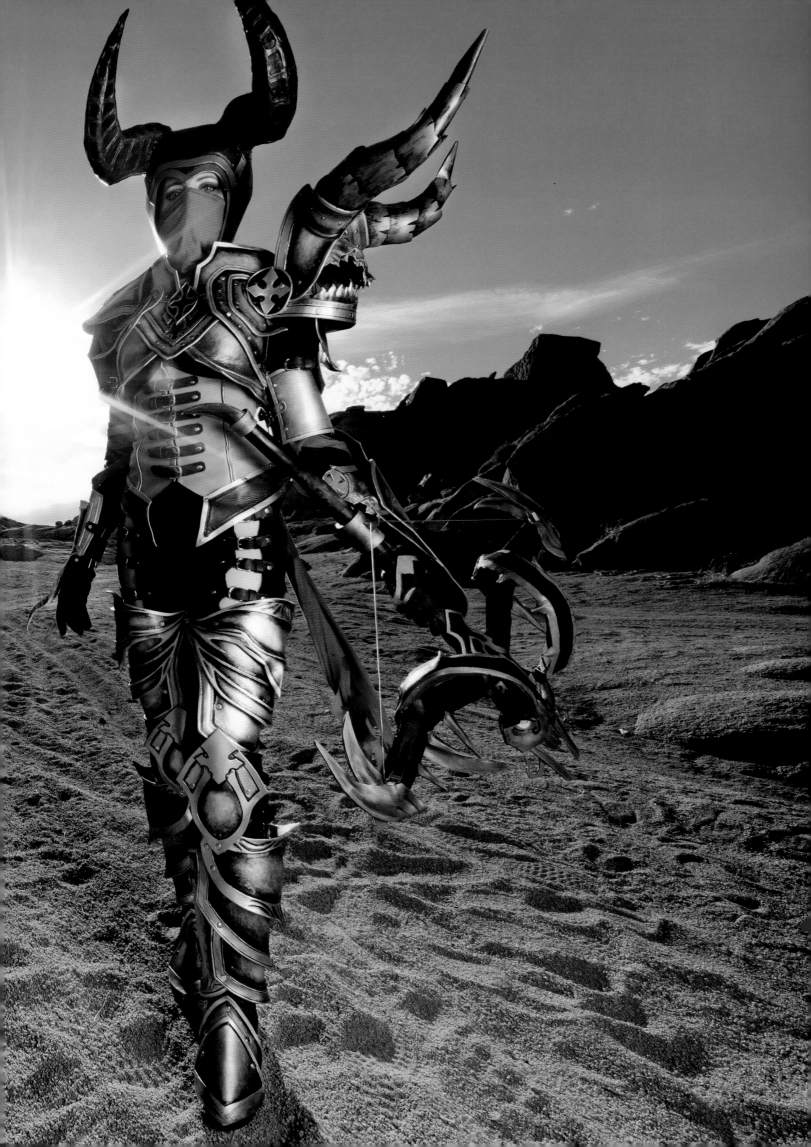

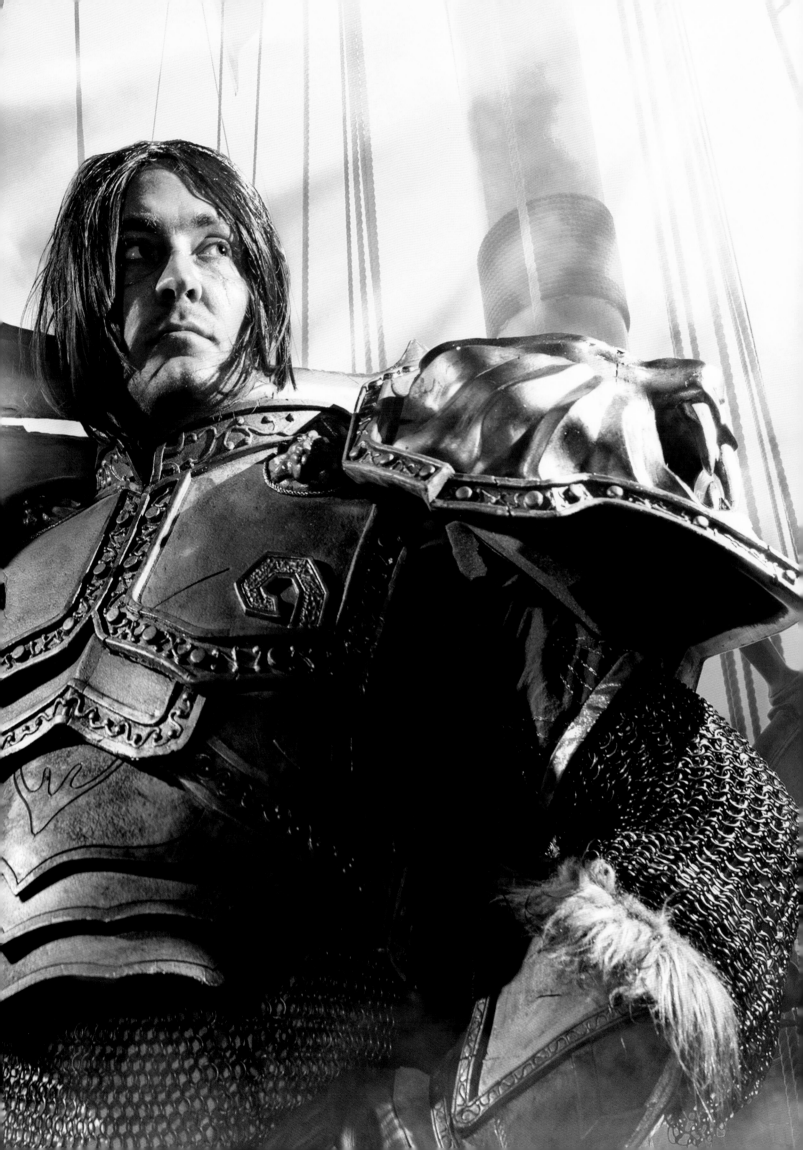

**DANNY LANTERN** • SOLDIER: 76
*Photographer: BriLan Imagery*

"I was always blown away by the amazing cosplays I saw at conventions, and I even cosplayed a little myself. But I wanted to contribute more, and what better way than by using photography to show my support for the hard work and creativity that cosplayers bring to the community? What draws me to cosplay photography more than anything is that it allows me to pour my imagination and ideas into the pot and make them into reality."
—*Brian Lansangan*

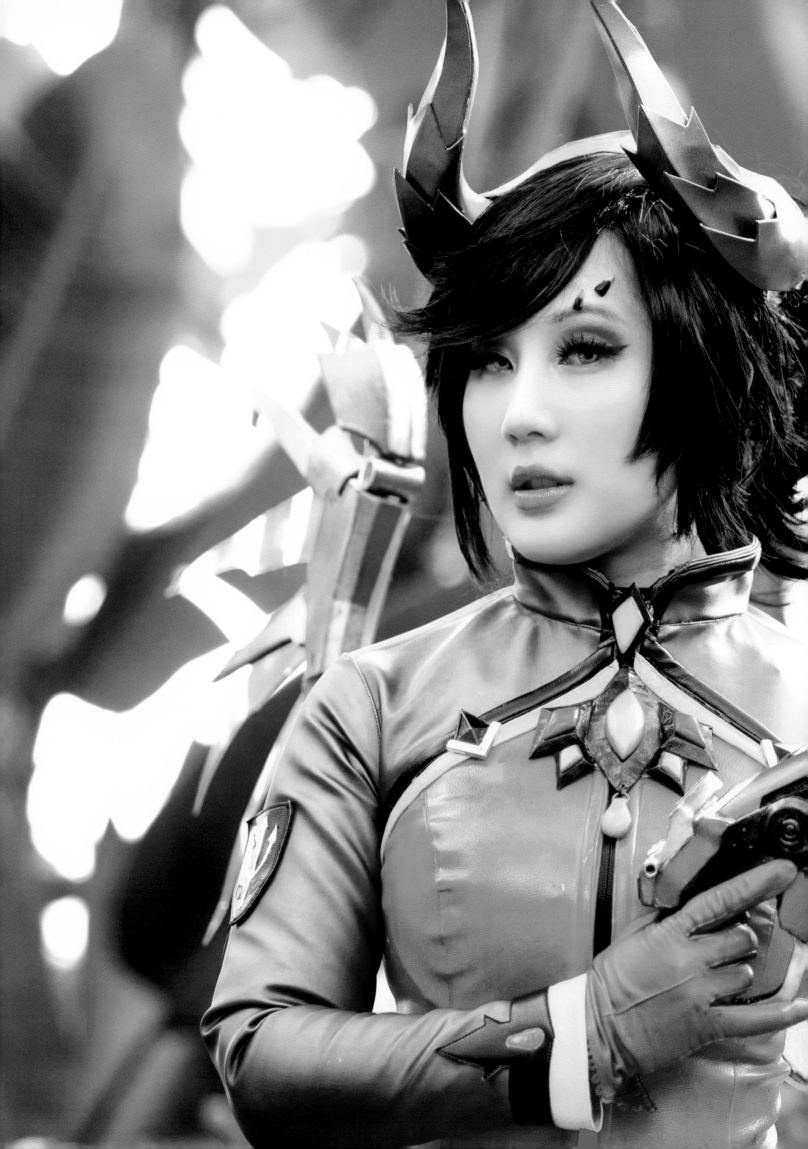

**KAFUR COSPLAY ▪ BLACKHAND**
*Photographer: Daniel MacGibbon*

"The photo is about the cosplayer. I want to cap-
ture what they want others to see. Sometimes
that means the perfect pose with the perfect
lighting; other times it's capturing their joy of
finally finishing and wearing their costume they
spent thousands of hours making."
—*Daniel MacGibbon*

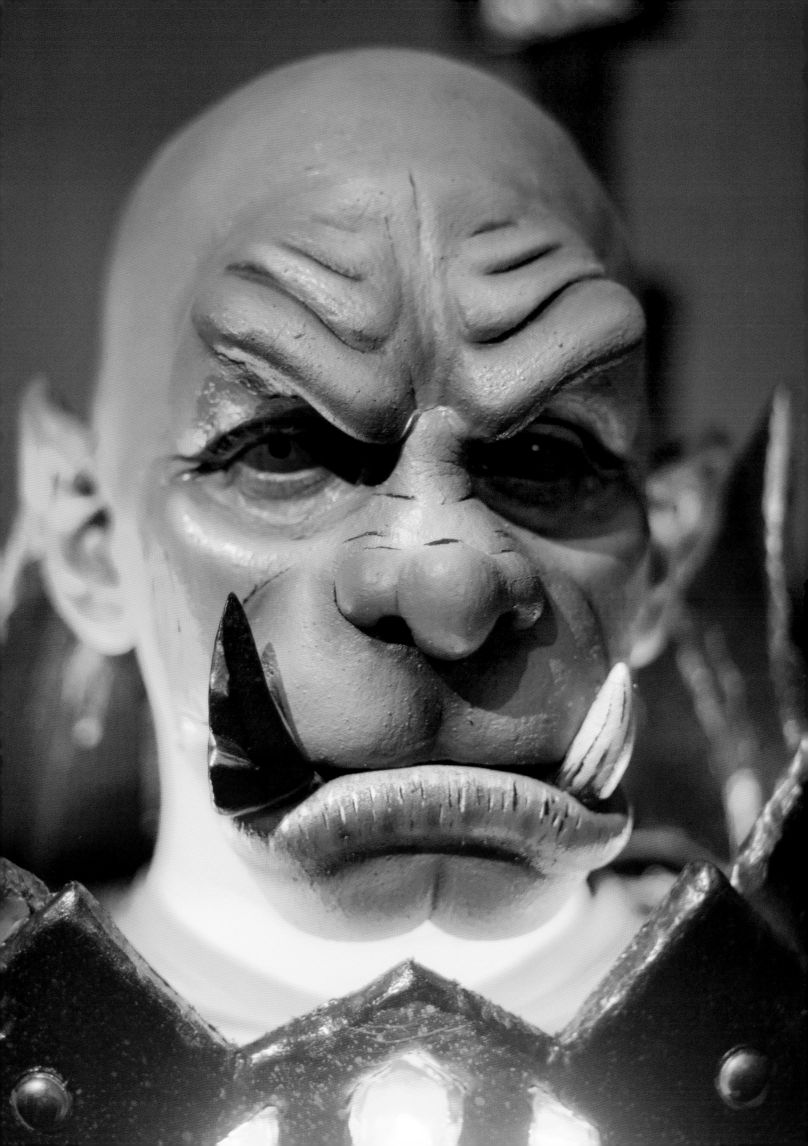

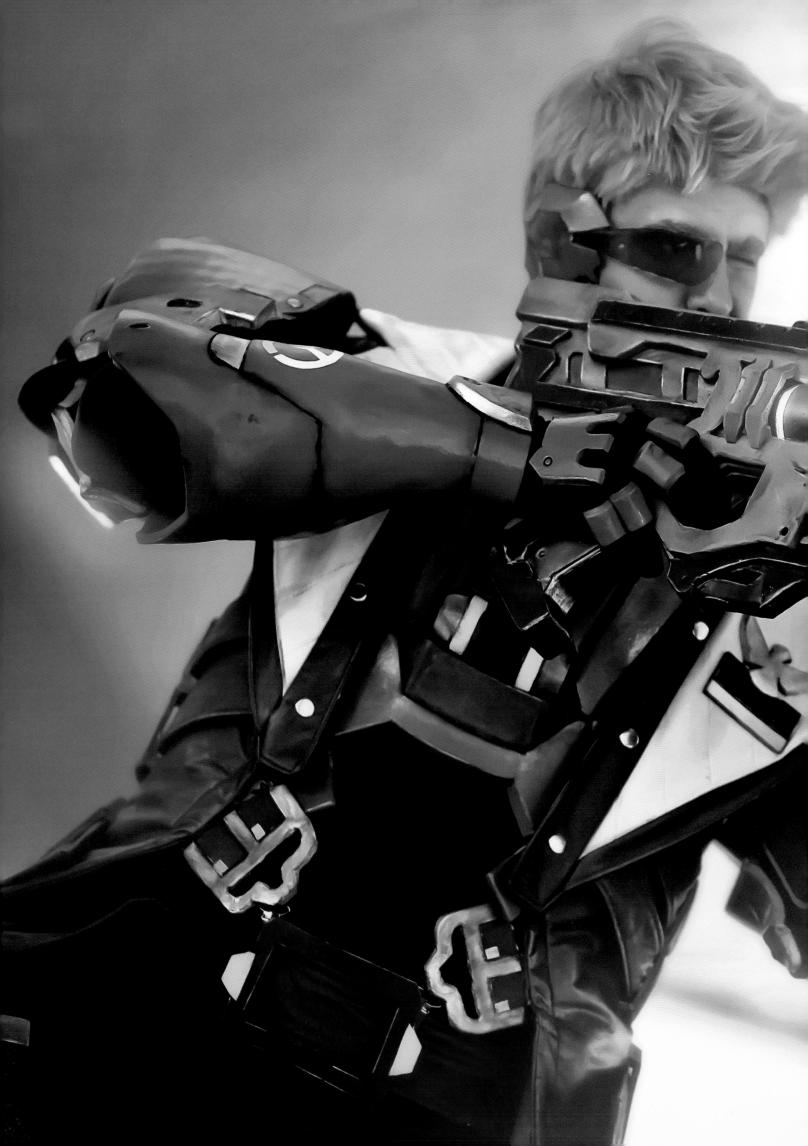

**SERAPH COSPLAY • STRIKE COMMANDER MORRISON**
*Photographer: Jayce Williams a.k.a. Photo NXS*

"My version for any planned shoot comes from the source material, be it a game, animation, or a book. I hunt a location that seems relevant to showcase the look and feel of the cosplay, and I also consider what lighting scenario will work best. I have an obsession with clarity and lighting, always wanting the sharpest and cleanest representation of my subject. There are moments, working with a darker, grungier subject, when clarity isn't the best way to portray character(s) and scene. But, for the most part, I like when my photos feel like they want to jump off your screen and be that much more real to the viewer."
—Jayce Williams a.k.a. Photo NXS

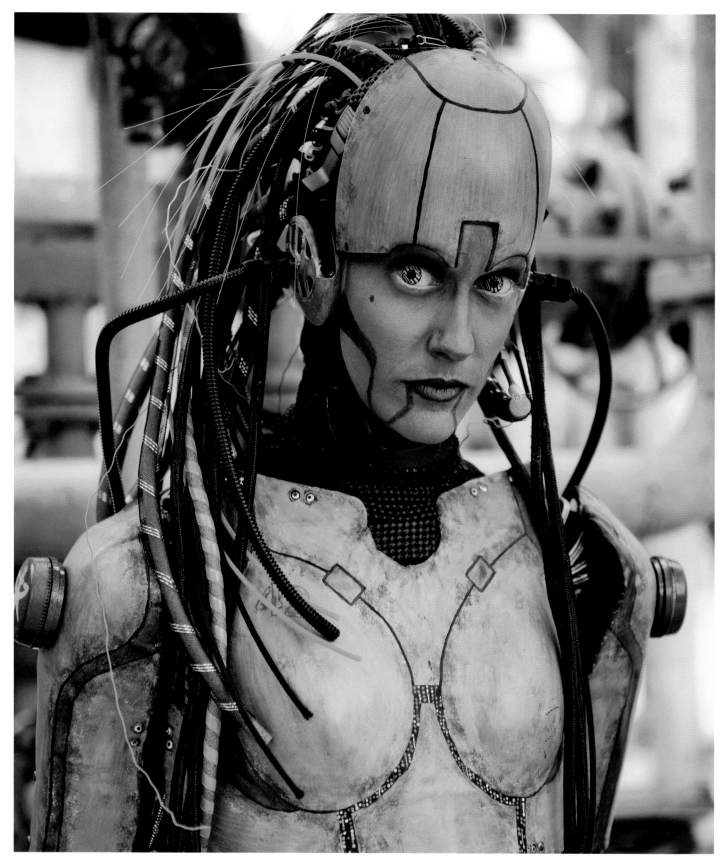

**AVERY FAITH** • *STARCRAFT II* ADJUTANT
*Photographer: Tom Hicks*

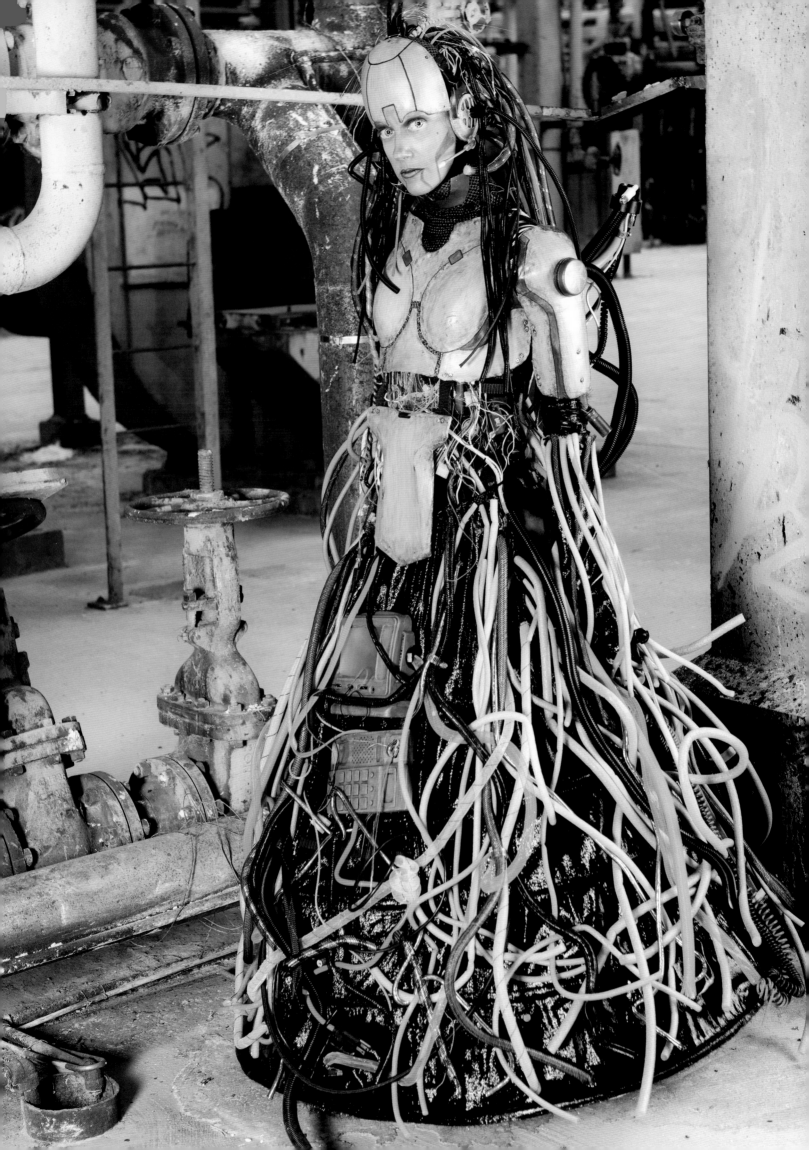

**SERAPH COSPLAY ▪ MALTHAEL**
*Eric Ng a.k.a. Bigwhitebazooka Photography*

"I like to make up a narrative whenever I shoot. I find it
especially satisfying when I can convey a story that my
audience can see. I hope that my work is more cinematic
so that the image goes beyond documentation and really
becomes a storytelling piece."
—*Eric Ng a.k.a. Bigwhitebazooka Photography*

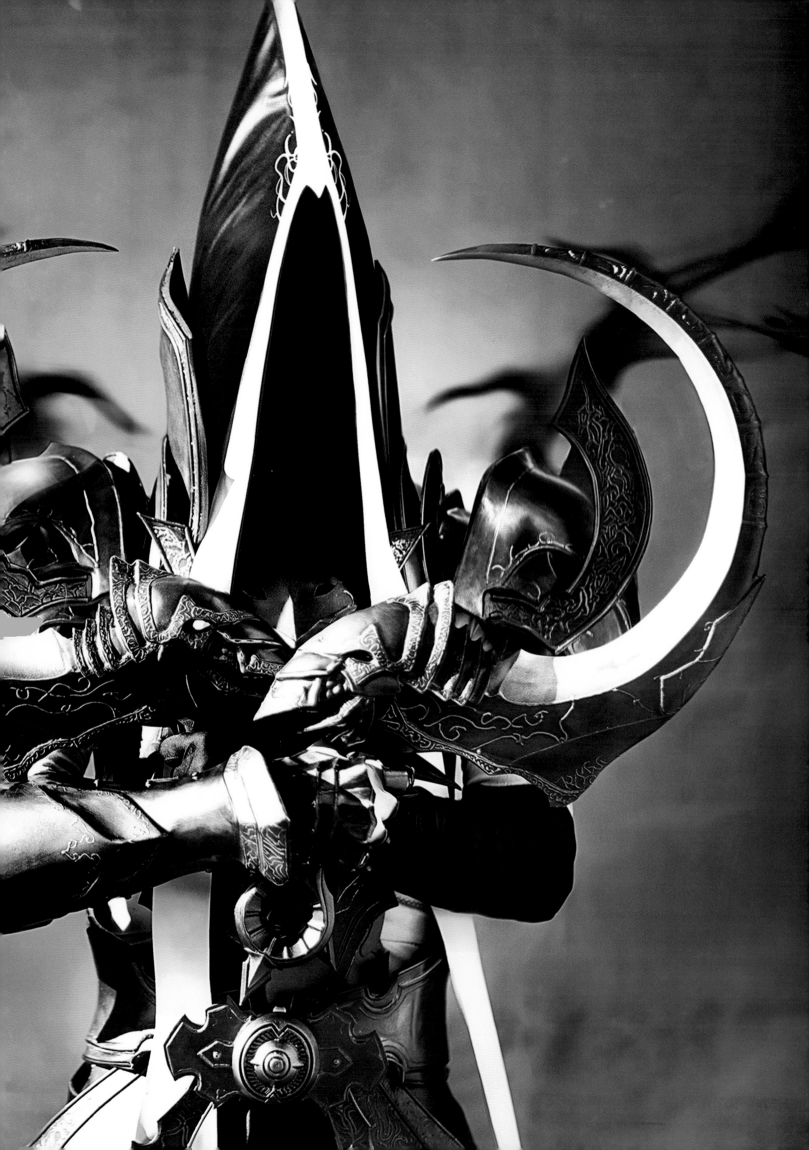

**KATE SARKISSIAN • ALLERIA**
*Photographer: Carl Pangi a.k.a. Pangi Pictures*

"My vision for a shoot starts with the character: who, what, why, when, and how. I also think about what they would be doing and the environment they would be in. I then narrow down the appropriate locations to the ones that I can control the most."
—*Carl Pangi a.k.a. Pangi Pictures*

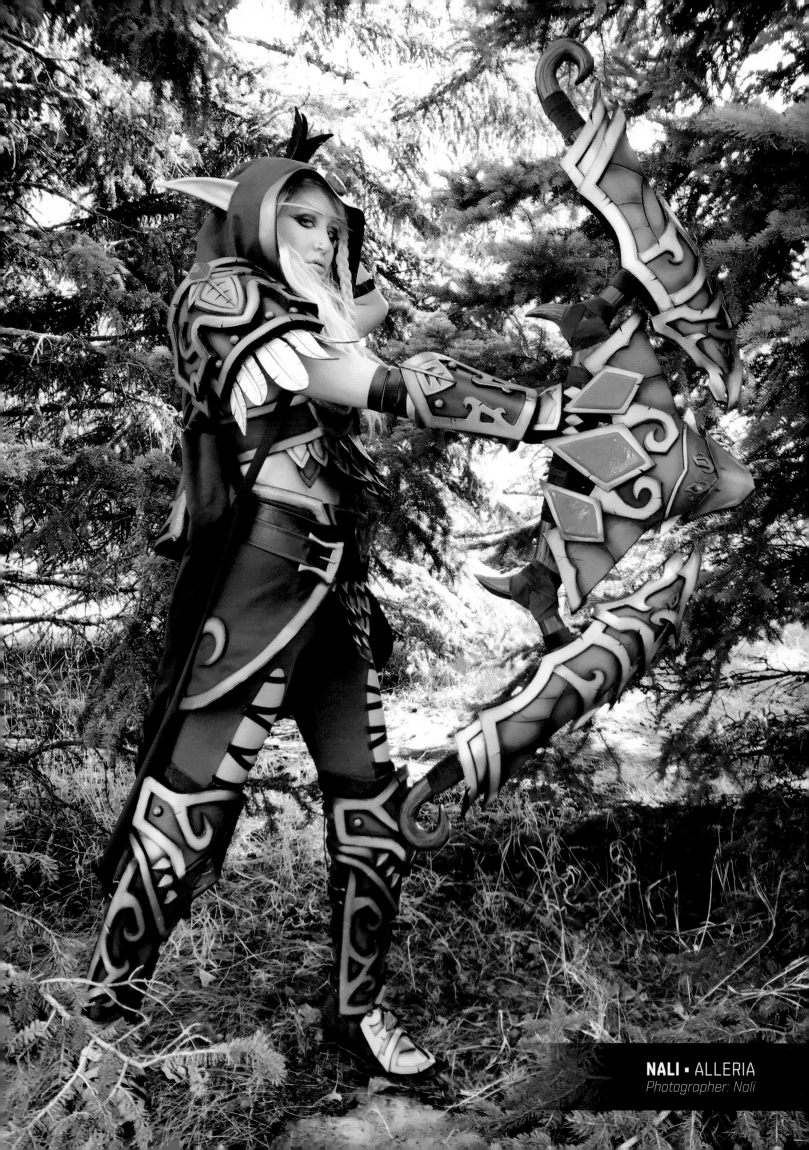

**LAURA & RALF FROM
LIGHTNING COSPLAY** ▪
*DIABLO III* BARBARIANS
*Photographer: Darshelle Stevens*

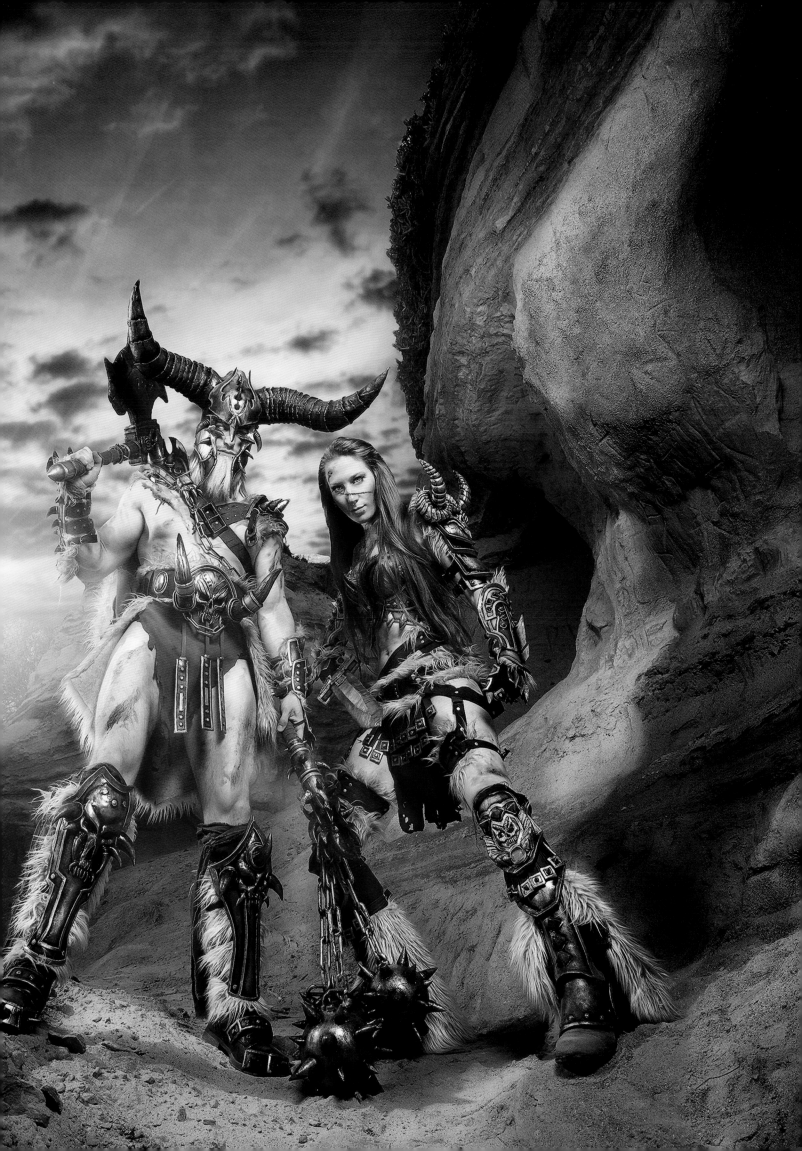

**SPIIDER MOM · TRACER**
*Photographer: Jayce Williams a.k.a. Photo NXS*

"I'm a fan of shooting outside on a convention site. Very rarely do I opt to shoot inside a facility. With the right background, a patch of wall/trees with a special crop, a photo can take on new life and look like it was captured anywhere but a con."
—Jayce Williams a.k.a. Photo NXS

**NEFENI COSPLAY · *DIABLO III* FIREBIRD WIZARD**
Photographer: Jayce Williams a.k.a. Photo NXS

**ASHLEY O'NEILL**
**A.K.A. OSHLEY COSPLAY ·**
*WORLD OF WARCRAFT* HUNTER
*Brandon Klemets Photography*

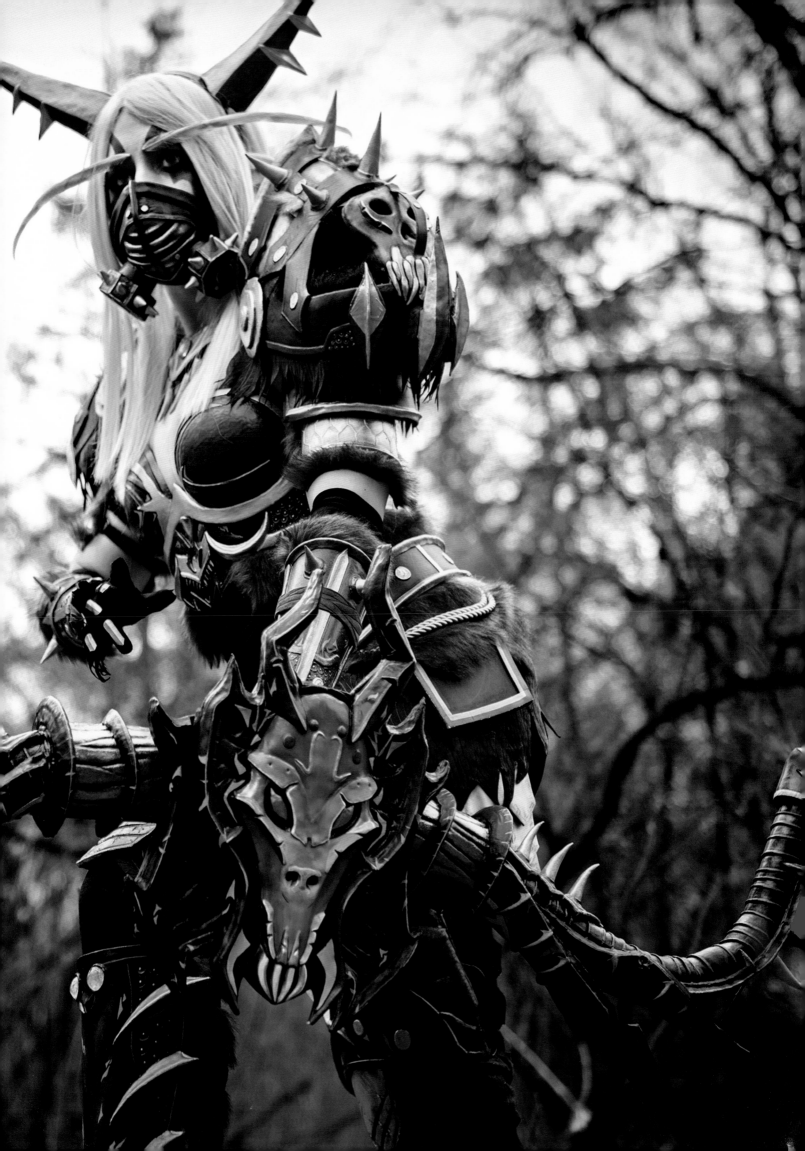

**JESSICA NIGRI** ▪ ALEXSTRASZA
*Martin Wong Photo*

"I have hiked hours in jungles and down valleys, or even climbed into the snow and played with fire, to get the shot that I wanted to create. Incorporating adventures into my photo shoots makes them much more unforgettable and satisfying when I can create the ideal photos."
—Martin Wong

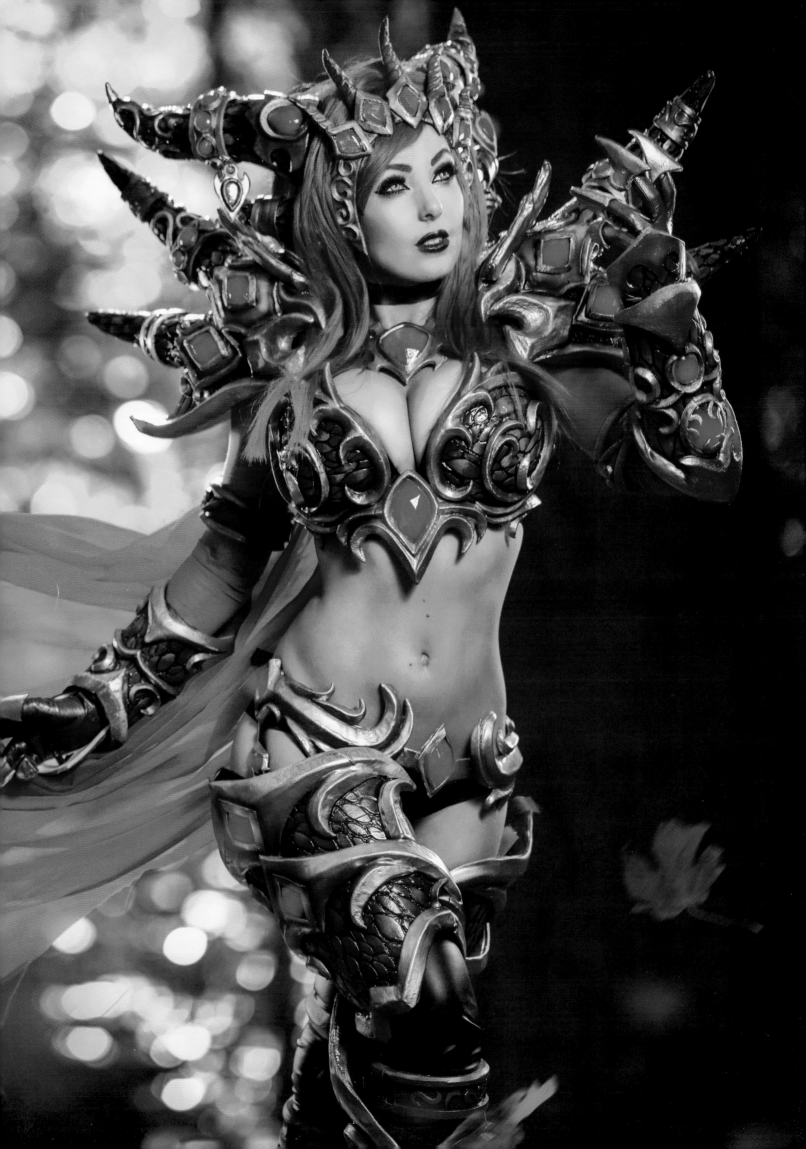

**TINAKINZ** ▪
COMBAT MEDIC ZIEGLER
*Photographer: David Ngo
a.k.a. DTJAAAM*

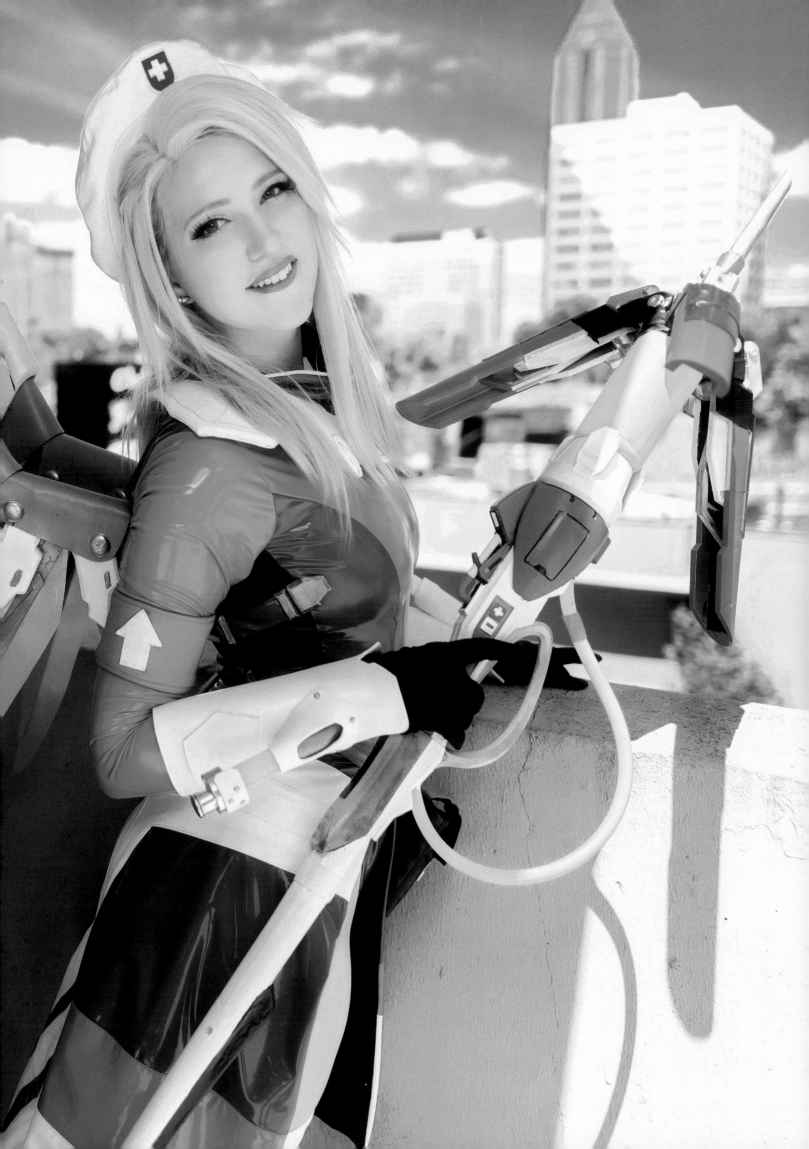

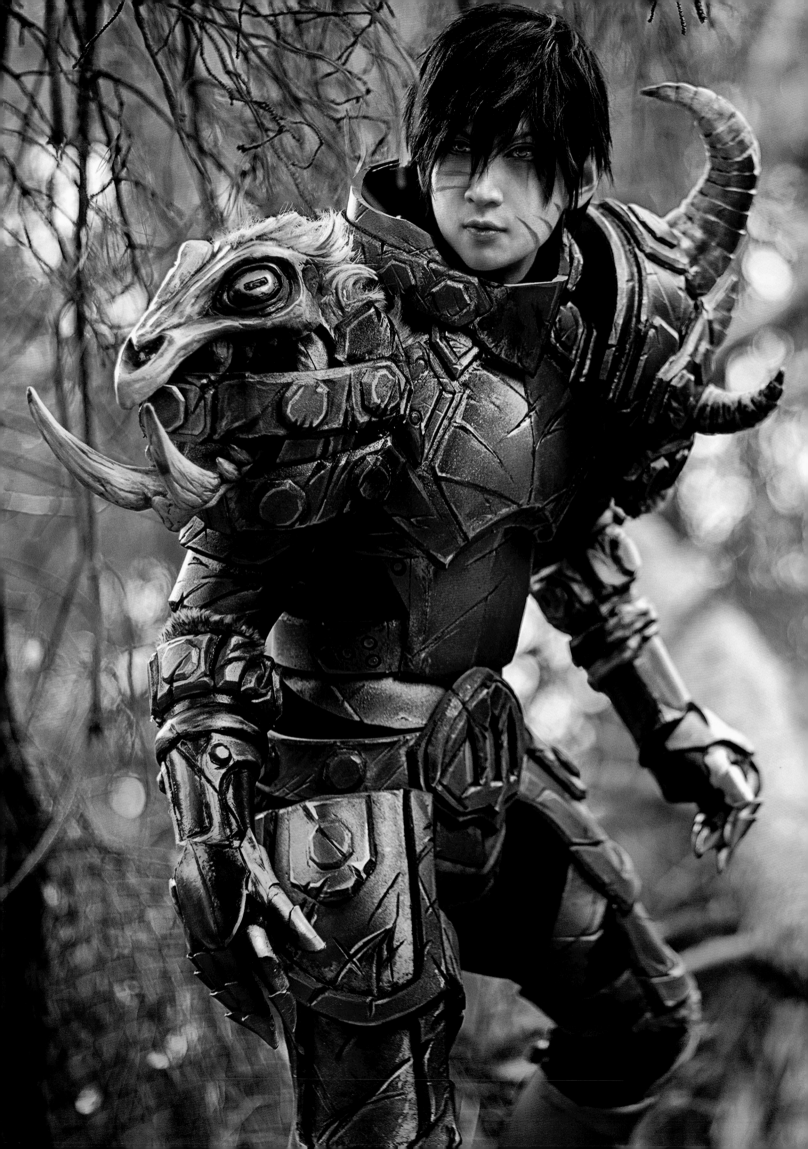

**OKAGEO COSPLAY ▪**
GRIEVOUS GLADIATOR'S
PLATE ARMOR
*Eric Ng a.k.a. Bigwhitebazooka
Photography*

"I love to be able to show the true character-
istics of a character through their emotions
in any image that I create, especially with the
usage of mood and colors that can elevate a
costume to be larger than life."
—*Eric Ng a.k.a. Bigwhitebazooka Photography*

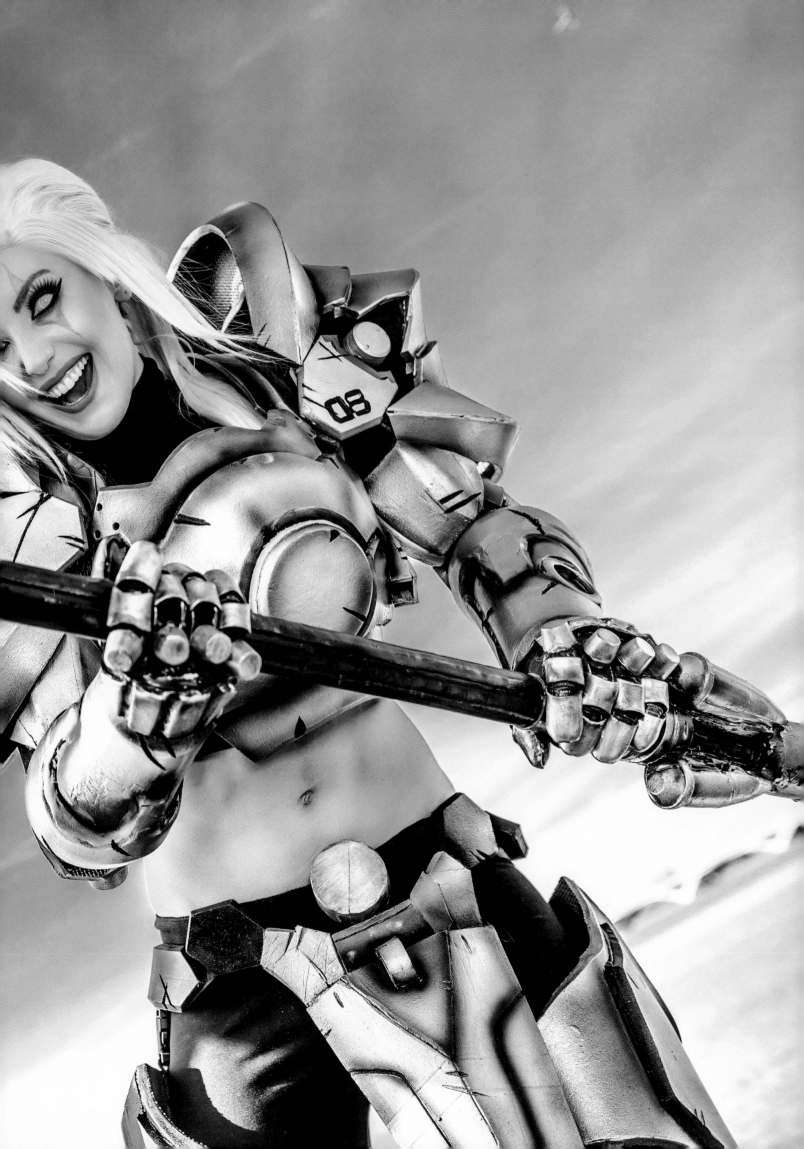

**MACKENZIE SMITH & CHRIS EYLES ·**
ALLERIA & TURALYON
*Photographer: Benjamin Koelewijn*
*Costume by Henchmen Studios*

"The social experience of going to conventions and meeting tons of new people has always been one of the biggest draws for me. I've met so many incredible people and made lasting friendships with people all over the world because of cosplay—I honestly couldn't imagine how different my life would be otherwise!"
—*Jordan Duncan of Henchmen Studios*

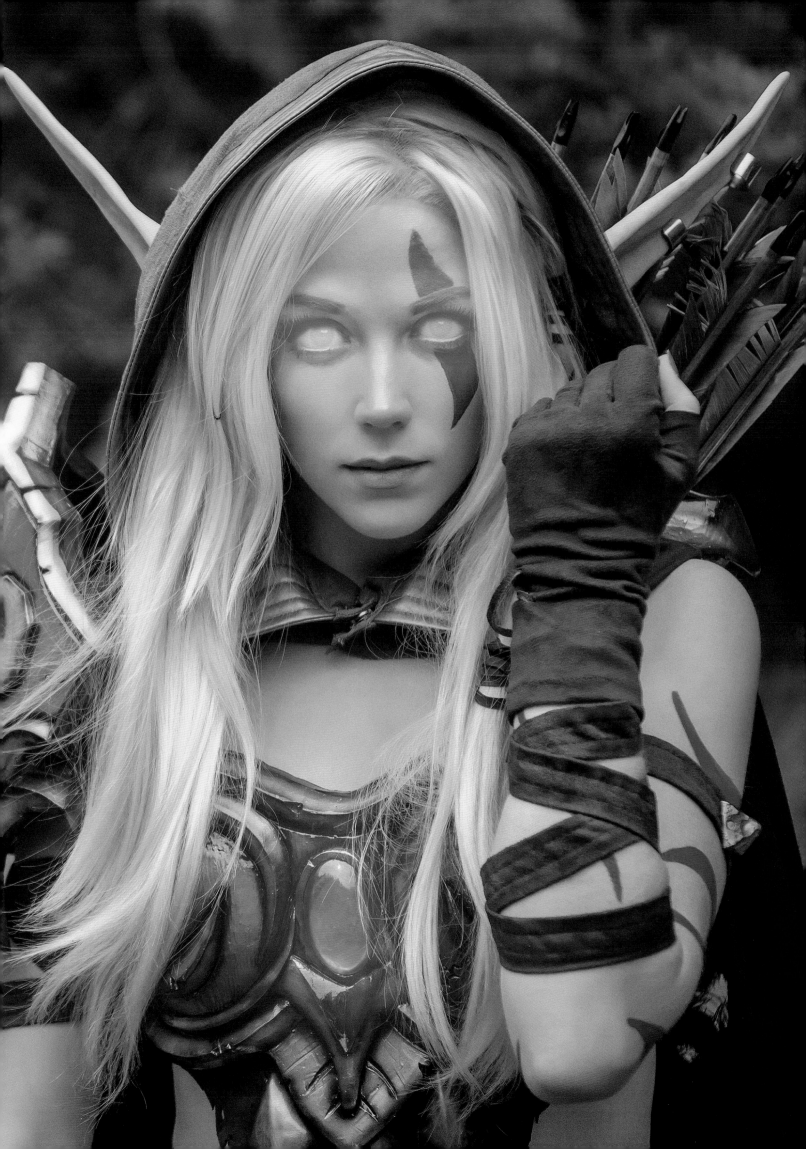

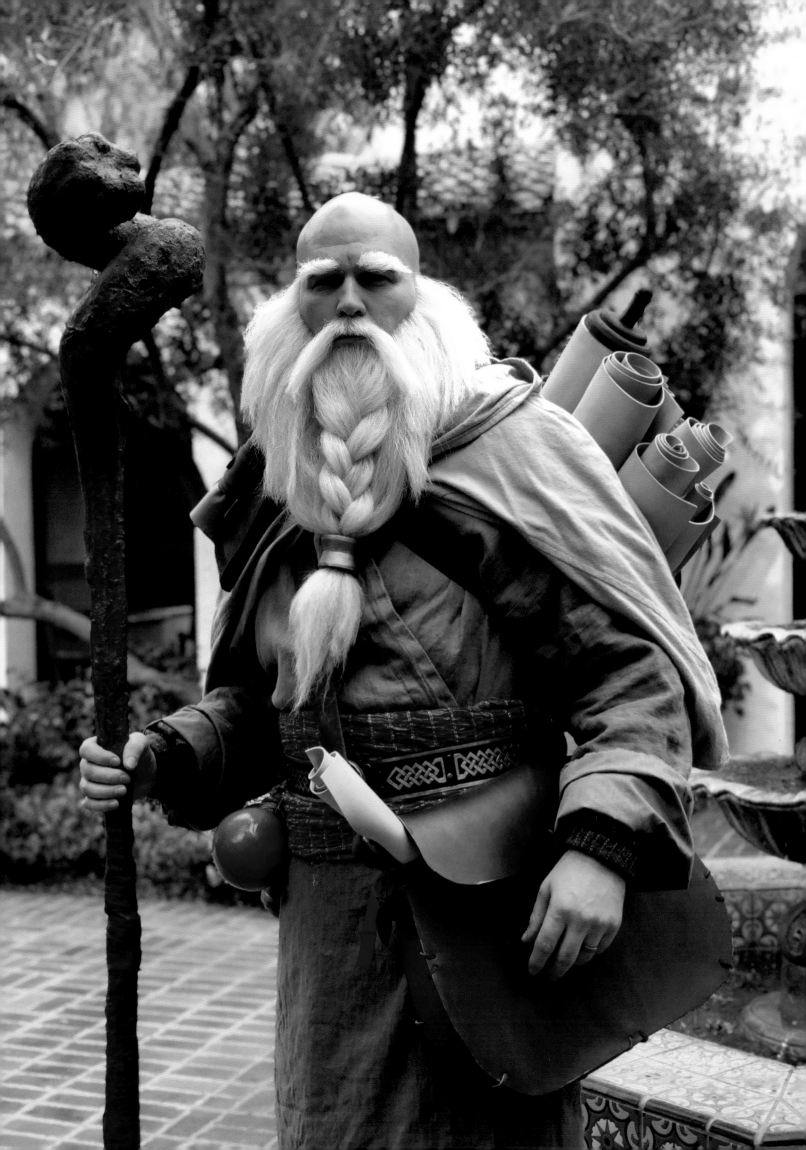

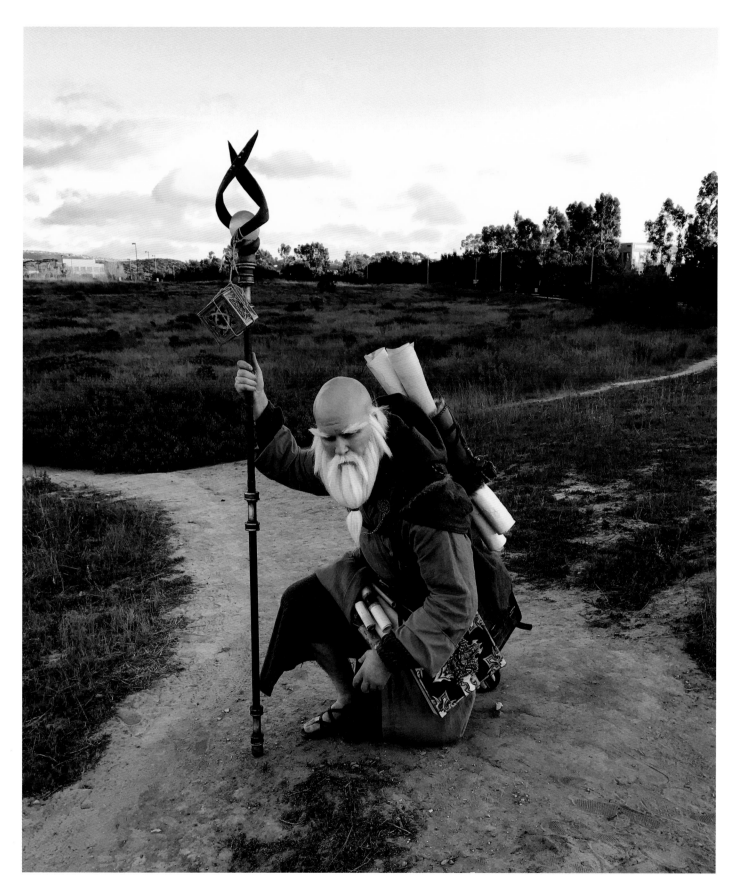

## MICHAEL CASTEEL ▪ DECKARD CAIN
*Photographer: Brandi Cooper*

"Every year we get to go and meet people from around the world who are passionate about the same things we are. Seeing people get excited about what you've made and getting to see other people's incredible work is just so fulfilling. And everyone, from other cosplayers to employees to con goers, has been incredibly friendly, helpful, and supportive on our cosplay journey, and there just really isn't any other experience like it."
—Michael & Ashley Casteel a.k.a. SteelBarrel Cosplay

**NIKKI LEE COSPLAY** • GENJI
*Photographer: David Ngo a.k.a. DTJAAAM*

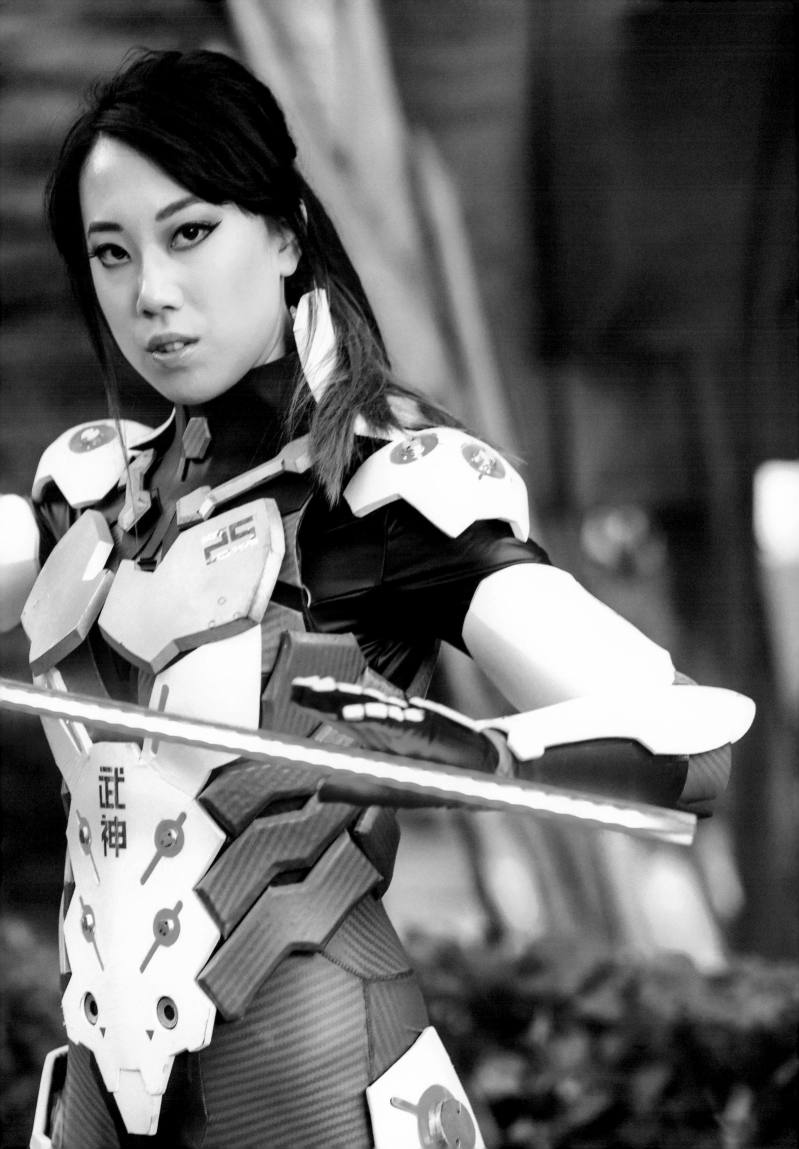

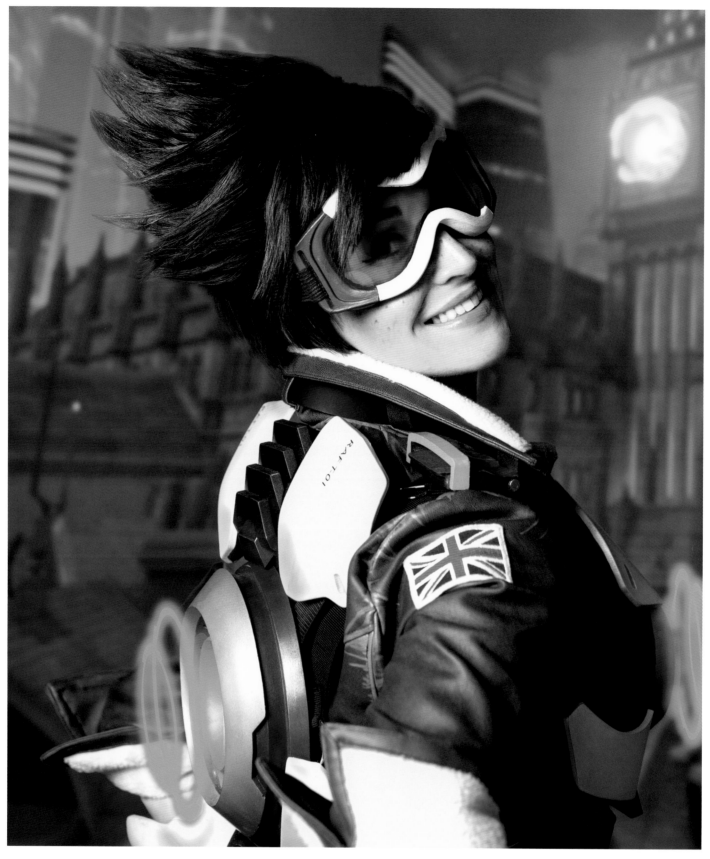

**MEGAN EMBREE A.K.A. VOLDE COSPLAY • TRACER**
*Photographer: Pablo Lloreda*

"Many of the cosplayers that I have met through BlizzCon have become my extended family. The relationships I've built there, specifically in costume, are astonishing to me, and I would not be who I am today if I hadn't started cosplaying all those years ago."
—*Megan Embree a.k.a. Volde Cosplay*

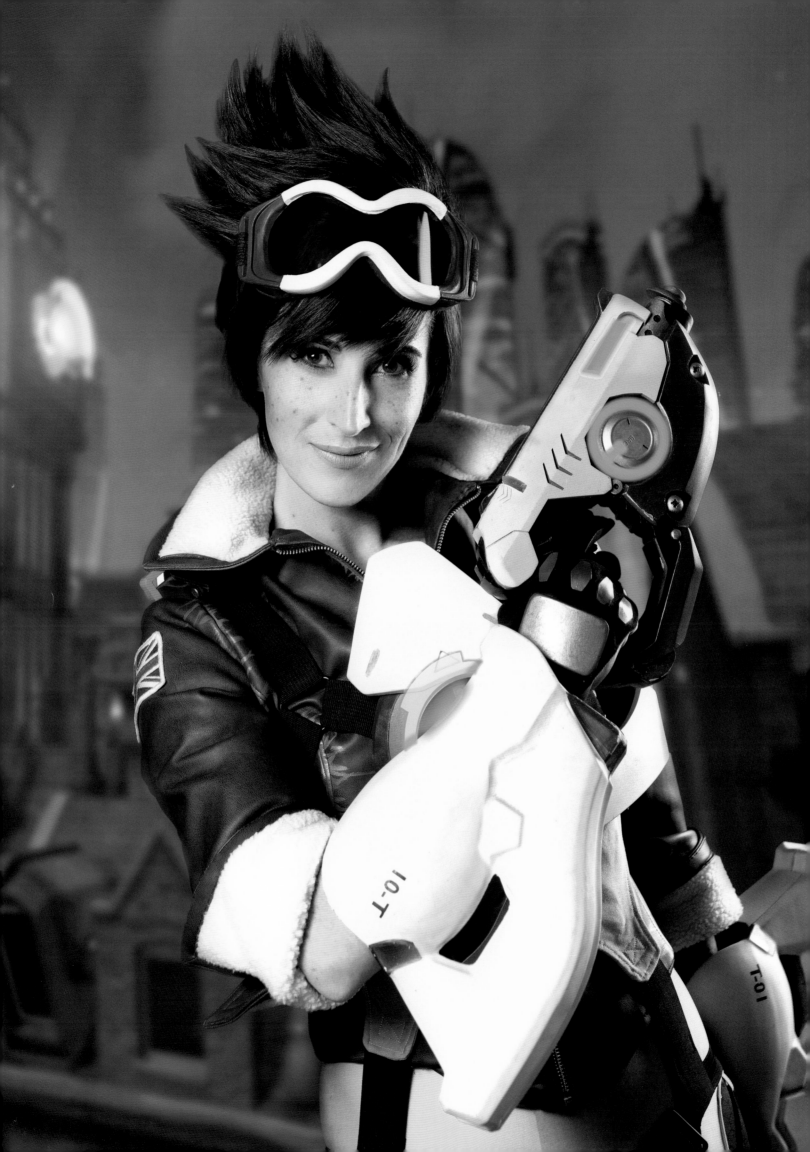

**SVETLANA QUINDT A.K.A. KAMUI COSPLAY** • TROLL DRUID
*Photographer: Kamui Cosplay*

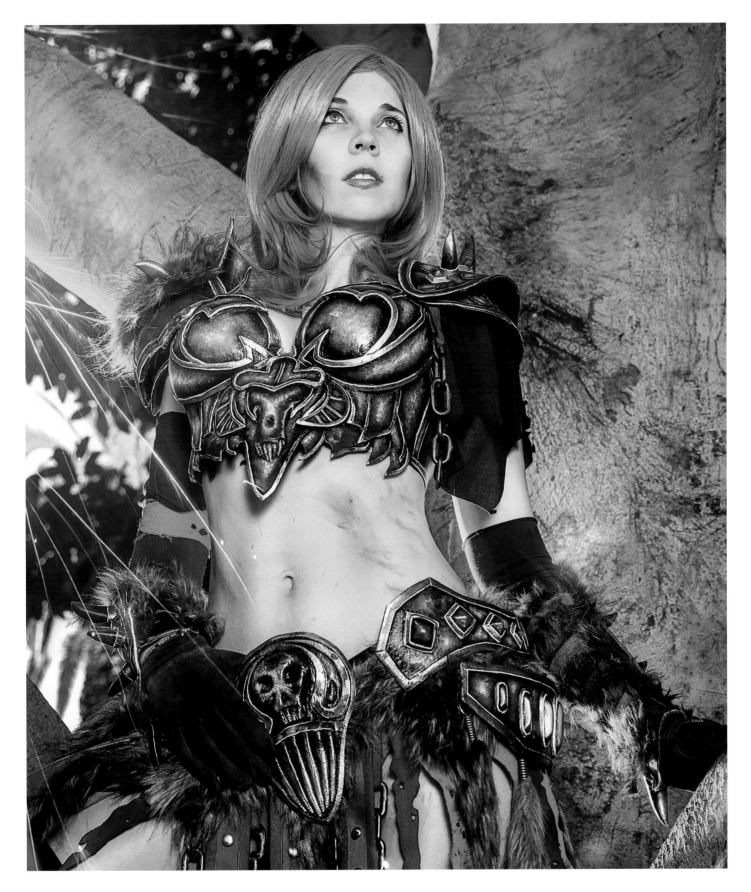

## SVETLANA QUINDT A.K.A. KAMUI COSPLAY • *DIABLO III* BARBARIAN
*Photographer: Darshelle Stevens*

"My most interesting BlizzCon was in 2009, which was also the very first time I've ever been to the United States. I actually didn't speak or understand a single word of English back then, so the whole trip was a crazy adventure. I signed up for as many contests as possible (the Art, Dance, and Costume Contests) and wanted to be extra early at the convention floor. Despite not understanding anybody and having a few weird culture shocking moments, I had incredible fun. But I was actually so tired at the end of the day that I forgot I even went on stage. Complete blank. The only proof that I made it was a video of me dancing as a night elf on YouTube."
—*Svetlana Quindt a.k.a. Kamui Cosplay*

**CHRISTINA MIKKONEN**
**A.K.A. ZERINA** ▪ *DIABLO III* MONK
*Photographer: Tim Vo*

"I've met so many awesome people through
cosplay, and you have an instant bond with
people that you see cosplaying from a game that
you love."
—*Christina Mikkonen a.k.a. Zerina*

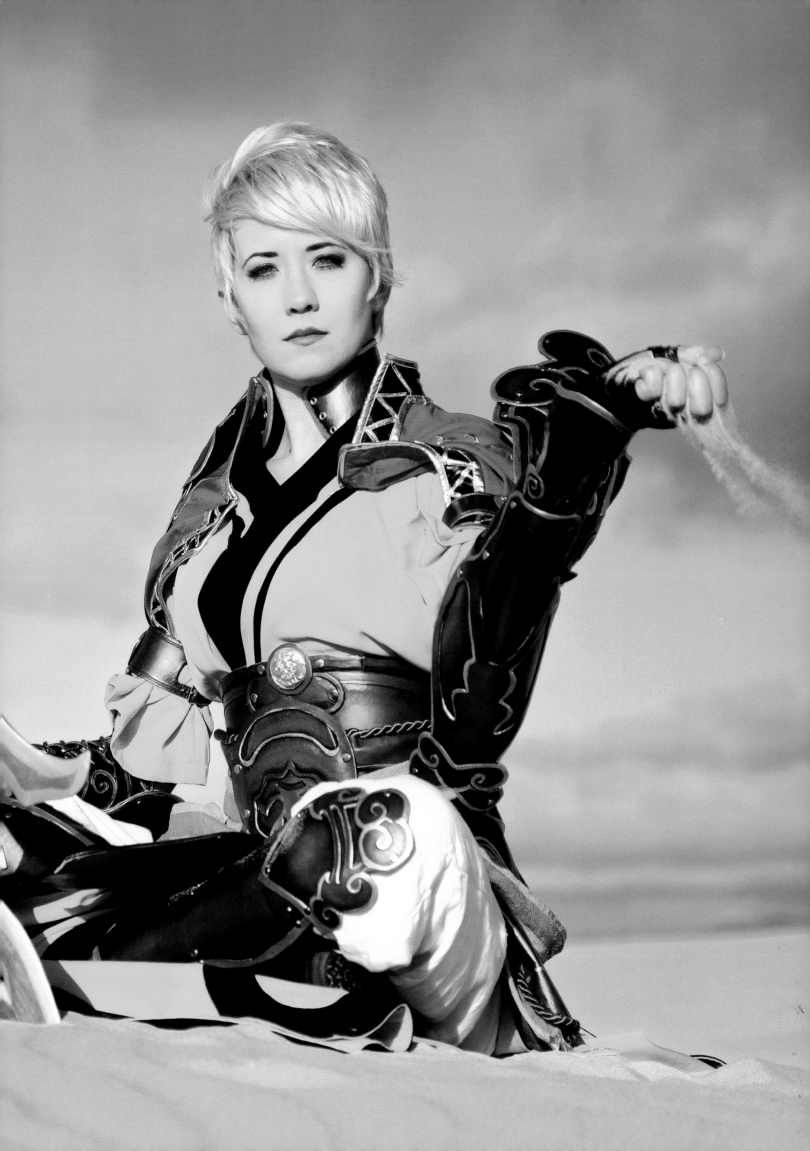

**MONIKA LEE • *DIABLO III* DEMON HUNTER**
*Photographer: Carlos Guerrero*

"Cosplay is a huge creative outlet for me. It's very rewarding
to create something, then look at it and say, 'I made that!'"
—Monika Lee

**KAY BEAR · *DIABLO III* DEMON HUNTER**
Photographer: Carlos Guerrero

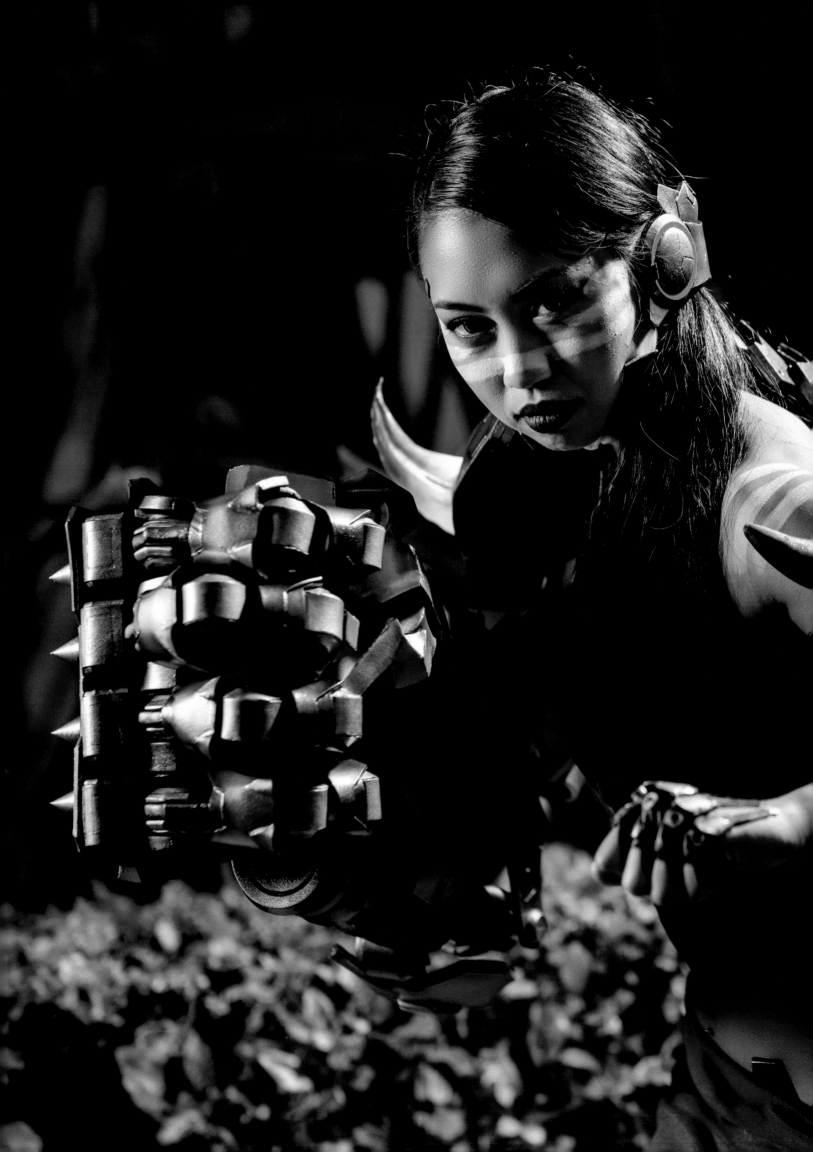

**KANOSCOS** ▪ DOOMFIST
*Photographer: Gil Riego*

**KEEGAN ROCKLEY · DOOMFIST**
*Photographer: Long Ty*
*Costume by Henchmen Studios*

"It's always an incredible feeling when people are excited to see a character you've brought to life through cosplay. There's a shared passion and love for a character or story that can connect people with completely different backgrounds, so it's always exciting to meet people who feel the same attachment to that world."
—*Jordan Duncan of Henchmen Studios*

CAVIER BLEU • DOOMFIST
Photographer: Carlos Guerrero, Costume by Henchmen Studios

**PIXELPANTZ** ▪ *DIABLO III* CRUSADER
*Photographer: Alec Rawlings*

"I have cosplay to thank for my dearest friends. If I had never cosplayed or gone to the events I have, then I wouldn't have met so many amazing people. Cosplay can connect us with people from all over, just like the games we play. I can even say BlizzCon in particular has connected me with some of my closest friends."
—PixelPantz

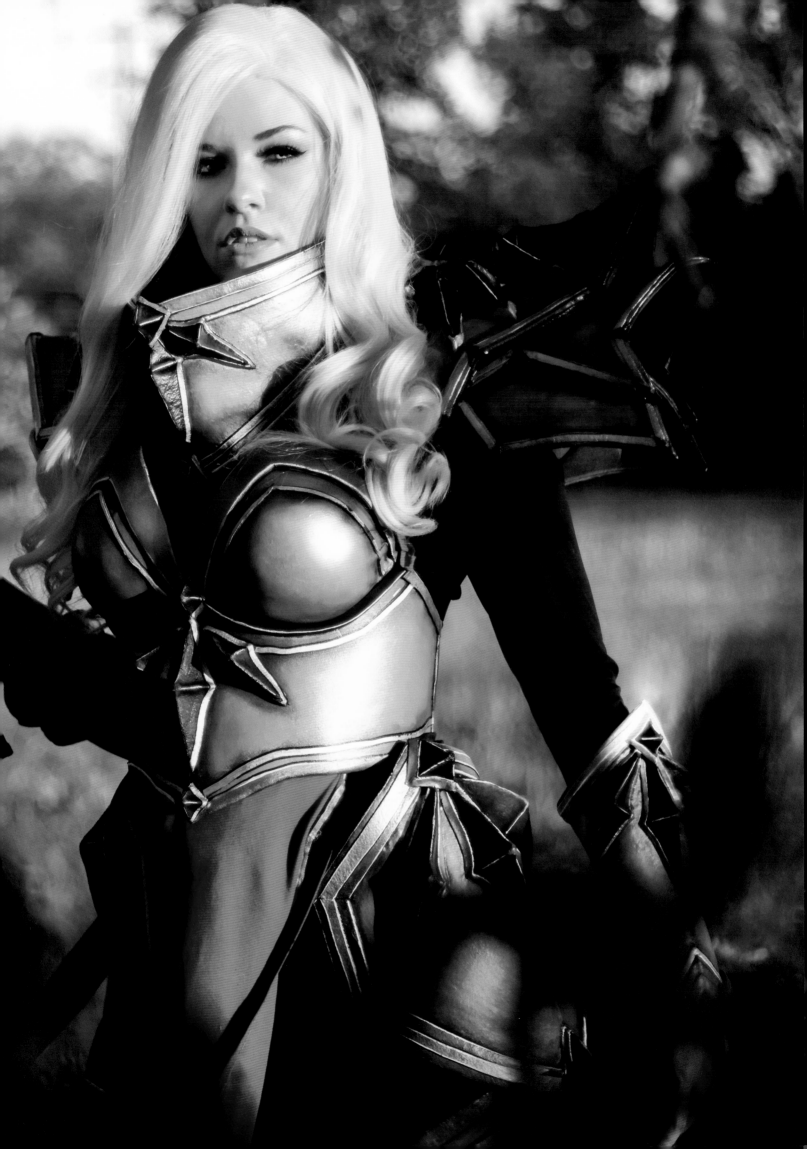

**SARAH SPURGIN** ▪ JUNKRAT
*Photographer: Tim Vo*

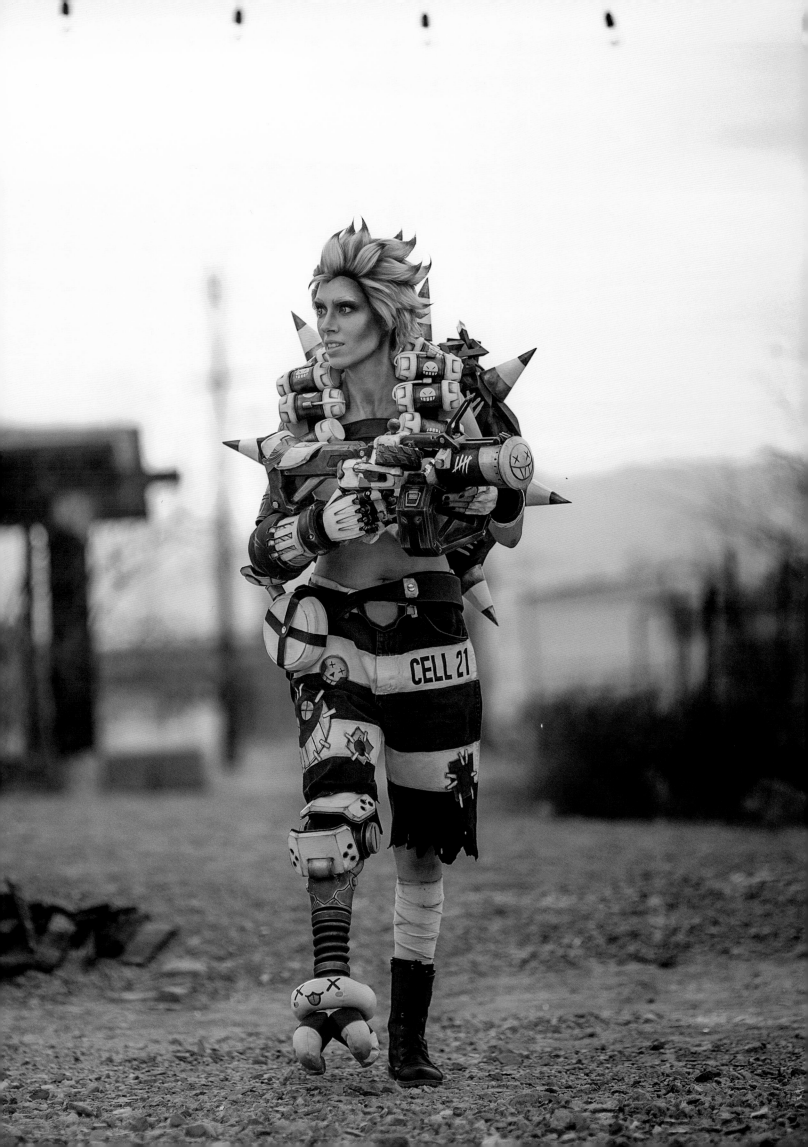

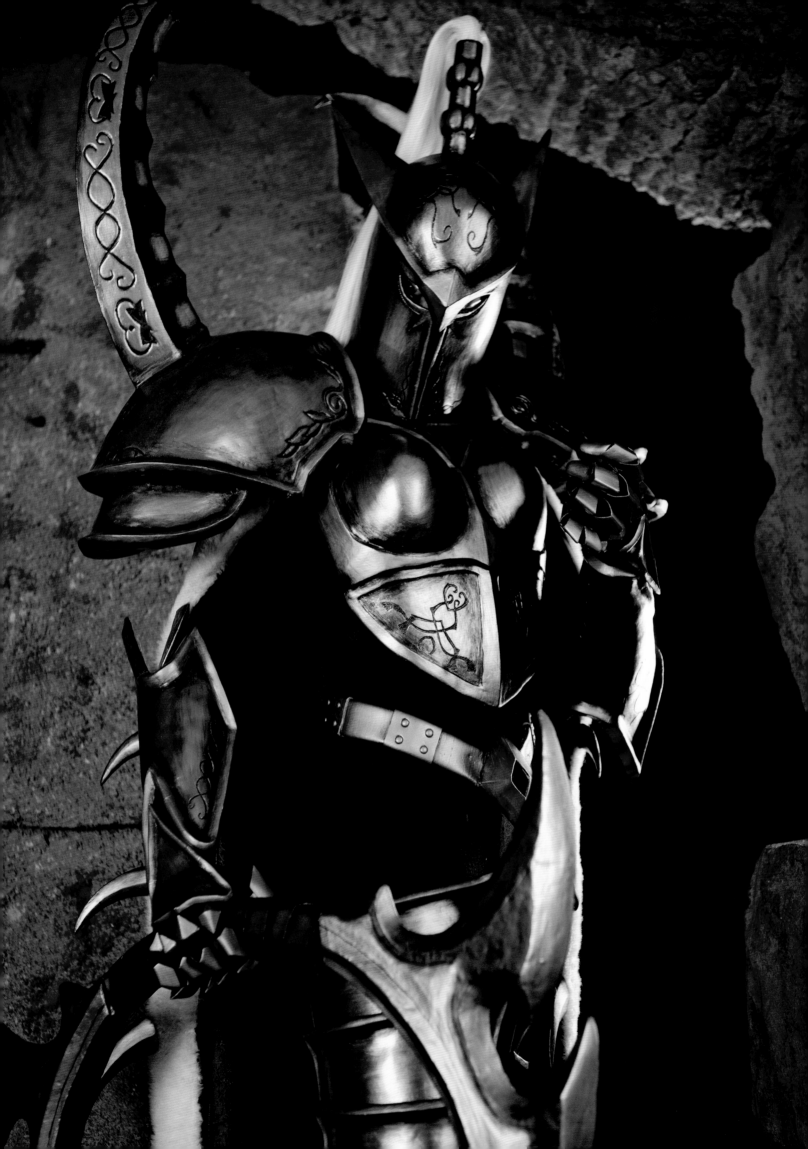

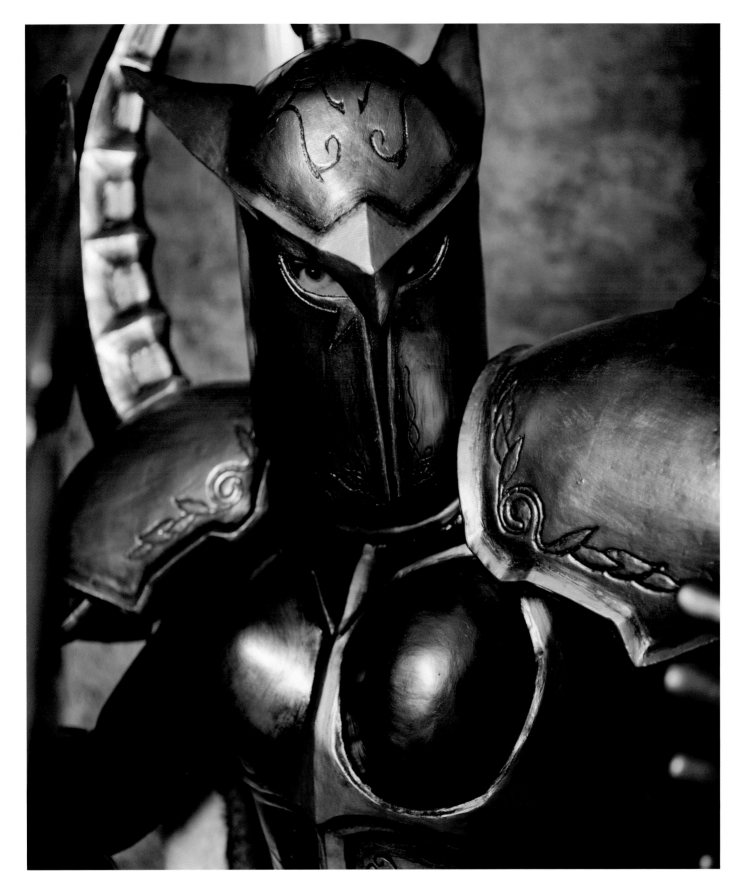

**MARY BOOTH** ▪ MAIEV
*Photographer: Tom Hicks*

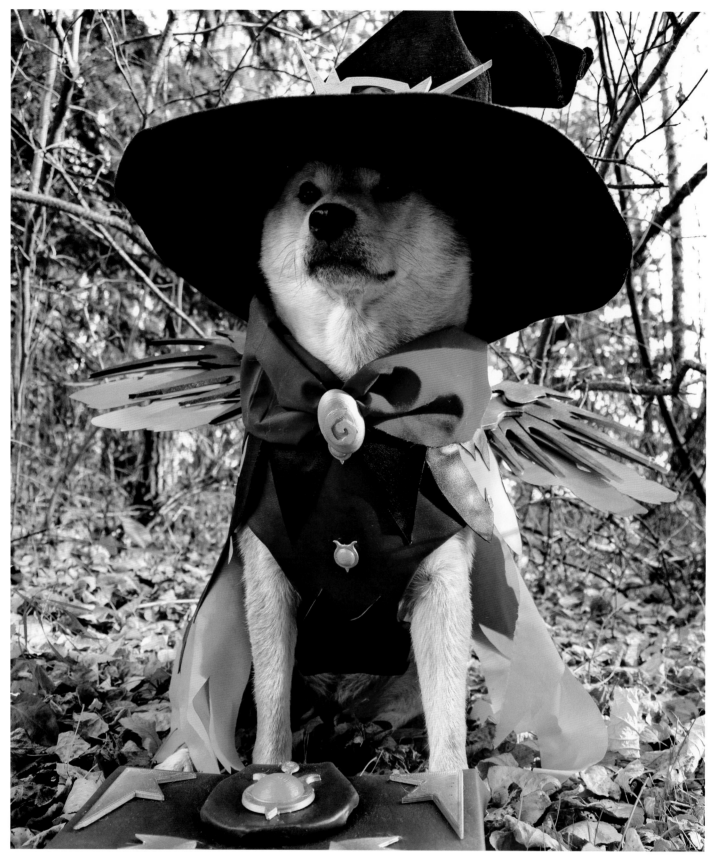

## VOX ▪ WITCH MERCY
*Photographer: Taylor Creighton & Vox a.k.a. Outside_the_Vox*

"Vox, my four-year-old Shiba Inu, and I, have kept cosplaying because it is such a great way to express creativity, and her followers absolutely love seeing her dressed up as cute characters. If Vox in her little cosplay can brighten even one person's day, it's worth it for me."
—Taylor Creighton & Vox a.k.a. Outside_the_Vox

VOX · D.VA
Photographer: Taylor Creighton & Vox a.k.a. Outside_the_Vox

**VOX ▪ ARTHAS**

*Photographer: Taylor Creighton & Vox a.k.a. Outside_the_Vox*

"I usually make a little sketch of Vox in costume so I can get an idea of how things
need to be sized. Then I make her a little vest and start putting things on it bit by bit!"
—*Taylor Creighton & Vox a.k.a. Outside_the_Vox*

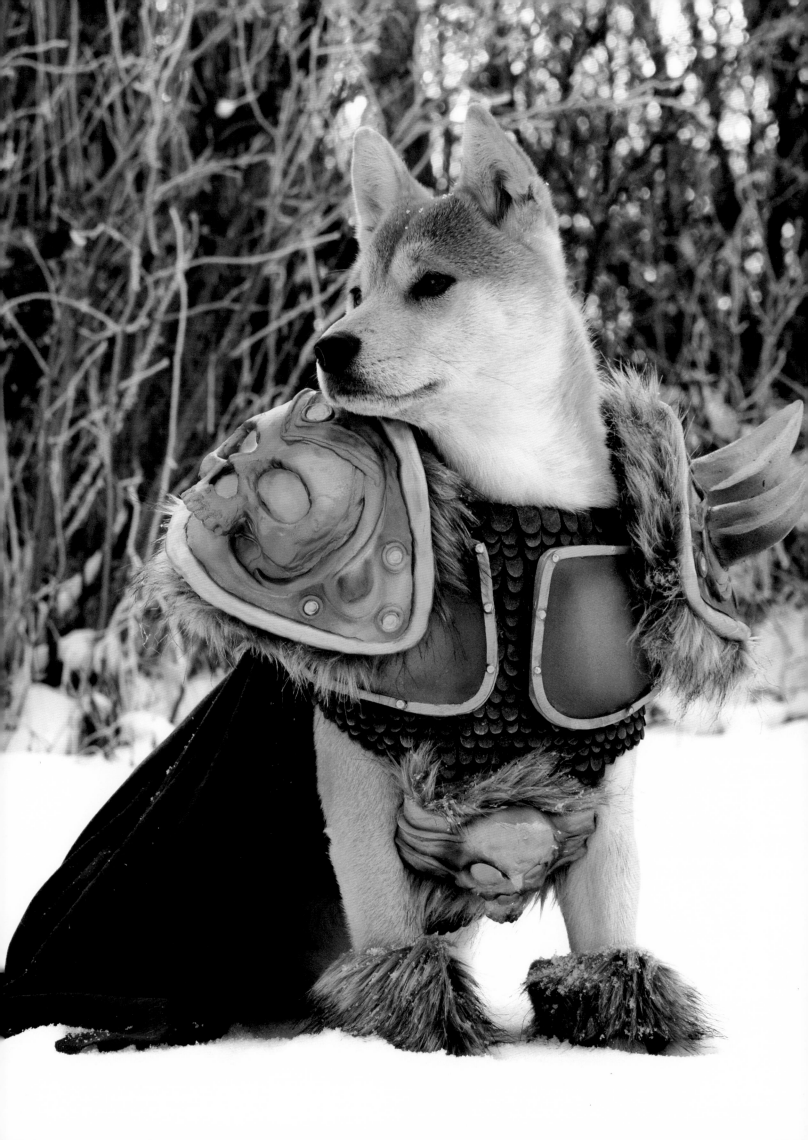

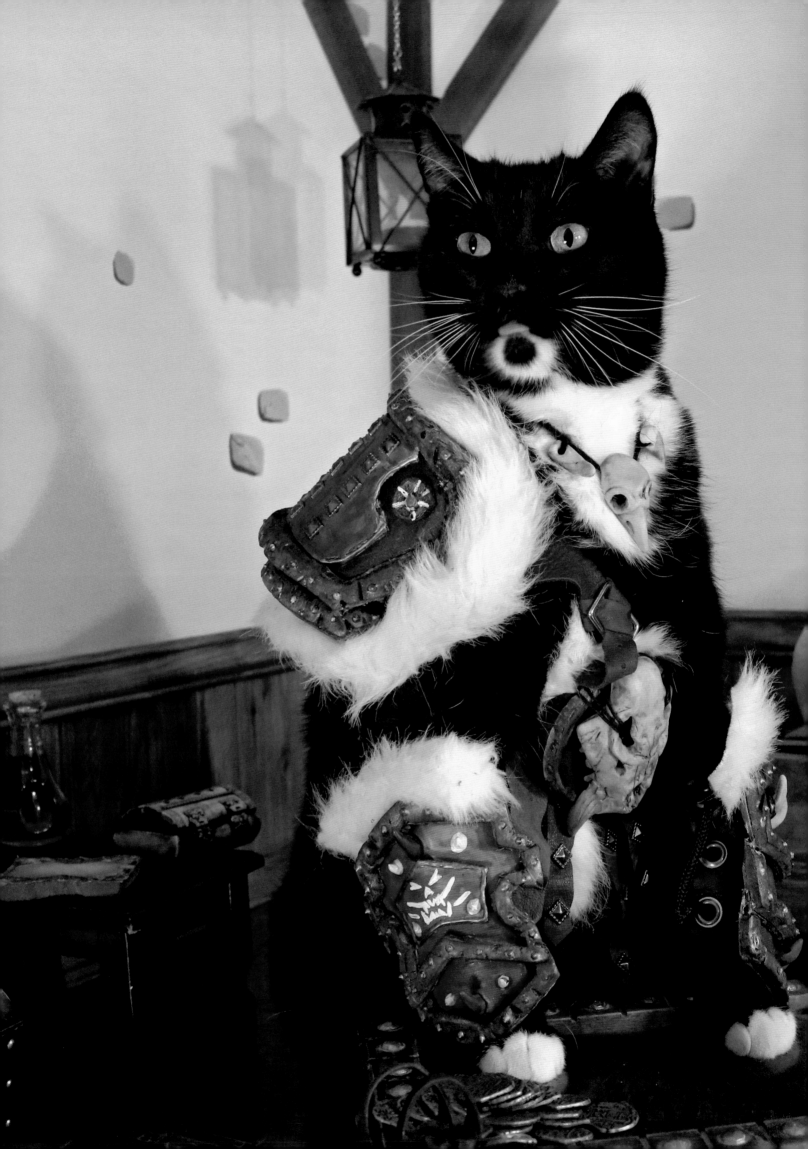

**FAWKES** ▪
GROMMASH HELLSCREAM
*Photographer: Cat Cosplay*

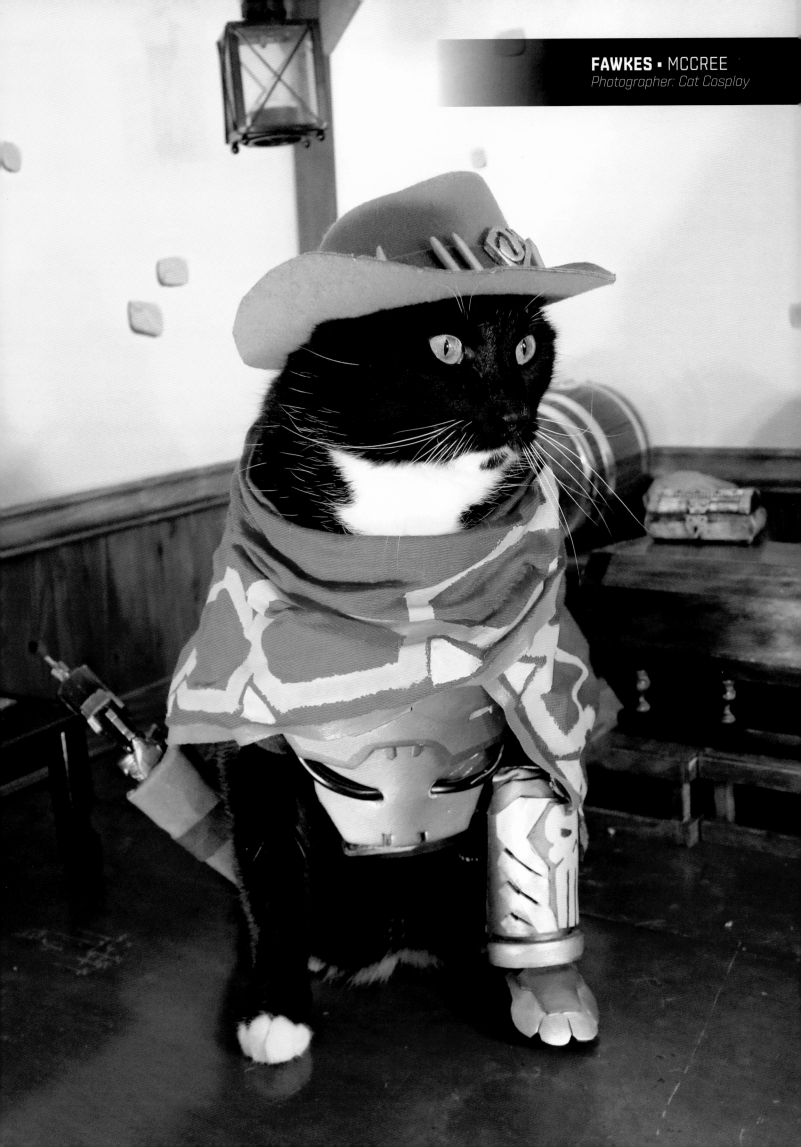

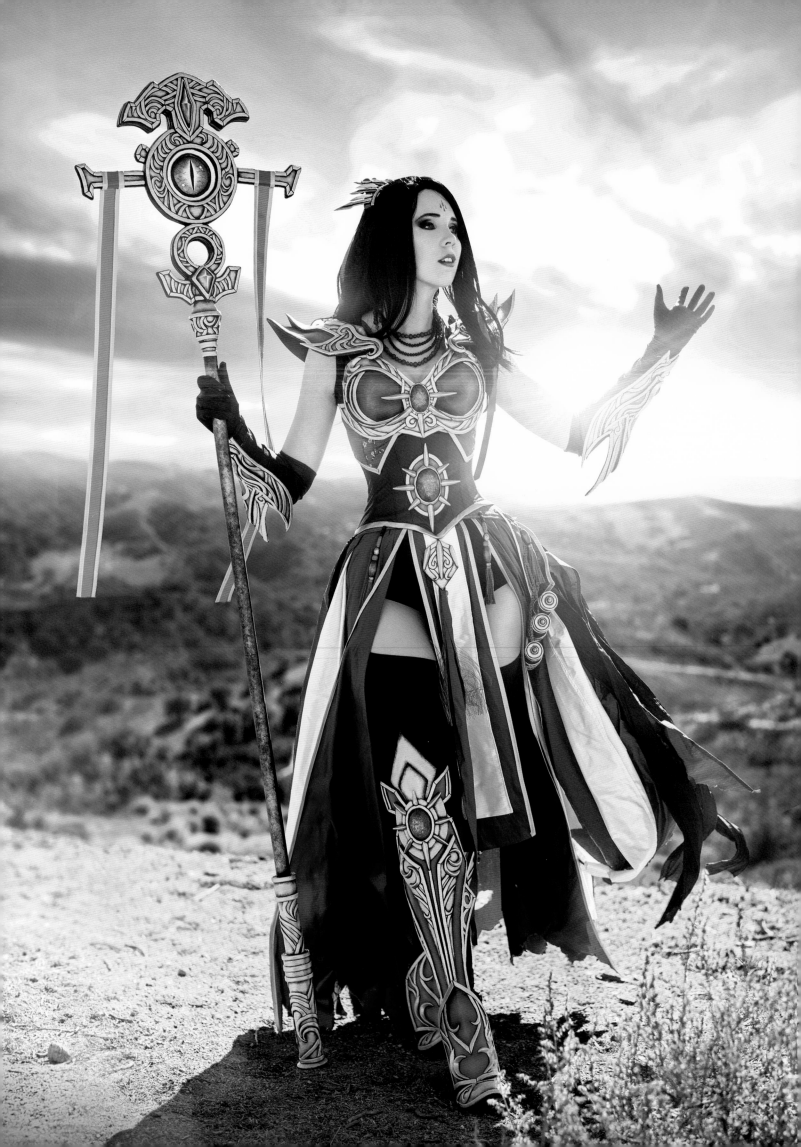

**SVETLANA QUINDT A.K.A.
KAMUI COSPLAY** • *DIABLO III*
WIZARD
*Photographer: Kamui Cosplay*

"I might not need many cosplay skills for my
everyday life, but it clearly helped me to shape
my personality in a positive way. I was very
shy and had no self-confidence, was not able
to talk in front of my school class, and was
generally not a very happy child."
—*Svetlana Quindt a.k.a. Kamui Cosplay*

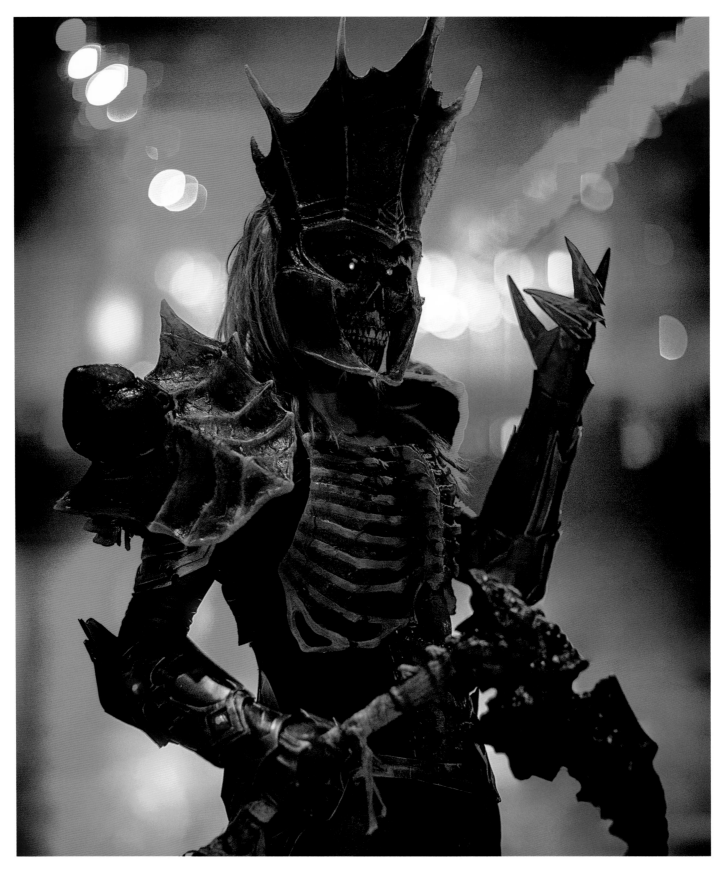

## DANA HOLMES-MCGUIRE & COURTNEY HOLMES
## A.K.A. EGG SISTERS COSPLAY • TRAGOUL'S AVATAR
*Eric Ng a.k.a. Bigwhitebazooka Photography*

"With cosplay, it feels like there's no end to the new things we can learn and improve on as well as being introduced to new inspiring characters. It seems most makers get addicted to the process of outdoing themselves and trying new techniques that other cosplayers are using. We plan to keep making stuff well into our old lady years."
—*Dana Holmes-McGuire & Courtney Holmes a.k.a. Egg Sisters Cosplay*

**DANA HOLMES-MCGUIRE & COURTNEY HOLMES**
**A.K.A. EGG SISTERS COSPLAY** • TRAGOUL'S AVATAR
*Photographer: Tim Vo*

**NATALIA KOCHETKOVA**
**A.K.A. NARGA** ▪ TYRANDE
*Photographer: Kira*

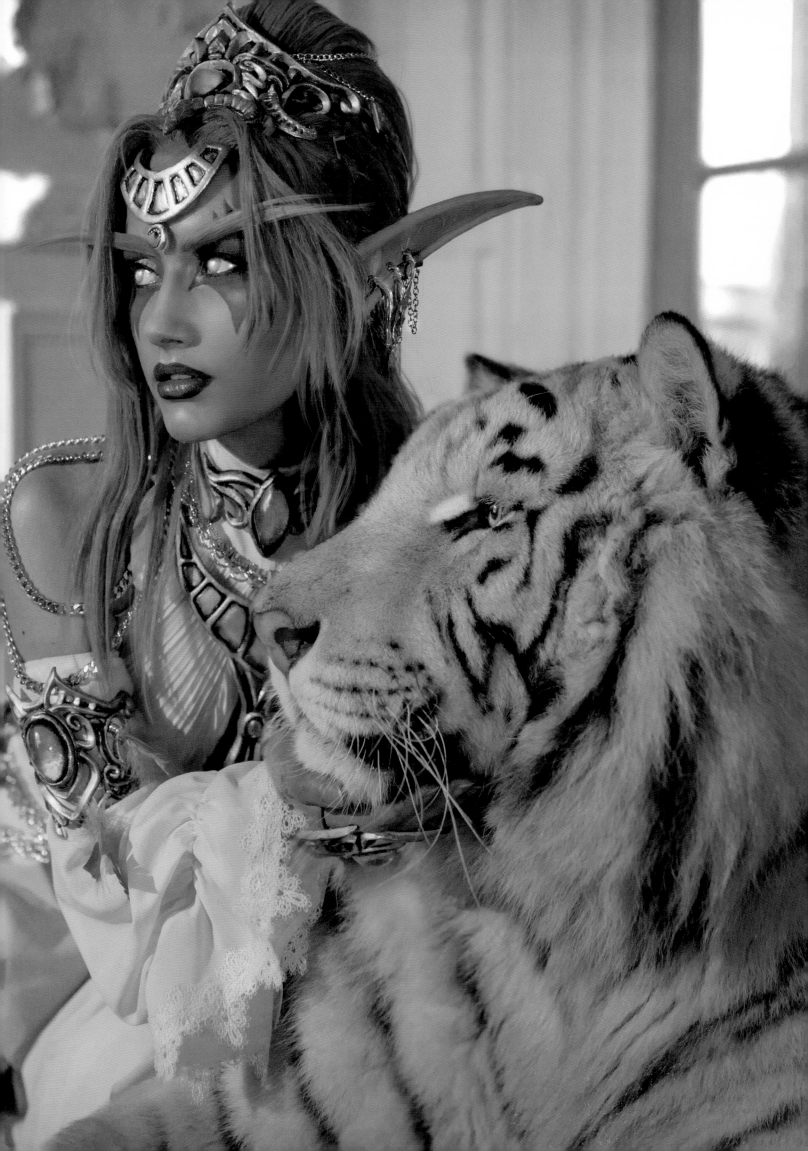

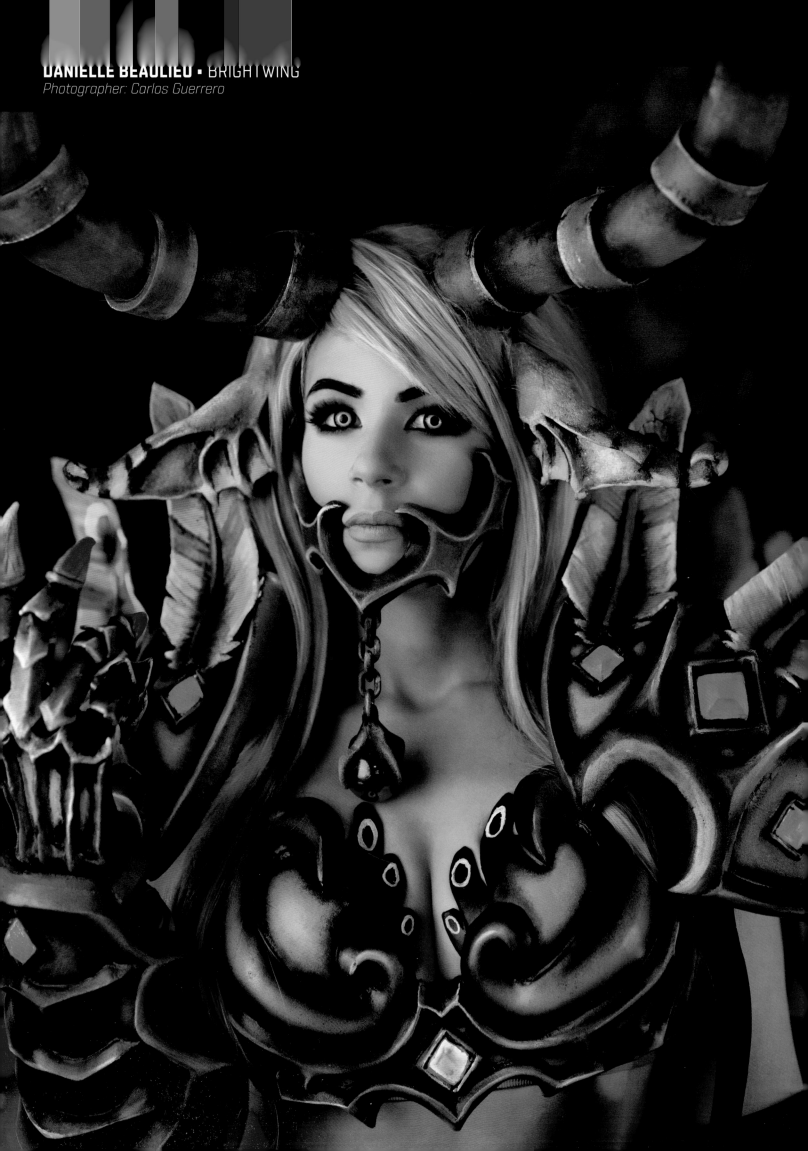

**DANIELLE BEAULIEU** · BLOOD ELF VENGEFUL GLADIATOR
*Photographer: Carlos Guerrero*

## PIXELPANTZ ▪ ARTHAS
*Photographer: Alec Rawlings*

"I keep cosplaying because it is genuinely my
happy place. The people I get to meet and
the entire process from beginning to end is
so therapeutic for me. Even during the worst
times, when I'm stressed about finishing a
costume in time or I've failed miserably on
a piece, I'm still enjoying myself. I've gotten
burned-out before just from working on a
long-winded project, but I always go back."
—*PixelPantz*

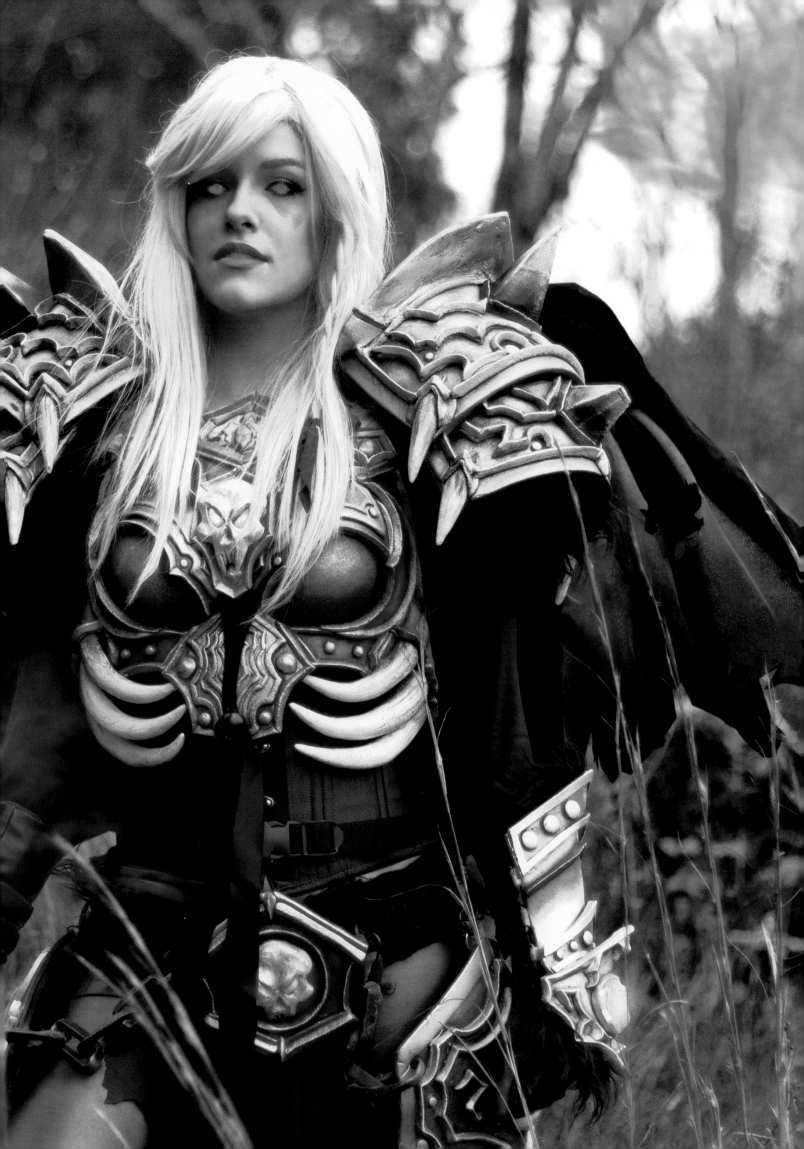

# Appendix:
# Behind the
# Curtain

**SARA MCMUNN**
**A.K.A. C'EST LA SARA ·**
*DIABLO III* FIREBIRD WIZARD
*Photographer: Sara McMunn*
*a.k.a. C'est La Sara*

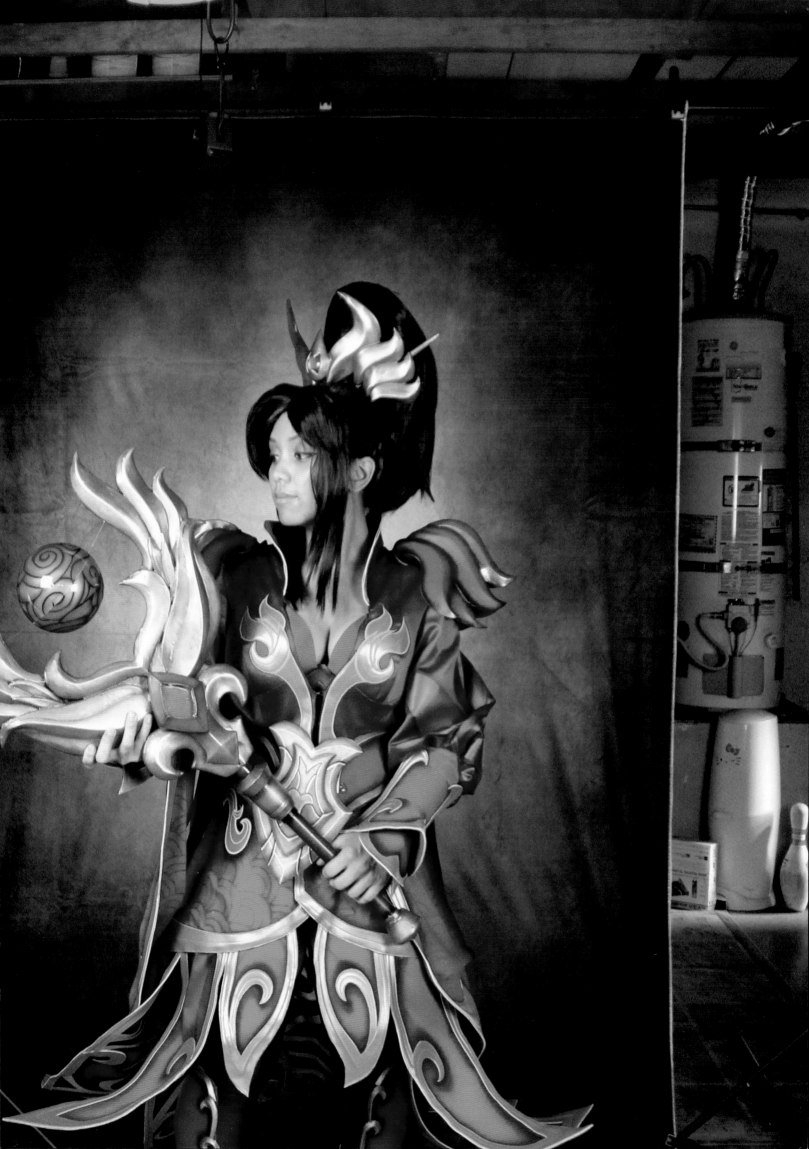

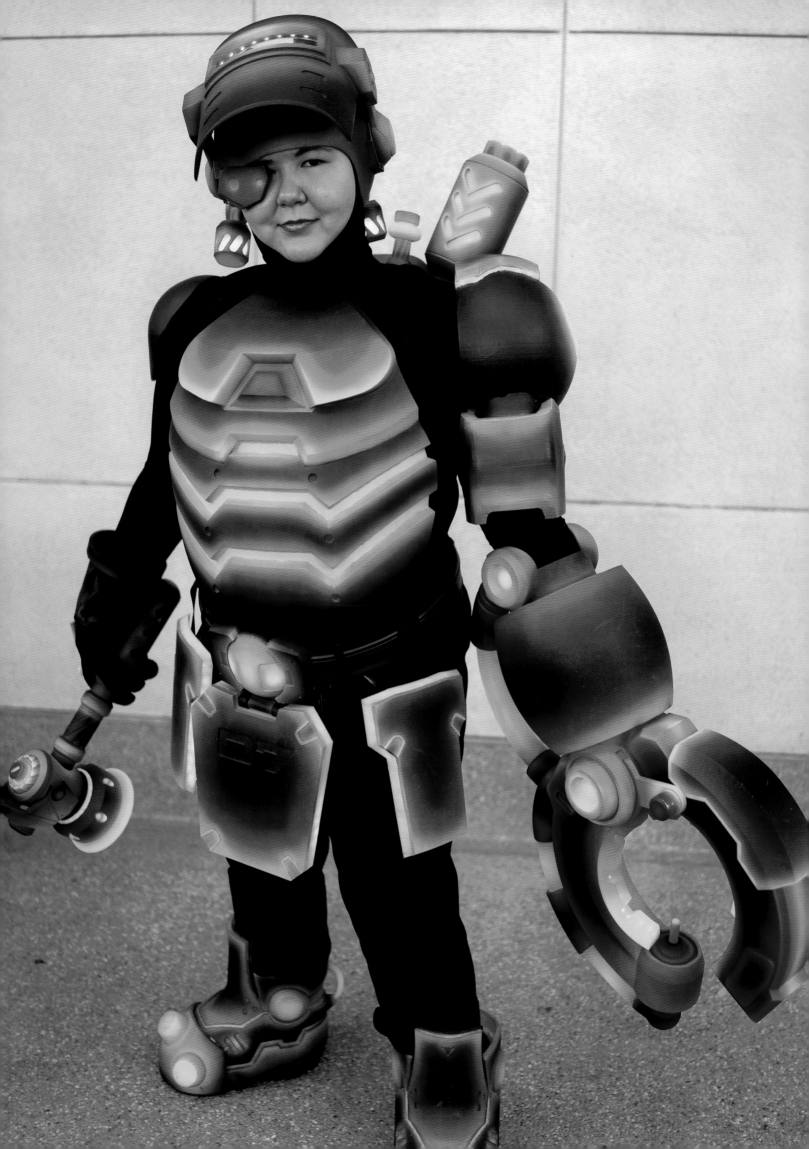

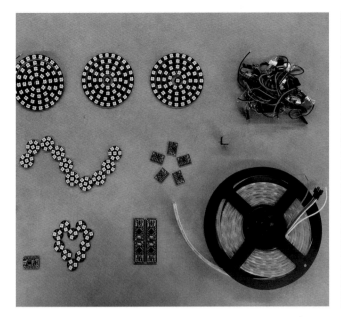

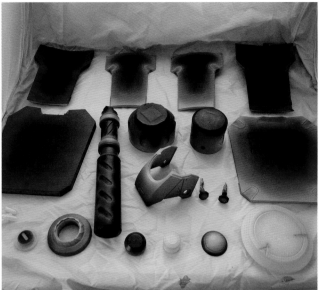

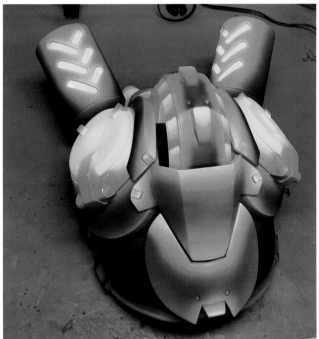

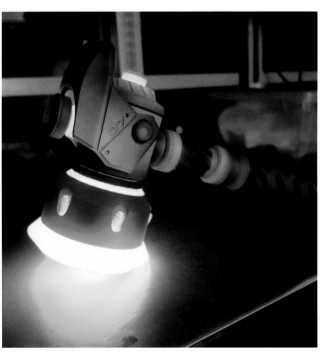

### ALINA GRANVILLE A.K.A. SPOON MAKES ▪ TORBJÖRN
*Photographer: Alina Granville a.k.a. Spoon Makes (main photo: Albert Ng)*

"The first questions I ask myself are scale, special effects, material? When I start a project, I make a rough sketch on top of a photo of me to get an idea how large each piece will be and determine how the proportions will work with my frame, while working side by side from a reference picture. Next, I determine all my goal special effects (lights, motion) and how they are triggered (button, motion triggered, remote, no trigger). It's super important to determine these early on since they might have very certain size-, weight-, material-, or structure-impacting constraints. From there I determine what material each part will be and will make some sketches how I think each piece will be designed and assembled. After this planning stage I can start building."
—*Alina Granville a.k.a. Spoon Makes*

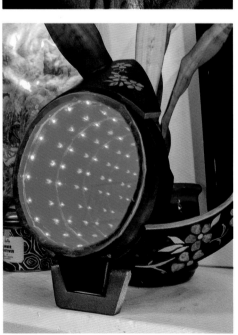

### TIGER LILY COSPLAY ▪ ROSE TRACER
*Photographer: Tiger Lily Cosplay (main photo: gamer_gent)*

"I normally don't make huge cosplays, so size restrictions don't really affect me. However, walking around a convention all day does force me to think about things I wouldn't normally think about. Something that weighs two pounds on your shoulders could end up hurting your back a lot after five hours. The crowds at a convention really make you think about whether you want to walk through them with pieces that stick out, such as wings. It is kind of scary to think that all that hard work you put into something could be easily broken by some stranger that accidentally bumps into you."
—Tiger Lily Cosplay

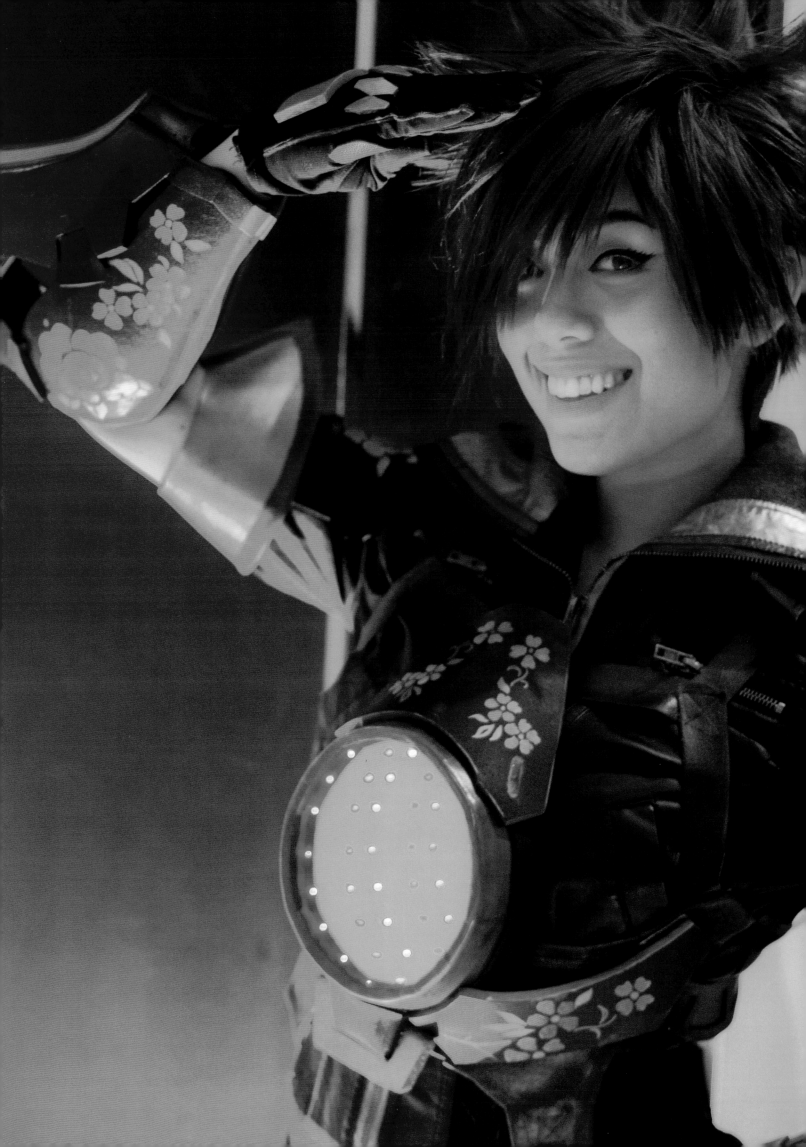

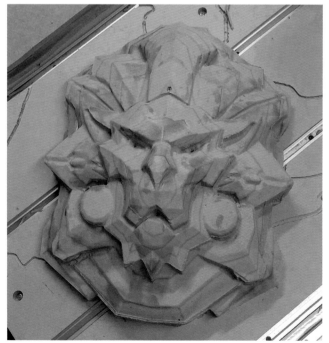

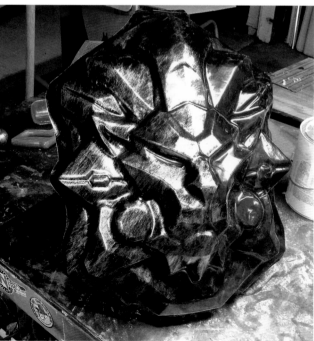

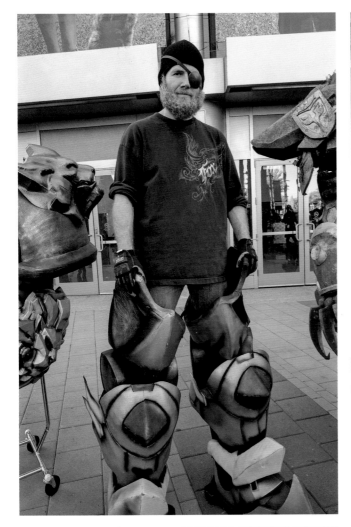

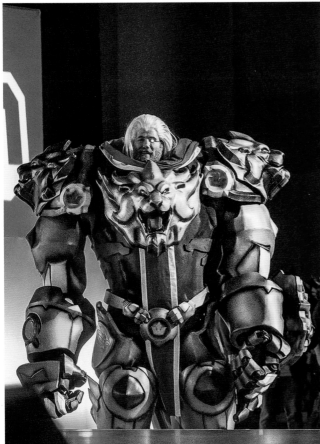

## CHAD HOKU A.K.A. HOKU PROPS ▪ LIONHARDT

*Photographer: Chad Hoku a.k.a. Hoku Props*
*(this page, bottom left photo: Jason J Kim Photography)*

"I went to school for 3-D Modeling and animation. I use those skills daily for my job; all my costumes and props are designed in 2-D and 3-D for mock-up and prototype."
—*Chad Hoku a.k.a. Hoku Props*

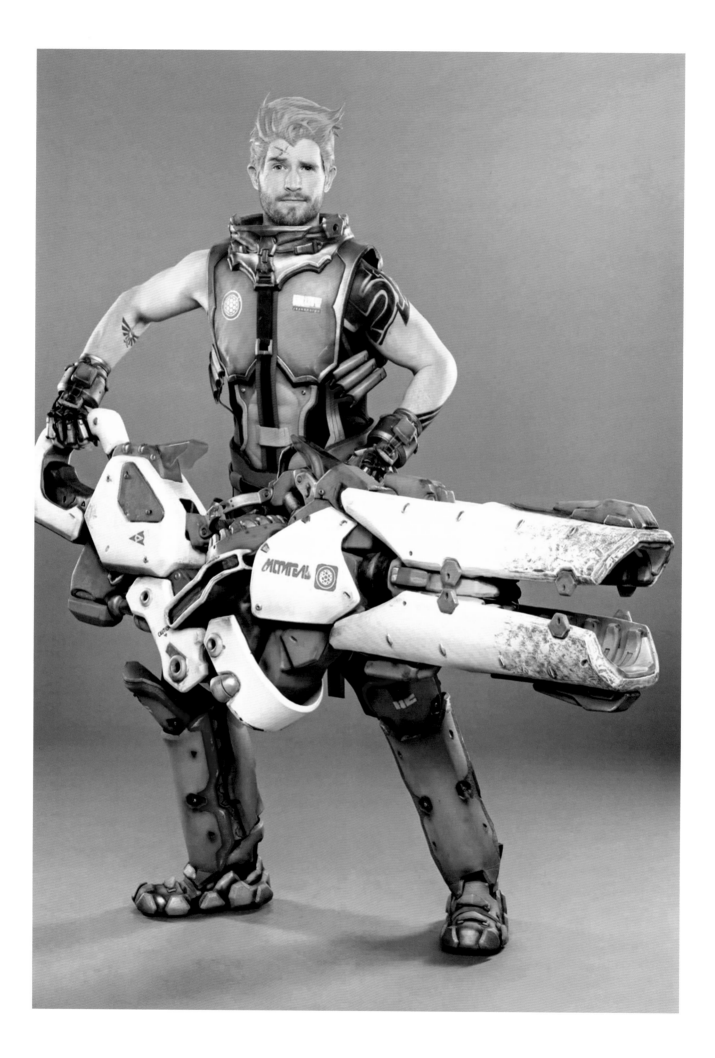

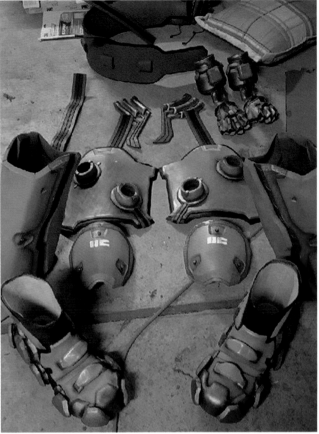

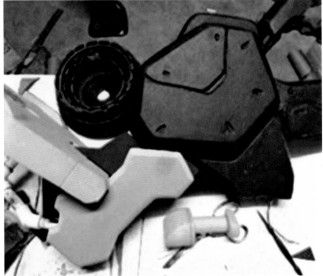

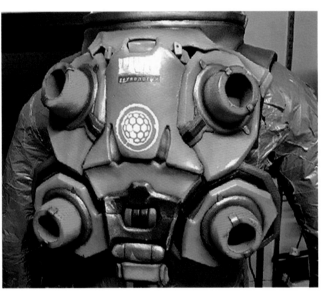

## DAVID O'ROURKE ▪ ZARYA

*Photographer: David O'Rourke*
*(main photo: Greg De Stefano)*

"I try to identify all of the individual pieces and details. Just about every design, no matter how intimidating and complex, breaks down to smaller shapes and details. By looking at the trees instead of the forest, I can start to get an idea for what the project is really going to take and plan small milestones for myself and my general approach."
—David O'Rourke

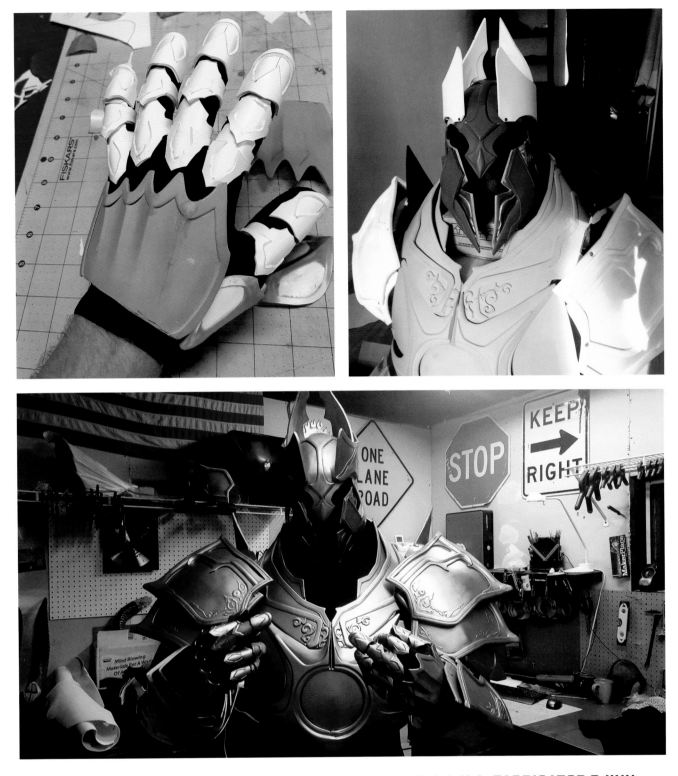

## CALEB NEAL A.K.A. FABRICATOR DJINN ▪ IMPERIUS

*Photographer: Fabricator Djinn (main photo: Eric Ng a.k.a. Bigwhitebazooka Photography)*

"My main material, Sintra (XPVC). It is a rigid plastic that is lightweight, cheap, extremely durable and smooth as marble. It has all the properties of EVA foam, with the rigidity of Styrene. It is a marvelous material. The trade-off being it is difficult to work with in comparison and the fumes from heating it are much nastier."
—Caleb Neal a.k.a. Fabricator Djinn

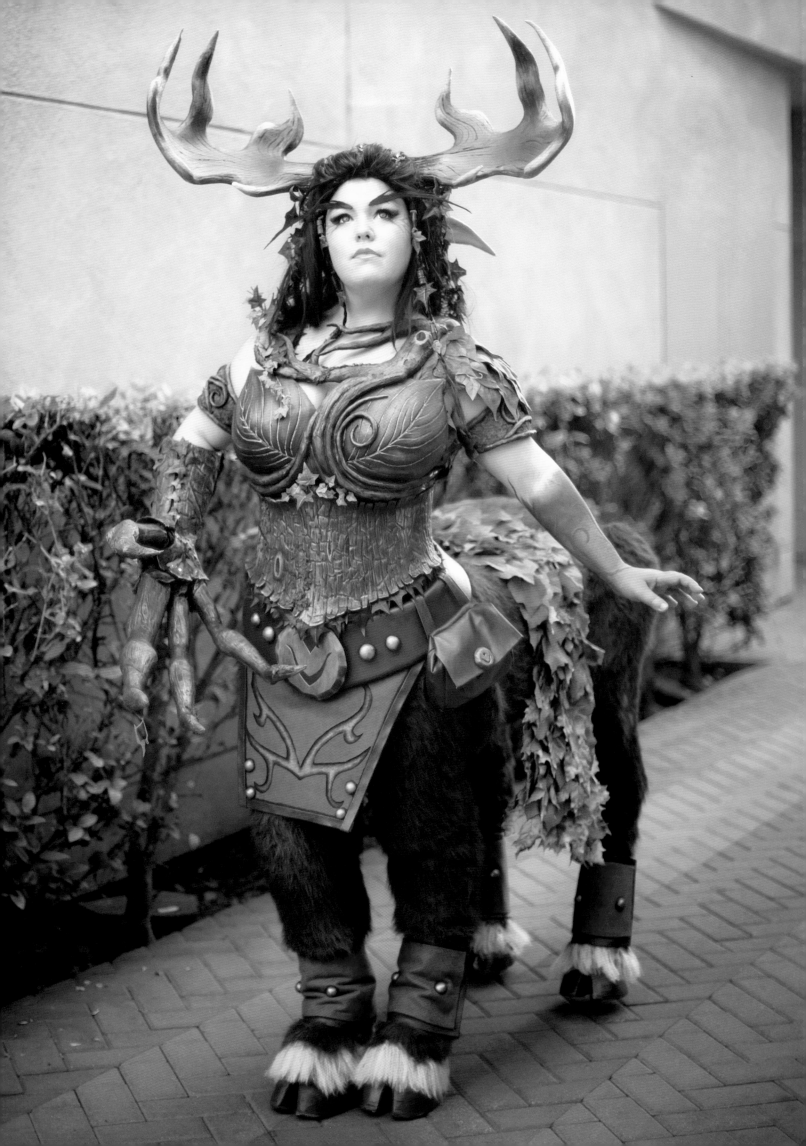

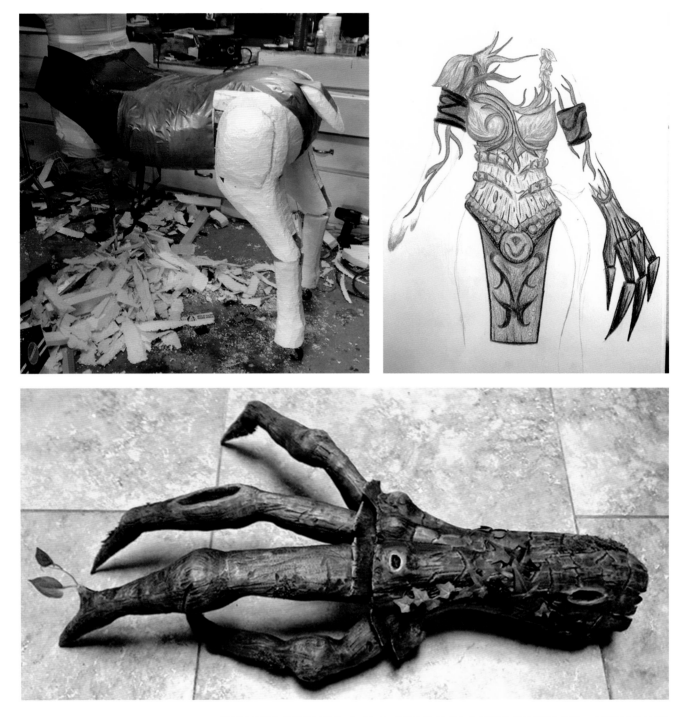

## KRISTIN STUMPP A.K.A. LITTLE SPARKZ COSPLAY · CENARIUS
*Photographer: Kristin Stumpp a.k.a. Little Sparkz*
*Cosplay (main photo: Beethy Photography)*

"After I've gotten many screenshots of the character from as many angles as possible, I will draw a flat drawing of the entire character so I can refine the shapes I see in the game to actual shapes I can make in real life. I will usually draw the cosplay from the front and back and also close-ups of individual pieces of armor. Then I'll move on to covering my dress form in plastic wrap and masking tape. It allows me to draw the forms from my flat character drawing on the form to get the base shapes and sizes of the armor. Then I cut the tape off and cut out the shapes to make flat patterns, which can be used for fabric or armor pieces."
—*Kristin Stumpp a.k.a. Little Sparkz Cosplay*

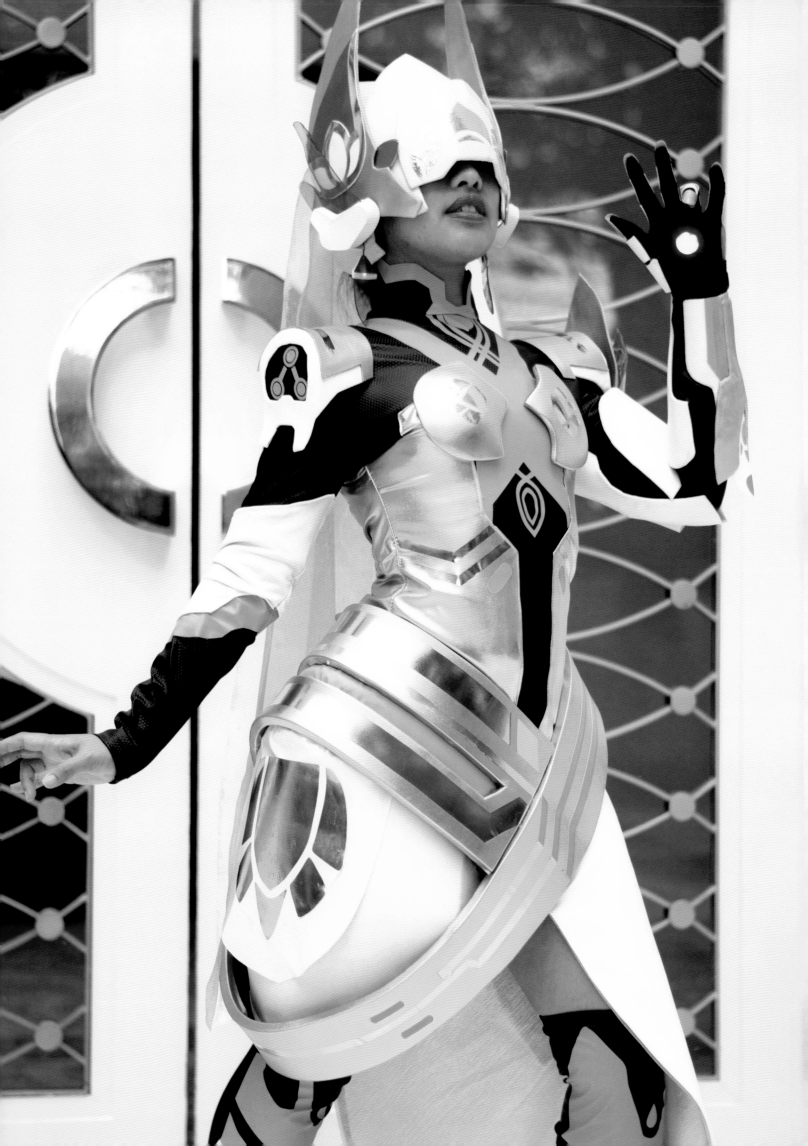

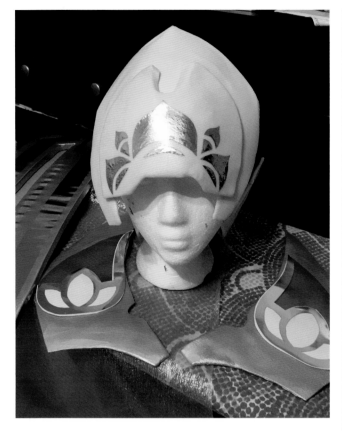

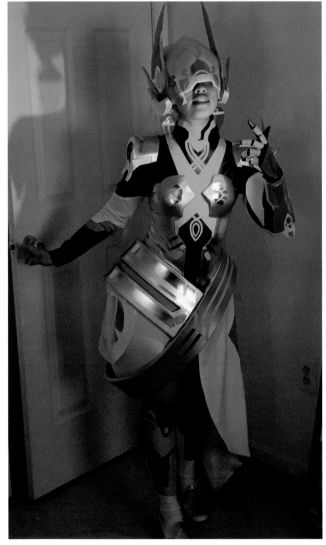

## STEPHANIE A.K.A. M42SC COSPLAY ·
OASIS SYMMETRA

*Photographer: Stephanie a.k.a. M42SC Cosplay
(main photo: Billy Causey)*

"For my electronics, I always bring a repair kit that includes (at minimum) a soldering iron, electrical tape, extra wire, scissors, craft knife, hot glue gun, wire stripper, and pliers. The electronics are (literally) the flashiest part of my cosplay, but they are also the most fragile. I have had some bad experiences starting out where I'd bring something I worked on for weeks before the con only to have it break during travel, and now I always bring the kit with me in case any last-minute repairs need to be made in the hotel room."
— *Stephanie a.k.a. M42SC Cosplay*

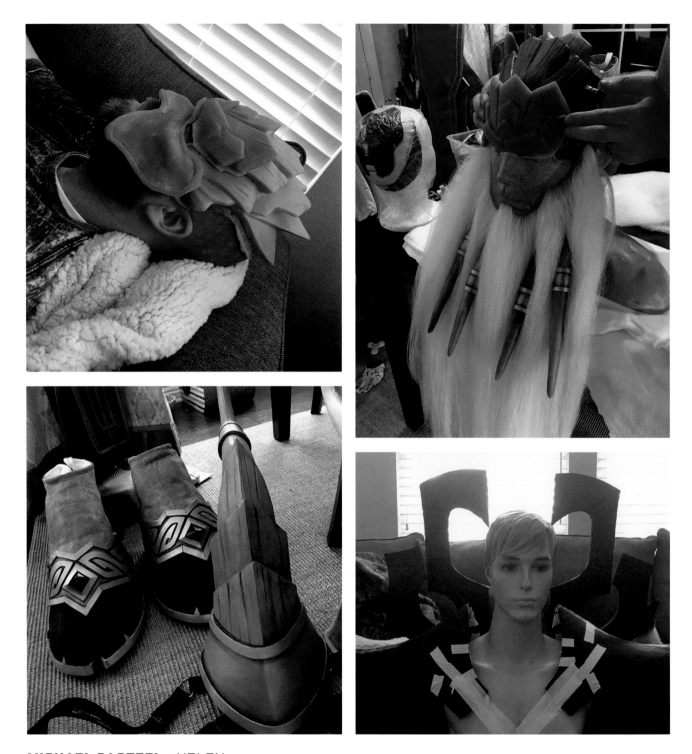

## MICHAEL CASTEEL • VELEN

*Photographer: Michael & Ashley Casteel a.k.a. SteelBarrel Cosplay*
*(main photo: Ashley Casteel)*

"I think the 'weirdest' material we've used in the sense that it doesn't seem like you'd use it for making a serious costume is a pool noodle! We used it as the edging of Kel'Thuzad's hood. But I think the 'weirdest' in terms of actually working with a material would be expanding polyurethane foam; it was really tricky and took a lot of tries to get right! We used poly foam to make Velen's tail and the top of his head since it's lightweight, moldable, and flexible. It was the first time we ever worked with prosthetics and it was a BIG challenge. The very first step in the process was to make a life cast that the prosthetics sculptures would go on, and even that was a complete failure on the first attempt."

—*Michael & Ashley Casteel a.k.a. SteelBarrel Cosplay*

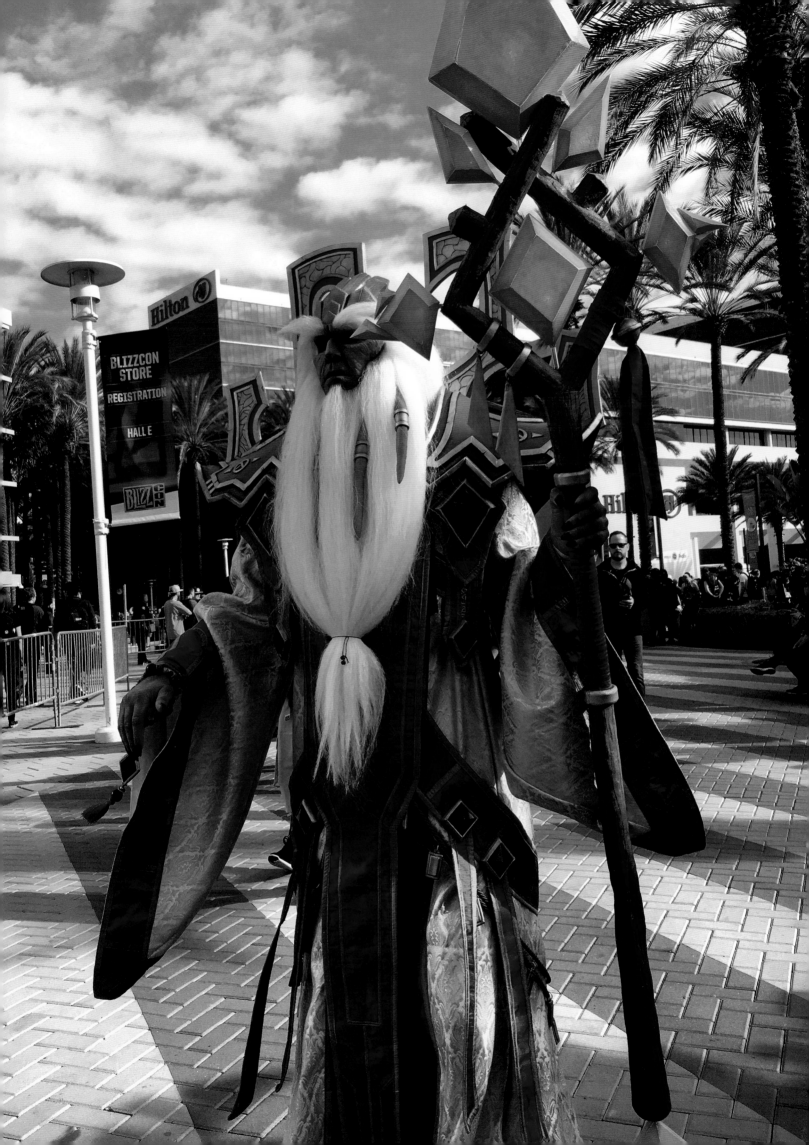

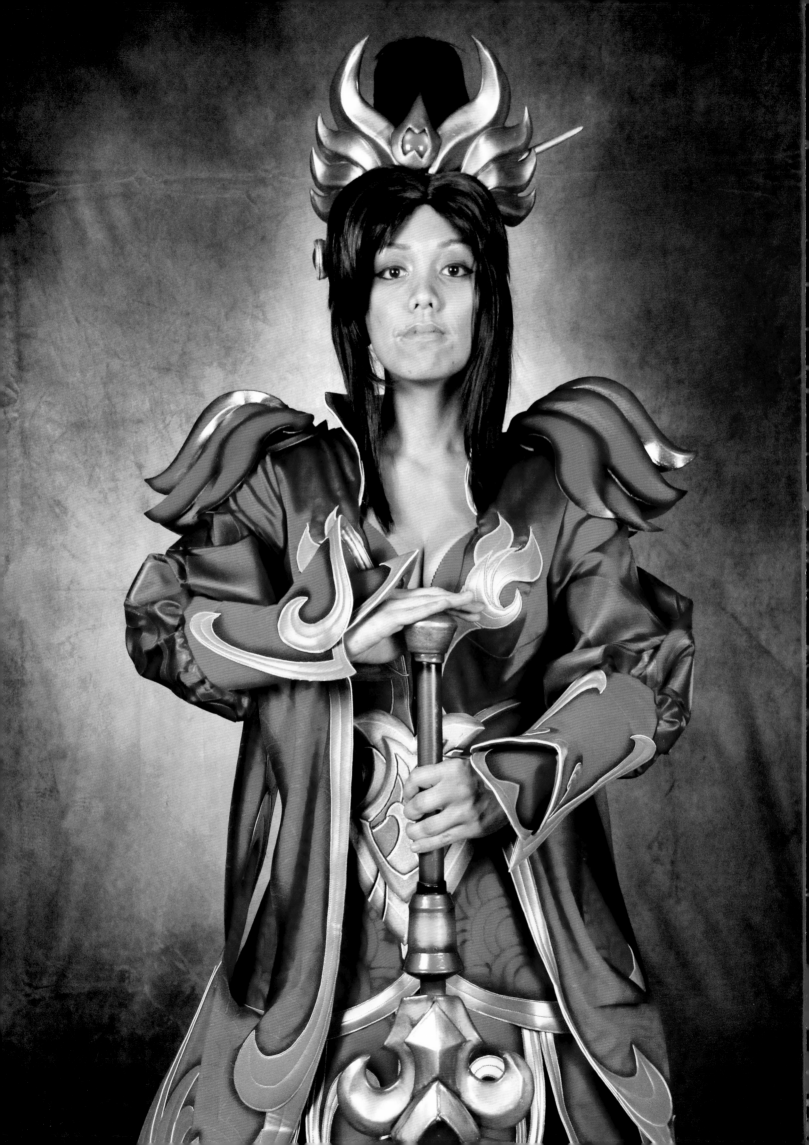

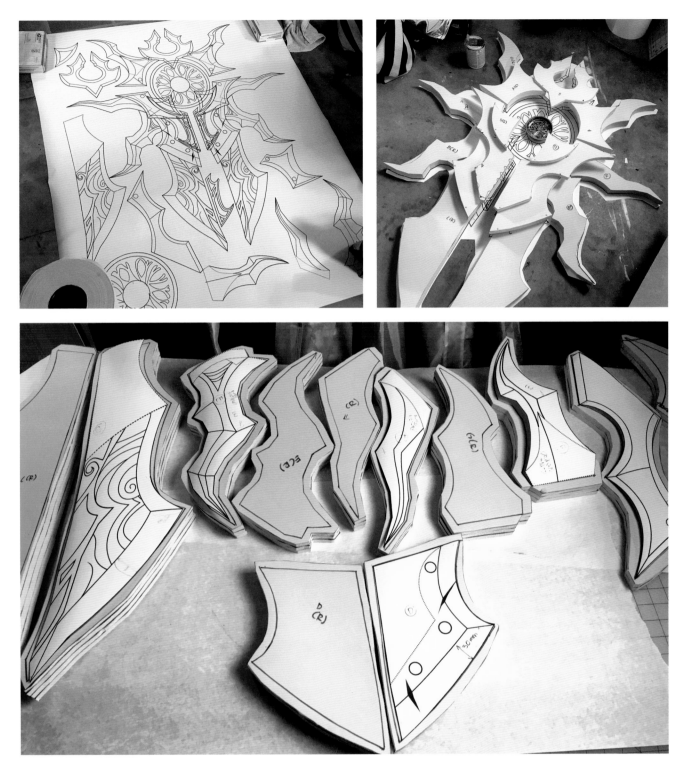

## SARA MCMUNN A.K.A. C'EST LA SARA •
### *DIABLO III* FIREBIRD WIZARD
*Photographer: Sara McMunn a.k.a. C'est La Sara*

"I often start from the center, then move outwards. The bodice, or chestpiece, then shoulders, function as the main piece that holds the whole costume together as the main focal point when viewing from afar. I usually construct parts of a costume by order of importance, with my hand and shoe pieces often the last, since these are usually the easiest to craft. In other cases, I can arrange my crafting pipeline based on how I feel at a given moment (I feel like sewing or being in the garage) or when I'm waiting for materials to arrive from ordering online. When I don't feel like thinking too much, I will work on boring aspects of a costume, such as sanding or priming. When I need to use a huge chunk of thinking power, I have to be in a happy mood, and I often use this time for researching, designing, and planning aspects of the project."
—*Sara McMunn a.k.a. C'est La Sara*

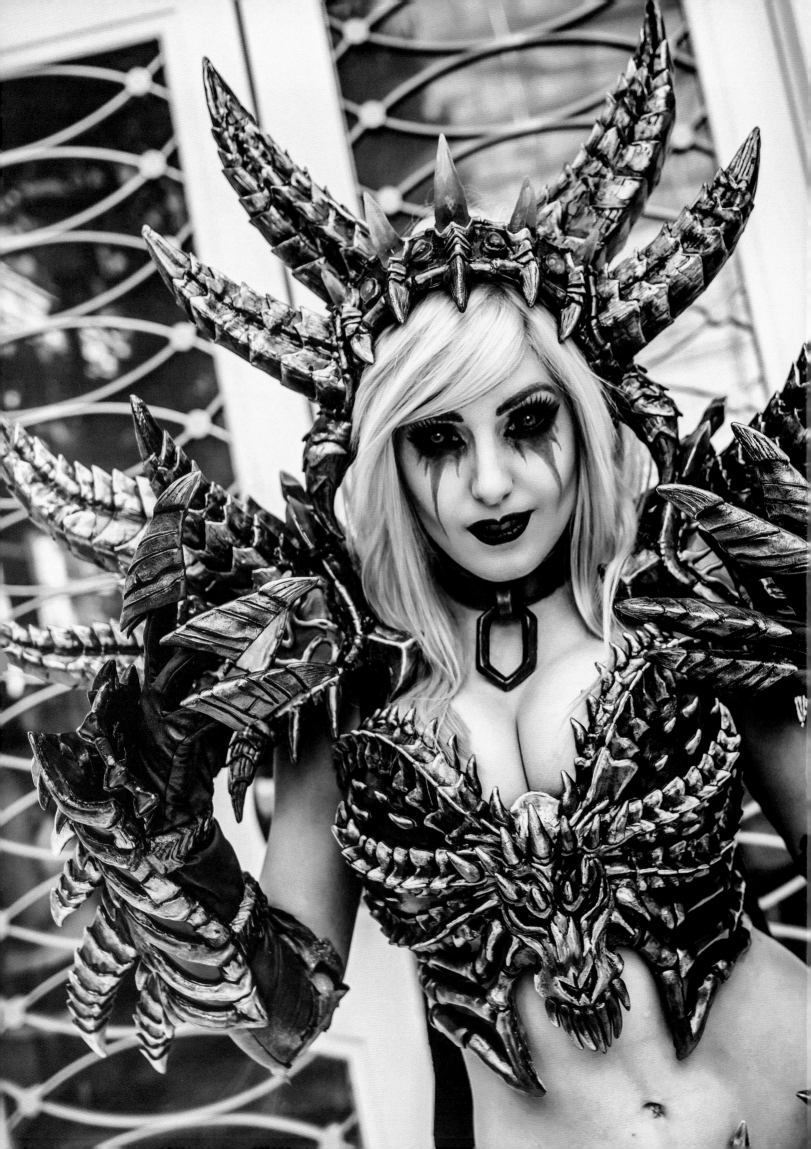

**JESSICA NIGRI** ▪ SINDRAGOSA
*Photographer: David Ngo a.k.a. DTJAAAM*
*Costume designed by Zach Fischer*

"If you stray too far from what makes characters iconic, it will be difficult for others to recognize them. I am constantly distilling down a character's design to what is most vital about it. Knowing what can be changed and what shouldn't be meddled with can make all the difference."
—Zach Fischer

## PROJECT EBON BLADE
*Costume designed by Zach Fischer*

"Project Ebon Blade is the single largest scale cosplay collaboration and group project I have ever seen. At present, there are approximately one hundred plus cosplayers pledged to be part of it, and the number continues to grow. The premise is that during the massive and ongoing war between the Horde and the Alliance, Bolvar Fordragon, the new Lich King, takes advantage of the distraction to consolidate his own power by raising fallen champions of both factions as new death knights to serve him and the Ebon Blade. So imagine many of Azeroth's most prominent heroes as death knights. That is essentially what we are doing. I am redesigning many of the Ebon Blade's existing champions, such as Koltira Deathweaver, High Inquisitor Whitemane, and the Lich King himself. In addition, I am redesigning many of the faction heroes and other notable characters, such as Alexstrasza, Chromie, and Medivh as death knights. It is an incredible task, but with every design I get more and more excited for BlizzCon 2018 when the Ebon Blade will march upon the gates of BlizzCon itself and the dead shall rule!"
—Zach Fischer

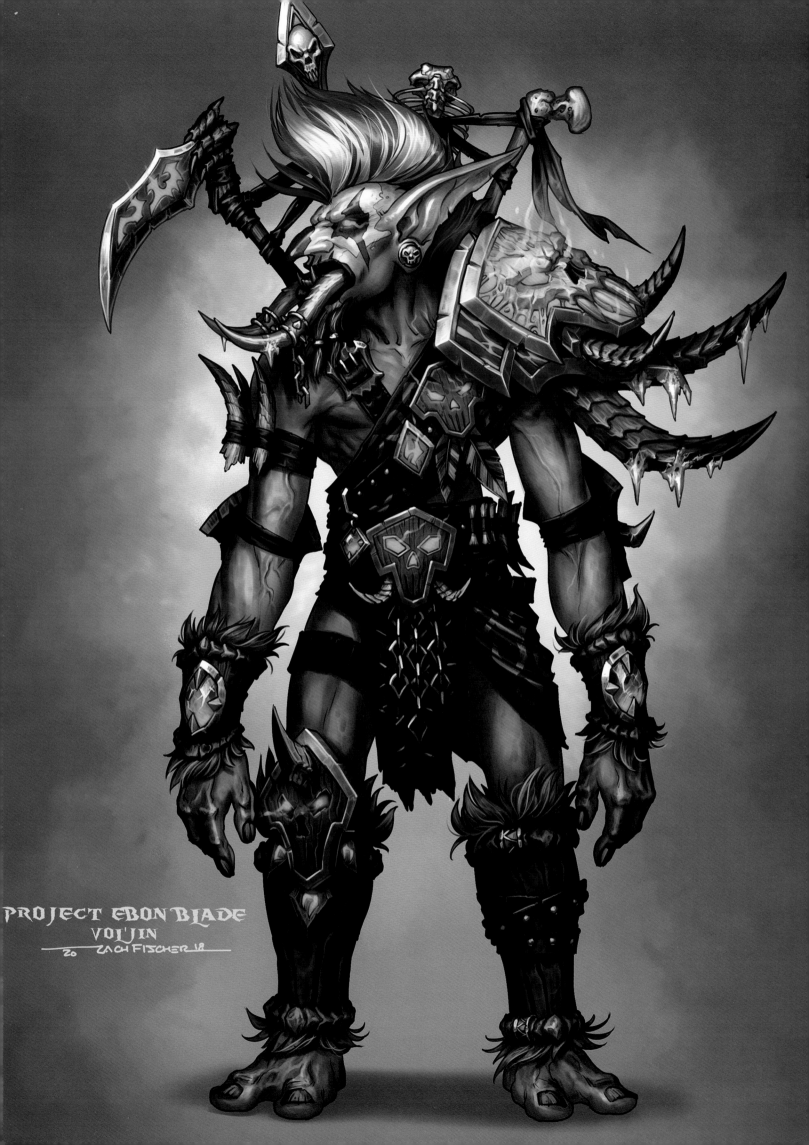

PROJECT EBON BLADE
VOL'JIN
20 ZACH FISCHER 18

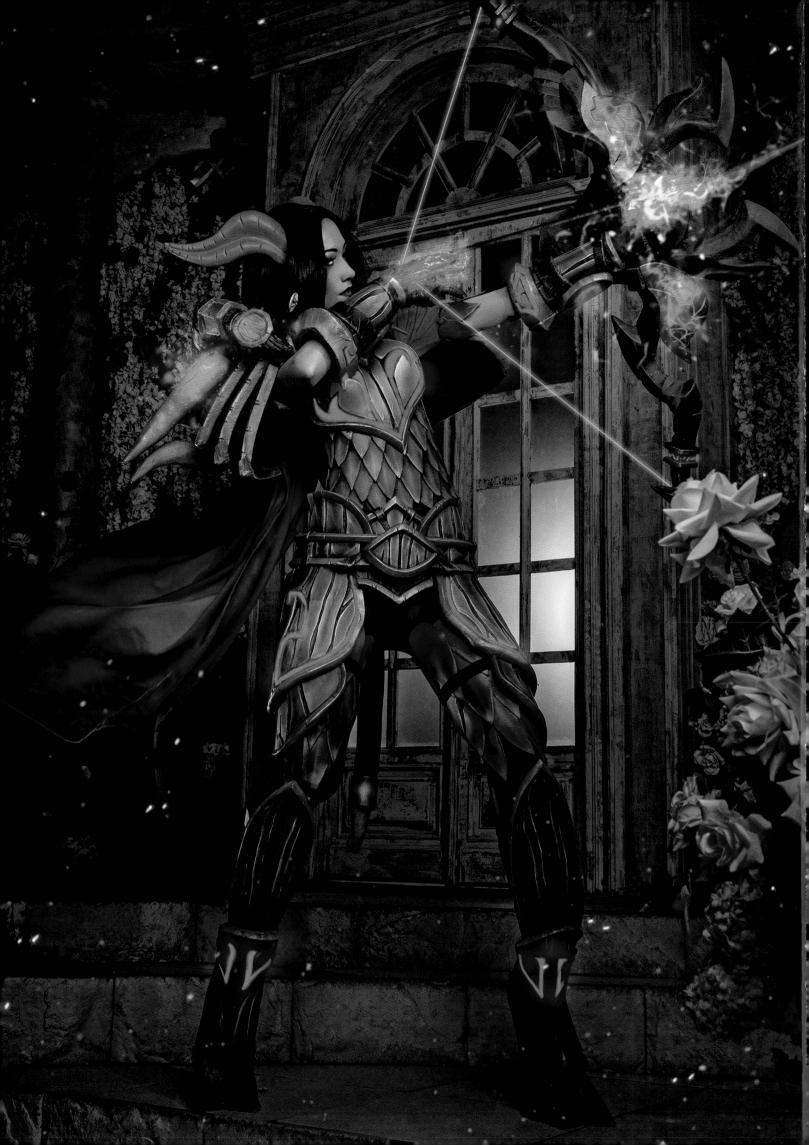

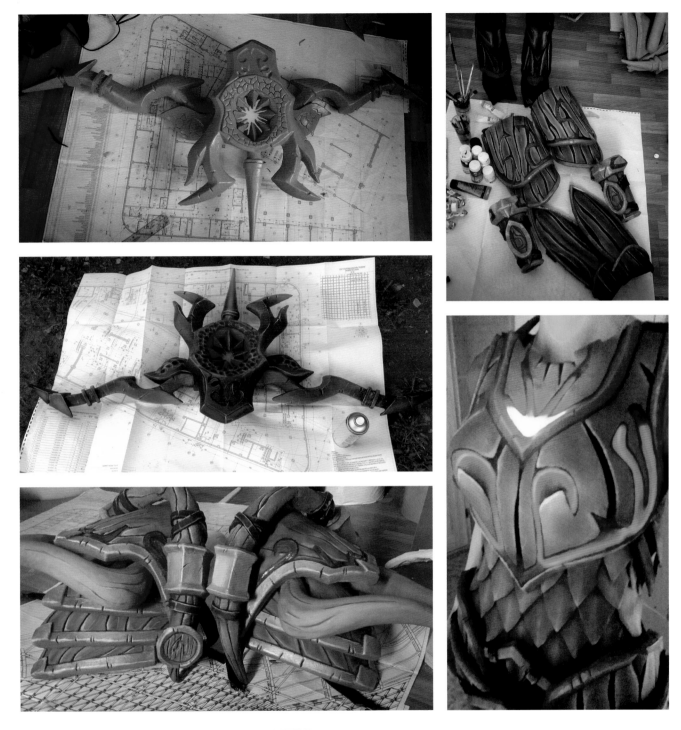

**FEYISCHE COSPLAY** ▪ DRAENEI HUNTER
*Photographer: Feyische and Enishi Cosplay*
*(main photo: SeiPhoto)*

"We don't set a budget when we start making a new costume. First, we use any materials we already have; then we buy whatever we need. It's too hard for us to calculate the cost in advance, because we like to improvise until the costume is ready."
—*Feyische & Enishi Cosplay*

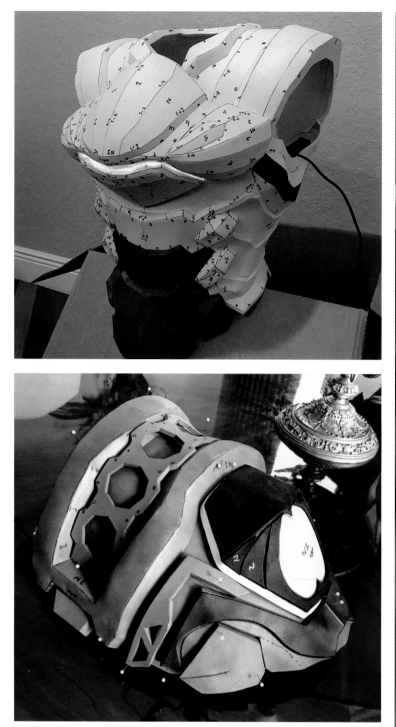

## JUSTIN HADEED A.K.A. JUSCOSPLAY • PHARAH
*Photographer: Justin Hadeed a.k.a. JusCosplay*
*(main photo: Martin Wong Photo)*

"My greatest success in cosplay has been creating a fully functioning Pharah costume. That build challenged me to reach beyond the scope of my knowledge. One notable challenge to overcome was finding a way to motorize the suit while keeping everything light. New materials and some physics learned along the way assisted in making that possible."
—*Justin Hadeed a.k.a. JusCosplay*

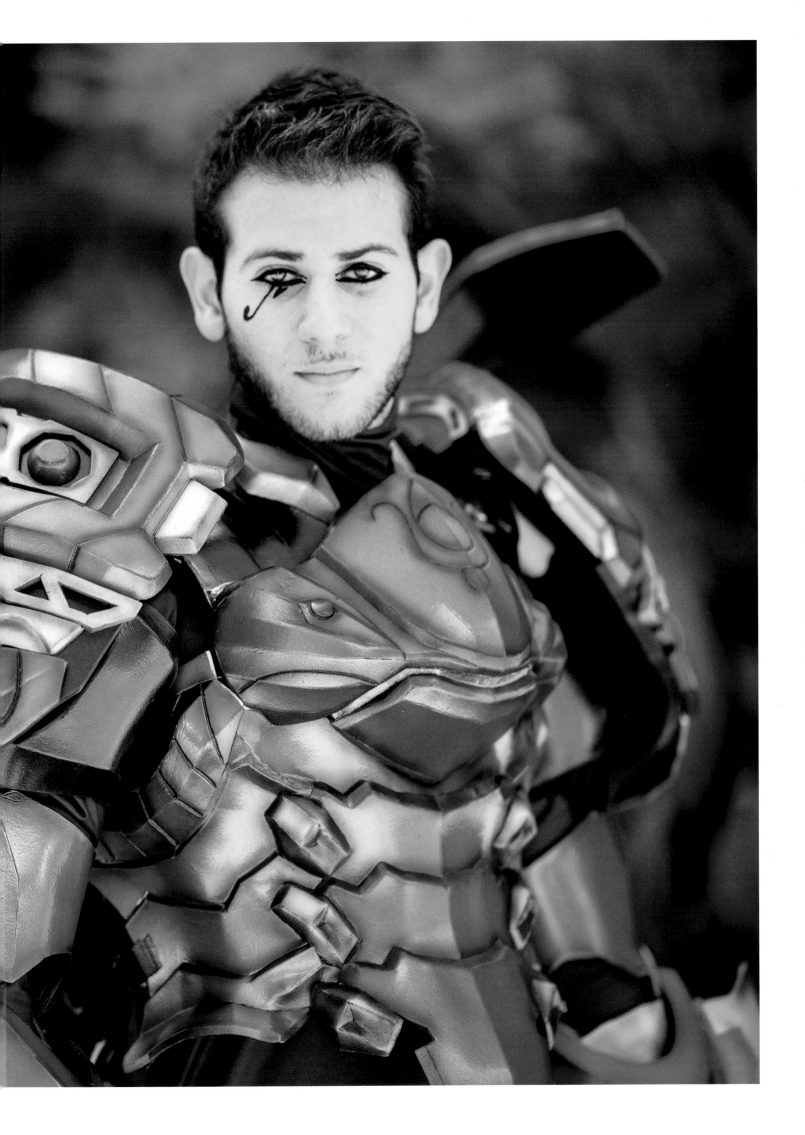

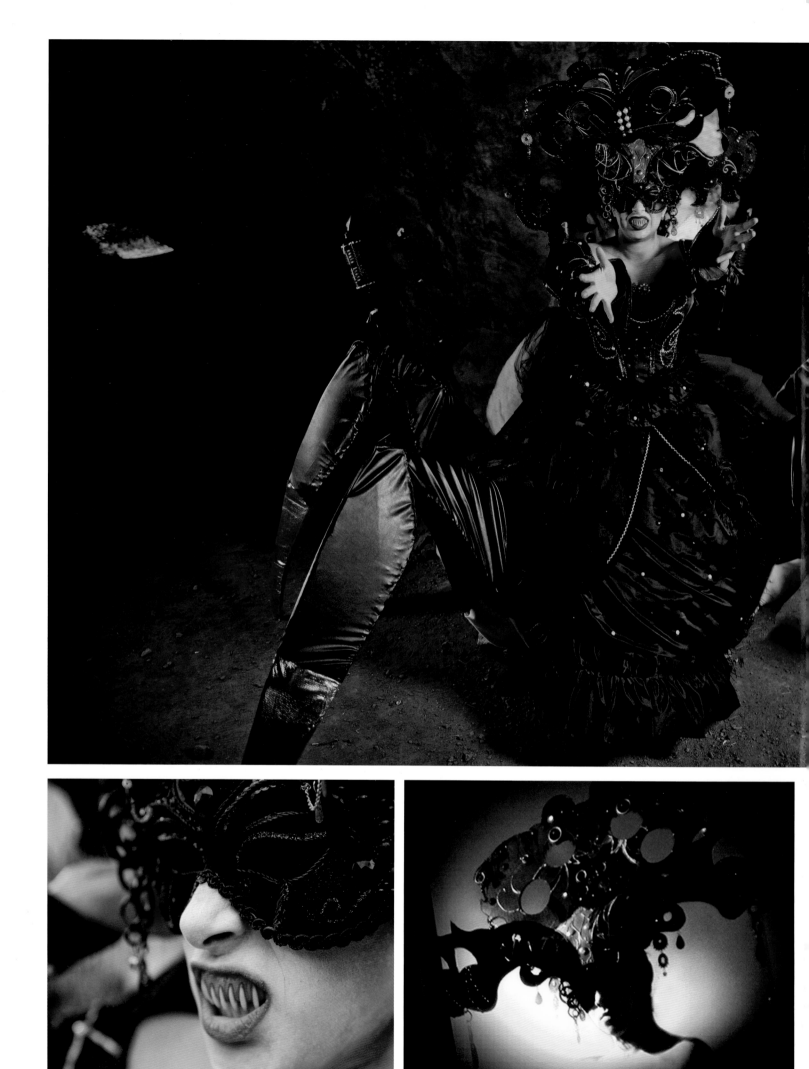

**LORRAINE TORRES** ▪ CYDAEA
*Photographer: Lorraine Torres*
*(main photo, bottom left photo: Tom Hicks)*

"A great deal of planning went into this cosplay, with special considerations for transportation (to and from Florida), convention/stage mobility, and 'near/far' appeal. 'Near/far' appeal is what I call the ability for a costume to be detailed and impressive both close up and far away—in person and on camera under heavy lights."
—Lorraine Torres

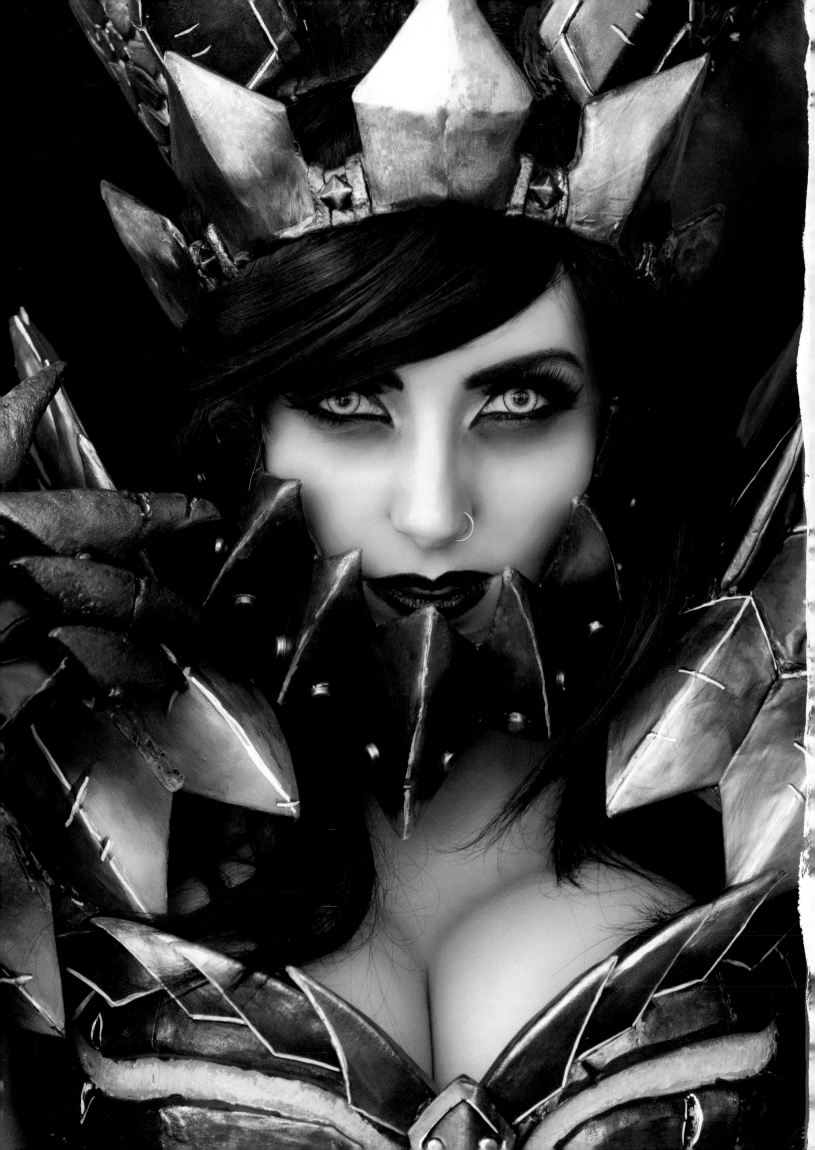